About this book Historica urally, the societies that
produced still life painting could hardly be more diverse. What is it,
then, that allows us to place such different types of image in a single
category? Norman Bryson argues that the family resemblances
between the different types of still life stem from their common
portrayal of a level of material culture that retains its fundamental
outlines through long spans of time and across the boundaries and
divisions of national culture: the culture of domestic routine and
the rituals of hospitality. How this 'low plane reality' is historically
viewed and inflected by the 'higher' levels and discourses of the
surrounding culture is the fundamental subject of this book.

About the author Norman Bryson is currently Head of Art History
and Theoretical Studies at the Slade School of Fine Art, University
of London, and has written extensively on painting and critical
theory. A leading advocate of change in art historical method, his
work seeks to enlarge the traditional scope of art history by
drawing on the ideas and perspectives of semiotics, literary
criticism and cultural history. His books include *Word and Image:
French Painting of the Ancien Régime* (1981), *Vision and Painting: The
Logic of the Gaze* (1983), and *Tradition and Desire: from David to
Delacroix* (1984). He edited *Calligram: Essays in New Art History from
France* (1988), has authored numerous exhibition catalogues, and is
the general editor of *Cambridge Studies in Art History and Criticism*.

Looking at the Overlooked

Four Essays on Still Life Painting

Norman Bryson

REAKTION BOOKS

For Peter and Eileen

Published by Reaktion Books Ltd
79 Farringdon Road, London EC1M 3JU, UK

www.reaktionbooks.co.uk

First published 1990, reprinted 1995, 2001

Series design by Humphrey Stone
Colour printed by Balding & Mansell Ltd, Norwich
Printed and bound in Great Britain by
Biddles Ltd, Guildford and King's Lynn

British Library Cataloguing in Publication Data

Bryson, Norman, 1949–
Looking at the overlooked: Four essays on
Still life painting.
I. Title
758'.4

ISBN 0-948462-07-8 (hbk)
ISBN 0-948462-06-x (pbk)

Contents

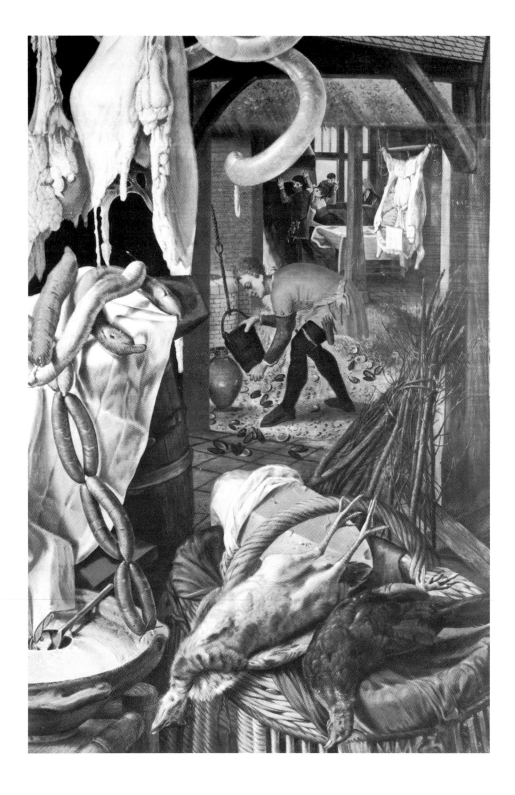

Foreword

The first difficulty facing any book on still life painting lies in its opening move, in the assumption that still life *exists*. Of course we all know what still life looks like; that is not the problem. But despite our familiarity with still life and our ease in recognising it, there is still something unjustified about the term, in that it takes in so much: Pompeii, Cubism, Dutch still life, Spanish still life, *trompe l'oeil*, collage. Why should these entirely different kinds of image be considered as a single category? What is the real relationship, if any, between these images that are historically, culturally, and technically so diverse? Or is there *no* real relationship between them, outside of modern critical discourse?

To this objection my first answer is: how can any discussion of painting occur outside of critical discourse – where else is it going to happen? Still life as a category within art criticism is almost as old as still life painting itself. The first modern still lifes showing such things as fruit, baskets, goblets, bowls, as independent pictures (not just details or margins in religious scenes) date from the early 1600s: by the 1660s the French Academy already finds a place for still life in its aesthetic debates (Félibien). In the later eighteenth century, Reynolds formulates a theory of still life in the *Discourses*, in which it features as a distinct branch of painting, taking its place alongside portraiture, landscape and history painting. For Reynolds' audience, still life was as viable and central a term in organising discussion of visual representation as it remains for us today. The literature around still life is already more than three centuries old. The essays in this book are written squarely within that tradition of commentary. What they undertake is to develop the critical discussion to some extent, by adding to it considerations which so far have not been heard. There may come a time when the critical category 'still life' corresponds to nothing viewers experience as actually or really felt; but meanwhile, when the term is still alive and well, it makes sense not just to settle for the inherited discussion but to try to move that discussion into our own time and to ask what still life might mean, for us now.

1 Detail of *The Butcher's Stall,* Pieter Aertsen (illus. 56).

The need to do so may in fact be a matter of some urgency. Although the genre of still life is as obvious a piece of our basic cultural furniture as history painting or landscape – or Westerns, or thrillers – its inevitability and indispensability have not helped it generate much corresponding light (or heat) in critical discussion. It has always been the least theorised of the genres, and when the academies that launched the first theoretical accounts of painting came to mention it at all, they did so disparagingly: still life was always at the bottom of the hierarchy, unworthy of the kind of superior attention reserved for history painting or the *grande manière*. Art history as taught in most universities perpetuates the comparative indifference of its antecedents in the academies; still life continues to struggle with the prejudice that while (of course) it would be a subject worth investigating, the real stakes lie elsewhere, in the higher genres where (of course) things have always been more interesting. It is still thought of in a manner of which Reynolds would have approved, as not quite the province of the serious and ambitious student; not really the most recommendable topic for a dissertation that would wish to show its professional mettle.

Though the twentieth century has seen a tremendous proliferation of exhibitions of still life, and of catalogues and monographs dealing with matters of chronology, provenance and connoisseurship, *interpretation* of still life has generally languished on all sides. Here Reynolds is not like ourselves; he had passionate reasons for his condemnation of still life, and the energy of interpretation in the *Discourses* is tumultuous compared with the polite avoidance of interpretation in today's average still life catalogue (where ritual invocations of *vanitas* sometimes constitute the sole critical act). Interpretation is still not part of art history's customary self-definition: the nineteenth-century dream of scientificity and the modernist dream of pure form have together resulted in a widespread silencing of critical speech concerning painting. 'Criticism' is what happens to contemporary art; it is not part of art *history* but, instead, of journalism.

The conditions here contrast rather starkly with those prevailing in the other humanities. Students of literature, graduates and undergraduates alike, regularly wrangle for hours over issues of interpretation; and they are able to do this, so much more than students of art history, not because painting is somehow mute, but because such discussion is expected of them: this is

what they are trained to do. At one point in *The Political Unconscious* Fredric Jameson describes the 'bewildering variety of competing and commensurable options' available to interpreters of Conrad, including

> the 'romance' or mass-cultural reading of Conrad as a writer of adventure tales, sea narratives, and 'popular' yarns; and the stylistic analysis of Conrad as a practitioner of what we will shortly term a properly 'impressionistic' will to style. Alongside these, however, and not related to them in any immediately evident way, we can distinguish other influential kinds of readings: the myth-critical, for instance, in which *Nostromo* is seen as the articulation of the archetype of buried treasure; the Freudian, in which the failure of Oedipal resolution is ratified by the grisly execution of Conrad's two son-heroes (Jim and Nostromo) by their spiritual fathers; the ethical, in which Conrad's texts are taken literally as books which raise the 'issues' of heroism and courage, of honor and cowardice; the ego-psychological, in which the story of Jim is interpreted as the search for identity or psychic unity; the existential, in which the omnipresent themes of the meaninglessness and absurdity of human existence are foregrounded as 'message' and as 'world-view'; and finally, more formidable than any of these, the Nietzschean reading of Conrad's political vision as a struggle against *ressentiment*, and the structuralist-textual reading ... of the impossibility of narrative beginnings and as the increasing reflexivity and problematization of linear narrative itself.[1]

If the novels of Conrad are a focus of analytic enquiry in literature, one might perhaps expect in art history to find a comparable variety and complexity of discussion around Raphael, say, or Ingres. Forlorn hope! Which is not to say that such debates are incapable of occurring in art history: Velázquez' *Las Meninas* and Manet's *Olympia* were sites of tremendous controversy in the 1980s, and there are presently major wars being waged over the interpretation of Dutch painting, mid- nineteenth-century French painting, and modernism/postmodernism, to name only the obvious. But still life has not featured in these vigorous and flourishing debates. Perhaps as the genre at the furthest remove from narrative, it is the hardest for critical discourse to reach. But certainly as the genre historically constructed as the lowest category of picture-making, it has never had much chance of

drawing debate anyway; and in the past decades the vacuum has tended to be filled by a single volume, Charles Sterling's still useful *Nature morte de l'antiquité à nos jours*.[2]

There is room, then, for more work on still life; to speak plainly, it is under-interpreted, and if the present essays manage to convince anyone that it is a genre worth analysing, and rewarding to analyse *as* a genre, they will have done their bit. It still needs saying: painting is an art made not only of pigments on a surface, but of signs in semantic space. The meaning of a picture is never inscribed on its surface as brush-strokes are; meaning arises in the collaboration between signs (visual or verbal) and interpreters. And 'reading', here, is not something 'extra', an optional supplement to an image that is already complete and self-sufficient. It is as fundamental an element as the paint, and there is no viewer who looks at a painting who is not already engaged in interpreting it, even (especially) the viewer who looks for 'pure form'. But this book is not meant to be a polemic about the semiotics of art. Its goal is more practical: to try to develop the critical discourse around still life through a group of essays which engage with the paintings in the terms of our own time.

My first response to the objection that still life has no unity outside of modern critical discourse is therefore to agree that critical discourse is indeed one site in which still life emerges as a coherent category; but then to add that the discussion is, however, not yet so richly sedimented that nothing remains to be said. On the contrary, discussion of still life remains oppressed and inhibited; it was virtually strangled at birth in the academies that relegated still life to the lowest level of art, and it is still marginalised in today's professional art history. My second response is to say that it is not only in *criticism* that the category possesses coherence, but in the production of the paintings themselves. Taxonomy is the name given to the branch of knowledge that deals with classification; the taxonomist takes a body of phenomena (plants, animals) and groups them into species and genera, according to criteria which the taxonomist creates for the purposes of analysis. But still life is not a *taxonomic* category of this kind. It is not the product of an analysis which comes along, as it were, only after the fact. Still life painters designed their individual works to appear *as* still life and to take their place in *series* of work of the same kind. Much of their meaning comes from the inflections they are able to introduce

into the field of previous work. The still lifes of Chardin are highly self-conscious adaptations of still life conventions first developed in the Netherlands in the seventeenth century. The luxury still lifes of de Heem and Willem Kalf depend on proto-types in the *vanitas* painting which they modify and push in specific directions, in the same way that Matisse in turn took de Heem and refashioned de Heem's designs for his own distinc-tive purposes.

If the word 'genre' has too many negative connotations (of the trans-historical study of art, of formalism, of idealism), the word *series* may be more useful here: still life paintings were made to enter the still life series. That series has no essence, only a variety of family resemblances. And it is not a *linear* series, like successive generations of computers or atomic reactors; rather the series (plural) regroup themselves around the indi-vidual work, the boundaries of the series fluctuate around each new case. It is a category, in other words, not only within recep-tion and criticism, but within the historical production of pictures.

It is right to stress the materiality of series at this point, because materialist thought may have some difficulty coping with the idea of series which cross boundaries of national culture and of period as insistently as the still life series does. Materialist analysis is much more comfortable with the act of referring indi-vidual works to their immediate casual genesis in social and historical factors *outside* the series. Take, for example, Chardin. It is obviously right to emphasise the historical specificity of a bourgeois painter working in *ancien régime* France, a painter closely involved with the Academy in Paris, whose works make use of conventions which may well depend on specifically eighteenth-century ideas concerning visual perception and ocular capacity. Such contextualisation points to the enormous differences between the historical and cultural base of Chardin, and of the seventeenth-century Dutch still life painters whose work he modified and adapted. Where social and historical analysis starts to feel uneasy is with the continuity of a material series that runs (or jumps) from the Netherlands to France and from the seventeenth to the eighteenth century. The series seems to cut across and therefore to lessen, if not nullify, the force of the local pressures which formed Chardin's immediate milieu; local pressures on which historical analysis will rightly insist. It seems more convenient for the materialist approach to play

down the concept of the series altogether, even to the point of outright nominalism at which each individual still life of Chardin is folded back into *its* local circumstances: better to give up the concept of the series or genre altogether, and regard each instance of picture-making atomistically. Because the alternative seems unacceptable: if the concept of the series is admitted in such a case, where the series is discovered to be discontinuous in space and time – to leap from the Netherlands to France and from one century to the next – it seems as though art is behaving in exactly the way the enemies of materialist thought always maintained it did: as timeless, universal, transcending local conditions, inhabiting a higher Platonic realm somewhere above and beyond the struggles of history.

I strongly sympathise with this materialist objection, and the essays which follow are firmly rooted in historical and material process. But the objection brings with it an exceedingly drastic consequence, if the only way forward would seem to be to abandon and disown the concept of generic series *even though* such series exist objectively and historically. Whenever a series is *dis*-continuous, and jumps from one specific cultural milieu to another, it would seem that materialist analysis must close its eyes, or issue an automatic accusation of idealism to anyone who thinks it is still a series. But it may be that the analysis is not being materialist *enough*.

An important resolution to this impasse comes if we consider the coherence of the category 'still life' as produced not only (a) by the institution of criticism, from the seventeenth century to the present day, and (b) by the painters themselves, working within pre-established material series, but (c) as produced by the actual objects with which still life painting deals, and the level of material culture to which those objects belong. The objects shown on the tables of seventeenth-century Dutch interiors (pitchers, bowls, goblets, plates, vases and so forth) belong to a further series of artefacts that is not fundamentally discontinuous with the corresponding objects which appear in Pompeian painting. The *things* which occupy still life's attention belong to a long cultural span that goes back beyond modern Europe to antiquity and pre-antiquity. When modern viewers accept a continuity between the *bodegónes* of Cotán in Renaissance Spain and the café tables of Juan Gris in Cubist Paris, it is not simply the force of a critical category, naturalised through repetition, which links these very different types of painting.

Behind the images there stands the culture of artefacts, with its own, independent history. The bowls, jugs, pitchers and vases with which the modern viewer is familiar are all direct lineal descendants of series which were *already* old in Pompeii.

No less than wars or revolutions, such artefacts are the products of cultural and historical pressure: to wars and revolutions, this level of cultural activity forms a permanent and inevitable background. Not an *unchanging* background: the culture of the table is as responsive to history as anything else. But the *rhythms* of change at this level are distinctive. The culture of the table displays a rapid, volatile receptivity to its surrounding culture in the mode of inflecting its fundamental forms. At the same time it also displays a high level of resistance to innovation in the forms themselves. It is centuries before Europe made use of tankards, deep dishes, forks, stemmed glasses; but once these things were in general use, they generally remained. At this level of culture, then, two rates of change can be distinguished: rapid – there is constant *inflection* of the objects under the influence of the fast-moving changes occurring in the spheres of ideology, economics, and technology; and slow – there is little actual *innovation* as a result of this influence. To the extent of its rapid sensitivity to, and assimilation of, influences from the other cultural spheres, the culture of the table is passive and dependent. But to the extent that it makes use of forms which endure over very long spans of time, in long-lived series that cut right across divisions of national culture and historical period, the culture of the table is an *authentically self-determining* level of material life, one which may be dramatically inflected from other spheres but cannot be *derived* from those. Besides the rapid, seismically sensitive rhythms set by consumption, its objects are also tuned to a slow, almost geological, rhythm that is all their own.

I conceived an odd project: to investigate still life as a response to this slowest, most entropic level of material existence. What is curious about this level is that it is inescapable. Access to the 'major' events of history is far more open to chance. The novels of Jane Austen manage almost completely to ignore the Napoleonic wars, a Parisian away from Paris might 'miss' the July Revolution, the audience at *The Winter's Tale* might or might not have followed the detail of its debate about nature and nurture: involvement with the 'higher' levels of culture is comparatively optional – but no-one can escape the conditions of creaturality, of eating and drinking and domestic

life, with which still life is concerned. I put inverted commas around 'major' and 'higher' because these terms exactly beg the question of how this level of material culture is judged and evaluated historically, from the viewpoint of other cultural spheres. Whether to see it as trivial, base and unworthy of serious attention, or to see it otherwise, is very much a matter of history and ideology (it is also, I argue in the final essay, a matter of the ideology of gender). To the question, What is the coherence of the term 'still life'? one can respond by invoking still life as a category in criticism, and as a category in painting production. But in fact the essays offered here are far more concerned with the third answer: that still life exists as a coherent category through being inextricably caught up in the process of evaluating, in visual representations – and through the most complex symbolism – the place of what might be called low-plane reality, as this appears within the 'higher' discourses of culture.

Still life can be said to unfold at the interface between these three cultural zones:

(1) the life of the table, of the household interior, of the basic creaturely acts of eating and drinking, of the artefacts which surround the subject in her or his domestic space, of the everyday world of routine and repetition, at a level of existence where events are not at all the large-scale, momentous events of History, but the small-scale, trivial, forgettable acts of bodily survival and self-maintenance;

(2) the domain of sign systems which *code* the life of the table and 'low plane reality' through discourses which relate it to other cultural concerns in other domains (for example those of ideology, sexuality, economics, class);

(3) the technology of painting, as a material practice with its own specificities of method, its own developmental series, its own economic constraints and semiotic processes.

These zones can be separated only in analysis: in practice the symbolism followed by painting interacts with cultural symbolism outside painting, the economics of the studio interact with wider economic life, the culture of the domestic interior is woven at every point into the public world which surrounds it. But the separation is justified by a rule of *non-derivability*: the culture of the table is inflected – massively so – by the codes of signification which surround it, but its forms answer to material needs which subtend signification and exist to one side of signification (all subjects require food, drink and shelter, even those who live

outside the symbolic order: infants, psychotics, the mentally handicapped). The technical procedures of painting may be employed in the service of particular ideological systems but cannot be derived from these alone. The four essays presented here examine particular aspects of still life's interface with these three zones.

Chapter 1 – *Xenia* – concerns the painting of 'still life' objects in the decorative schemes that survive from antiquity, and considers them in relation to issues of representation (realism, hyperrealism, simulation) on the one hand, and on the other to issues of power (class difference, control over nature, control over representation). Chapter 2 – *Rhopography* – examines the discourse in which painting is itself divided into two sectors: one dealing with the exceptional act and the unique individual, with the narrative and the drama of 'greatness' (megalography), and another dealing with the routines of daily living, the domestic round, the absence of personal uniqueness and distinction (rhopography). Chapter 3 – *Abundance* – explores still life painting in the Netherlands in the seventeenth century in terms of Dutch society's attitudes towards its own wealth, and the spectrum of responses to affluence, ranging from high moralism, to anxiety concerning the role of consumption, to the exuberant enjoyment of plenty. In particular this essay analyses how the sphere of consumption was re-absorbed, in still life imagery, back into the values of production. Chapter 4 – *Still Life and 'Feminine' Space* – asks what the distinctions between low-plane reality and high-plane reality, between rhopography and megalography, between still life and the supposedly 'higher' genres of painting, may have to do with gender positions and gender ideology.

In writing these essays I have been enormously helped by conversations with a number of friends, especially Margaret Pinder, Joseph Koerner, Mieke Bal, Rosalind Krauss, Hal Foster, Oliver Soskice, Stephen Bann, Simon Schama, Keith Moxey and Gloria Pinney. Richard Brilliant, David Castriota and Lawrence Richardson were kind enough to offer their comments on Chapter 1. My thanks to all of them. Some of the arguments in chapters 2 and 4 appeared in *Critical Inquiry* Vol. 15, No. 2 (Winter 1989).

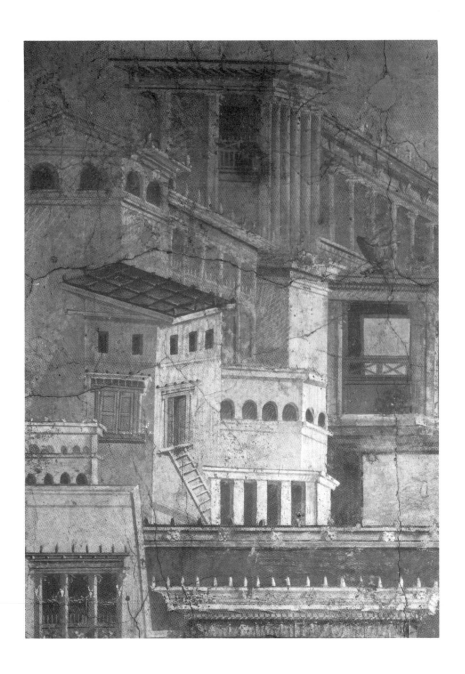

1 Xenia

We know from the villas buried beneath the lava of Vesuvius that the Romans possessed a category of painting much resembling what would later be called 'still life': *xenia*. The works that survive fulfil most subsequent definitions of this branch of painting: they represent *still-stehende Sache*, things standing still, *nature reposée*, things at rest; such things as fruit, baskets of flowers, loaves of bread, ewers, pitchers, platters, fish, seafood, game – the familiar repertoire of the later genre. Yet it would be wrong to decide that, because the ensemble of objects so resembles that of later painting, one must be dealing here with the same kind of work, with Still Life, or even with its origins.[1] The *xenia* need to be approached on their own terms. They are a fascinating group of images, and any reading of still life painting that ignored them would be radically incomplete. Yet they present peculiar difficulties of approach. Exactly because they seem so close in content to later still life painting, they are easily elided with images produced under quite different cultural conditions; what can be quickly lost is the sense of their specificity. And the *xenia* essentially come to us as a ruin; we possess only a minute fraction of the still life of antiquity, mere fragments of what once was there. The present essay is a reading of some of these fragments; given their brokenness and dispersal, it is necessarily tentative and incomplete. Our first step must be to establish at least some of the conditions that formed the semantic field of which the *xenia* were a part, and this necessarily will take us to those few texts concerning *xenia* which survive from antiquity – Philostratus, the *Natural History* of Pliny, suggestive asides by Plato and Vitruvius. The corpus of relevant texts is indeed scant, but enough for us to begin to look again at the images in detail, and not only at the images themselves, but at the decorative schemes which frame and structure them.

2 Detail of wall painting from the cubiculum of the villa at Boscoreale (illus. 7).

The *xenia* that come down to us would be pure enigma if we were unable to ascertain something of what they meant to their Roman viewers and why they were valued, their symbolic implications and semantic charge. It is fortunate that there

survives one particular source of information which deals explicitly with the codes of viewing that surrounded Roman painting, and not as brief digressions within a philosophical treatise or as entries in a compendium of general knowledge, but as a pedagogical text designed with the express purpose of guiding Roman students through the paintings of their culture: the *Imagines*. Their author, Philostratus, was a Greek Sophist who taught in Athens and later in Rome in the third century AD, and the work takes the form of descriptions of paintings supposedly forming the extensive collection of a wealthy art-lover in the city of Neapolis, ancient Naples. The question whether the paintings in the *Imagines* actually existed, or were wholly or largely imaginary, was the subject of heated and inconclusive debate during the last century, and the issue remains unsolved.[2] In a sense the question is irrelevant to the usefulness of Philostratus' text. If the paintings were non-existent, what the *Imagines* in fact describe are codes of viewing in a remarkably pure form: protocols, expectations and generic rules governing the viewing of pictures, almost in abstraction from its empirical objects. If, on the other hand, the paintings described actually existed in the collection of a Neapolitan amateur, those rules of viewing become anchored in the context of actual Roman art production. Either way, the *Imagines* are crucial to the understanding of *xenia*. In Philostratus' gallery mythological and historical painting are well represented; so is landscape; and among these other genres are two paintings of still life, the only ones in the collection.

XENIA I

It is a good thing to gather figs and also not to pass over in silence the figs in this picture. Purple figs dripping with juice are heaped on vine-leaves; and they are depicted with breaks in the skin, some just cracking open to disgorge their honey, some split apart, they are so ripe. Near them lies a branch, not bare, by Zeus, or empty of fruit, but under the shade of its leaves are figs, some still green and 'untimely', some with wrinkled skin and over-ripe, and some about to turn, disclosing the shining juice, while on the tip of the branch a sparrow buries its bill in what seems the very sweetest of the figs. All the ground is strewn with chestnuts, some of which are rubbed free of the burr, others lie quite shut up, and others show the burr breaking at the lines of

division. See, too, the pears on pears, apples on apples, both
heaps of them and piles of ten, all fragrant and golden. You
will say that their redness has not been put on from the out-
side, but has bloomed from within. Here are gifts of the cherry
tree, here is fruit in clusters heaped in a basket, and the basket
is woven, not from alien twigs, but from branches of the plant
itself. And if you look at the vine-sprays woven together
and at the clusters hanging from them and how the grapes
stand out one by one, you will certainly hymn Dionysos and
speak of the vine as 'Queenly giver of grapes'. You would
say that even the grapes in the painting are good to eat and
full of winey juice. And the most charming point of all this
is: on a leafy branch is yellow honey already within the comb
and ripe to stream forth if the comb is pressed; and on another
leaf is cheese new curdled and quivering; and there are bowls
of milk not merely white but gleaming, for the cream floating
upon it makes it seem to gleam.[3]

XENIA II
This hare in his cage is the prey of the net, and he sits on
his haunches moving his forelegs a little and slowly lifting
his ears, but he also keeps looking behind him as well, so
suspicious is he and always cowering with fear; the second
hare that hangs on the withered oak tree, his belly laid wide
open and his skin stripped off over the hind feet, bears witness
to the swiftness of the dog which sits beneath the tree, resting
and showing that he alone has caught the prey. As for the
ducks near the hare (count them, ten), and the geese of the
same number as the ducks, it is not necessary to test them
by pinching them, for their breasts, where the fat gathers
in abundance on water-birds, have been plucked all over. If
you crave for raised bread or 'eight-piece loaves', they are
here near by in the deep basket. And if you want any relish,
you have the loaves themselves — for they have been
seasoned with fennel and parsley and also with poppy-seed,
the spice that brings sleep — but if you desire a second course,
put that off till you have cooks, and partake of the food that
needs no fire. Why not, then, take the ripe fruit, of which
there is a pile here in the other basket? Do you not know
that in a little while you will no longer find it so fresh, but
already the dew will be gone from it? And do not overlook
the dessert, if you care at all for medlar fruit and Zeus' acorns,

which the smoothest of trees bears in a prickly husk that is horrid to peel off. Away with even the honey, since we have here the *palathè*, or whatever you like to call it, so sweet and dainty it is! And it is wrapped in its own leaves, which lend beauty to the *palathè*.

I think the painting offers these gifts of hospitality to the master of the farm, and he is taking a bath, having perhaps the look in his eyes of Pramnian or Thasian wines, although he might, if he would, drink the sweet new wine at the table here, and then on his return to the city might smell of pressed grapes and of leisure and might belch in the faces of the city-dwellers.[4]

Why should we turn at this point to Philostratus? After all, if the paintings never existed, one would be relying on the evidence of an ingenious mythomane. The Sophist philosopher might have invented the entire gallery, together with improvised and misleading suggestions for viewing its contents, solely as an exercise in rhetoric or the bizarre use of imagination. Yet the paintings which Philostratus describes do correspond to the evidence of the archaeological excavations in Campania; the practice of thematically grouping paintings into clusters or cycles, so striking in this text, closely resembles the painting programmes present, for example, at Pompeii;[5] and the discussion does not proceed randomly, but follows the pattern of other surviving works in the classical genre known as *ekphrasis*, words on the subject of images. The descriptions are consistent with the visual, archaeological and literary evidence. And they are more than verbal descriptions, they are commentaries. Although in his preface to the *Imagines* Philostratus stresses the importance of imitation, his argument is that the recognition of lifelike effects is only the first stage of a mature understanding of painting, and he warns his students against settling for superficial appreciation: to admire mere lifelikeness is to 'praise an insignificant feature of the painting and one that has to do solely with imitation: but we should not be praising its intelligence or the sense of decorum it shows, though these, I believe, are the most important elements of art'.[6] The admiration that a painting provokes is not related principally or only to the material objects it represents, but to the ideas it is able to suggest to the reflective observer: Philostratus expects painting, as Michel Conan puts it, 'to nourish the flow of thought'.[7] And the flow is not to be

idiosyncratic or subjectively associative: Philostratus is educating his readers in the properties of viewing, in public codes of recognition. What, then, are the ideas appropriate to *xenia*?

In his monumental work, *Rabelais and His World*, Mikhail Bakhtin observes that 'In the oldest system of images food was related to work Work triumphed in food. Human labour's encounter with the world and the struggle against it ended in food, in the swallowing of that which had been wrested from the world'.[8] Bakhtin's remark applies directly to the first *xenia* that Philostratus describes, but in reverse: what Philostratus first stresses is the complete absence of the dimension of human labour from a system of natural abundance:

> Purple figs dripping with juice are heaped on vine-leaves; and they are depicted with breaks in the skin, some just cracking open to disgorge their honey, some split apart, they are so ripe.

The figs break open of themselves; no effort or implement is needed to reach the goodness within. That goodness is 'honey', food that not only requires no cooking, but is unaffected by cooking: it can be heated, yet fire will not transform it into another state. The figs themselves render all preparation redundant: no need even for a dish or plate, a vine-leaf is enough to serve them. This is nourishment that nature produces for its own, and already a sparrow has chosen the best of the fruit. In a sense what is described is not *human* food at all, food that marks out humanity as different, as needing a diet that is 'species specific'. The figs equalise nature's species, or more exactly they place in suspension the cultural imperative to alter the natural world in order to appropriate nature to what is human. It is the opposite of a georgic relation to nature — the kind that Bakhtin describes.[9] There, the earth is grudging and will not yield its fruits without struggle; everything must be wrested from the soil with effort, so that what is eventually consumed and celebrated is the fruit of labour and (agri)cultural work. Here the human order is bracketed, and with it the distinction between what is nature and what is culture. The image seeks a moment prior to cultural intervention, when the distinction between these categories has not yet formed:

> All the ground is strewn with chestnuts, some of which are rubbed free of the burr, others lie quite shut up, and others show the burr breaking at the line of division.

Three states of the chestnut: unbroken and covered with burr; with the burr breaking along the natural seam; and open. What is mimed is the human action of breaking into the nut: nature performs this task by itself, casting what is human in a rôle of contented passivity. And the painting itself is caught up in this general obviation of effort: the red of the apples does not have to be 'put on from the outside', it glows 'from within'. It is unclear whether this red that is applied from the outside comes from the sun, or from pigment – which is exactly the point. Painting here takes on the colours of nature: it loses its connection with cosmetic application, the marks of a brush on a surface, so that the cultural labour of making a depiction is bypassed, and the painted fruit glow without the intervention of technique:

> Here are gifts of the cherry tree, here is fruit in clusters heaped in a basket, and the basket is woven, not from alien twigs, but from branches of the plant itself.

What would be repellent here is a basket woven from anything other than the same plant that produces the fruit: the text works to prevent the thought of human activity, of a division of labour that would take the making of baskets away from this plant and this one place into a farm economy, or any kind of planned agriculture. For a basket woven out of any other substance would necessitate the recognition of systematic work, of cultural operations that cut across natural abundance with a network of other places, times and acts. Everything must take place locally, so that the cherry tree itself supplies the frame for its own fruit: there must be no suggestion of a frame that cuts into this scene from somewhere else (and least of all a picture-frame).

Philostratus concludes his description of the first *xenia* with a list that might have come from Lévi-Strauss' *The Raw and the Cooked*.[10] What do all these foods have in common, the wine and honey, cheese and milk, if not that all are culinary invocations of a world without work? When the women in *The Bacchae* of Euripides leave the city of Thebes for the hills and for the cult of Dionysos, all toil is forgotten: scratch the soil with bare fingers and milk comes welling up, strike a thyrsos in the earth and a spring of wine pours forth; pure honey spouts from the wands.[11] The honey and the milk are raw and their richness testifies to the dispensability of culture. The wine and the cheese require, by contrast, elaborate preparation, but they are foods produced by fermentation, a process which leaves the work of

transformation to nature. The image calls upon categories of food which admit the raw and the rotten or fermented, but completely eliminate the need for culinary fire. In its final lines the *ekphrasis* comes closest to the domain of culture: the cheese has presumably required a fermenting vessel, bowls are supplied for the milk. Then as a final touch there is a leap into aesthetics and for the first time a purely painterly effect is mentioned – the white-on-white pigment that makes the cream seem to 'gleam' upon milk; but the force of the theme of 'nature without culture' is by now strong enough to re-absorb this discordant reminder of the imageness of the image back into the naturalness of nature.

The emphasis in *Xenia* I on an image which bypasses cultural work (and playfully effaces its own existence as a product of cultural work) closely corresponds to the social function of *xenia* as recorded by Vitruvius: 'For when the Greeks became more luxurious ... they began to provide dining-rooms, chambers, and stores of provisions for their guests from abroad, and on the first day they would invite them to dinner, sending them on the next chickens, eggs, vegetables, fruits, and other country produce. This is why artists call pictures representing things sent to guests 'xenia'.' [12] The figs, honey, the basket of cherries, the milk and cheeses described in *Xenia* I are foods for the guests to prepare for themselves, as part of the ceremony of bringing the stranger (*xenos*) into the *oikos* or household. This particular form of hospitality is precise about the boundaries that demarcate social distance: the stranger is welcomed and absorbed into the household through the gift of food, yet at the same time the gift creates a sort of satellite household within the house, so that strangers eat their own food separately prepared, in a separate space of their own. A certain emotional generosity surrounds the provisions sent by the host. They are raw, not cooked, and the freedom given to prepare the foodstuffs separately marks a respect for the stranger's needs, for sustenance but also for autonomy and a measure of independent existence within the *oikos*; this is the difference between such provisions and, say, a banquet.

The Greek word *xenos* is significant here, in that it is a 'reversible' term (like *hôte* in French), referring equally to host and guest: its reversibility signals exactly the equalising process of hospitality at its best, when the relation of dependence between host and guest is overcome and replaced by one of humane

equality.[13] In the host's household, the guests are to be and to feel just as they would in their own. What this form of hospitality aims for is the fiction of a suspension of actual social relations of rank and patronage: the necessary asymmetry between host and guest, the social distance between different regions and communities, as well as differences of aesthetic culture, are declared absent or irrelevant by the spirit of reversible hospitality. Today the guest may be in a dependent rôle, but the bond is reciprocal, at some future time the host may be a guest in the stranger's household, and in recognition of this mutuality the complex social distances between the two sides are abolished here and now through the symbolic gift of food. The provisions are therefore not elaborately prepared and costly dishes, even when Greek luxury stretches to guest dining-rooms; they are of the simplest, raw foodstuffs, unadorned. Where dishes that were sumptuous would emphasise exactly those differences of wealth, regional taste and culinary tradition that the whole system of reversible hospitality seeks to annul, provisions that are raw place both host and guest in a relation of dependency upon the bounty, not of households, but of nature itself. By an elegant displacement the generosity of the host, source of the inequality that is to be concealed or euphemised, is converted into the generosity of a nature that supplies its materials in profusion. The relation *guest – host* is converted into the relation *nature – man*; the desired symmetry between guest and host is expressed as their identity before a third term, nature – where this 'nature' shows no traces of cultural work (and thereby of social difference and distance).

It is this suppression of the signs of cultural work that Philostratus' *Xenia* I dramatises: the honey that oozes from the comb all by itself, the figs and the chestnuts that break open of their own accord, stand in for a social generosity too tactful to express itself directly. Behind *Xenia* I, with its stress on a nature that performs all the work of culture and so makes culture seem escapable or unnecessary, stands an idea of collective abundance, the fantasy of a wealth of nature shared equally by all, regardless of social hierarchy. The images which correspond most closely to this idea, the Campanian *xenia* which display the contents of the guest's larder (illus. 3) are therefore quite different in character from the scenes of private eating which fill, for example, seventeenth-century still life in the Netherlands. The latter expresses the satiety of private appetite, personal

3 *Eggs and Game*, Pompeii. Museo Nazionale di Napoli.

enjoyment of wealth and status; *Xenia* I, and these Campanian larder-scenes, are by contrast a 'banquet for all the world',[14] with the earth and sea yielding their fruits for all in a moment prior to hierarchy and social division. They represent the equality of strangers before a world so abundant that there is no need, as yet, to fight for one's share; a plateau of equal contentments in which the idea of 'stranger' exactly has no place, since all are equally at home on earth and enjoy the same rights to the world's wealth, under the protection of Zeus, god of hospitality.

If *Xenia* I expresses relations of pre-cultural harmony between men and nature and between individuals, *Xenia* II reverses these relations point by point: the second text is almost an inversion, in the musical sense, of the previous ideas, a rhetorical antitype to the first picture:

> This hare in his cage is the prey of the net, and he sits on his haunches moving his forelegs a little and slowly lifting his ears, but he also keeps looking with all his eyes and tries to see behind him as well, so suspicious is he and always cowering with fear; the second hare that hangs on the withered oak tree, his belly laid open and his skin stripped off over the hind feet, bears witness to the swiftness of the dog which sits beneath the tree, resting and showing that he alone caught the prey.

Xenia II explores the threshold between nature and culture which *Xenia* I had eliminated in order to project its idyll. The earlier sense of harmony had depended on the passivity of man before a bounteous nature, and there nature did all the work;

but here the food needs actively to be pursued and captured: we move from gathering to hunting. In *Xenia* I the dividing line between nature and culture had been declared absent, in the same way that the opposition between guest and host was annulled and equalised through mutual hospitality. But here the conceptual division is powerfully present: it actually appears as a physical function in the scene, the cage in which the trapped hare is imprisoned. The *line* of division nature/culture is expanded into a *border* inhabited by the category of creatures that belong neither wholly to the wild nor to the interior of the house: domestic animals. The dog has caught its prey 'alone' – the word indicates that although humans have harnessed and channelled its hunting instincts, those instincts in themselves are culturally untransformed; but at the same time the dog is a creature that is close to human beings, and serves their needs. The hare, too, occupies an ambiguous space, sitting terrified in its hutch: protected from the dog by the walls of its cage it is outside nature, in the safety of an artificial enclosure or outhouse; but the dead hare hanging from the tree is a reminder that this space is unstable. What is isolated is the volatile zone between culture and nature, where each borders on its opposite – the dog reverting to beast in the kill he performs alone, the hare caught between the categories of animate and inanimate:

> As for the ducks near the hare (count them, ten), and the geese of the same number as the ducks, it is not necessary to test them by pinching them, for their breasts, where the fat gathers in abundance on water-birds, have been plucked all over. If you crave for raised bread or 'eight-piece loaves', they are here near by in the deep basket. And if you want any relish, you have the loaves themselves – for they have been seasoned with fennel and parsley and also with poppyseed, the spice that brings sleep.

The ducks and geese, plucked and ready for cooking, function here as antitypes of the sparrow which had tasted the best of the figs in *Xenia* I: the image of the banquet of the world, which men and birds may share, is replaced by the banquet of man alone, and at last the work of human hands appears, plucking, testing, organising by number:

> But if you desire a second course, put that off till you have cooks, and partake of the food that needs no fire. Why not, then, take the ripe fruit, of which there is a pile here in the

other basket? Do you not know that in a little while you will no longer find it so fresh, but already the dew will be gone from it? And do not overlook the dessert, if you care at all for medlar fruit and Zeus' acorns, which the smoothest of trees bear in a prickly husk that is horrid to peel off. Away with the honey, since we have here the *palathè* [a confection of figs], or whatever you like to call it, so sweet and dainty it is! And it is wrapped in its own leaves, which lend the *palathè* beauty.

The text of *Xenia* I had been built up by eliminating the signs of culture in a regression *into* nature. *Xenia* II reverses this movement into a progress *away* from nature towards the culture of the table. Food is no longer the simultaneous plenitude it was when the theme had been pre-cultural abundance — now food is structured temporally, as a series of dishes. First is served the raw fruit, yet now accompanied by what is cooked (bread), and cooked completely, without fermentation (the 'eight-piece loaf' is unleavened). Then follows a second course, food requiring fire and cooks to roast the geese and duck; and finally a third course, dessert. This will not be the delicious chestnuts of *Xenia* I, which opened of their own accord, but medlar fruit and 'Zeus' acorns' (maybe cactus fruit) that are exactly difficult to unhusk: the ease of the natural world gives way to effort and irritation (as well as decay: soon the fruit will have lost its freshness). Nor will the dessert be honey, the raw food *par excellence*: this is explicitly dismissed in favour of the *palathè*, a delicacy or sweetmeat. The *palathè* is wrapped in its own leaves, which is to say in fig leaves; but where before these had provided a kind of robust natural plate for the meal, now they are a dainty wrapping, to be admired for its elegance. *Xenia* II repaints *Xenia* I in terms of the transformation of nature into culture, item by item: the natural honey turns into the *palathè* confection; the 'self-opening' chestnuts are changed to the difficult medlars and Zeus' acorns; natural flavours are replaced by spices (fennel, parsley, poppy-seed), and the last of these touches on extreme refinement in the use of food, as medication. The lively sparrow perched on a fig becomes the heap of water-fowl ready for the oven; and fermentation becomes cooking.

This alteration of the relations between nature and culture has immediate repercussions in the social domain implied by the second painting. We have seen that *xenia* refer to gifts of

hospitality from host to guest, in which social differences, differences of wealth and rank, are elided by placing both the 'superior' and 'inferior' rôles of hospitality in symmetrical relation to a third term, bountiful nature. But in *Xenia* II nature has all but disappeared. The absence of the categories of the raw, the wild, the untamed, makes it impossible for social difference to be euphemised and concealed in the fiction of the world's banquet. This new meal, with its cooks, its spices, its sweetmeats, its foregrounding of the *oikos* over the natural setting, is unable to dissolve the distances between ranks and rôles into the idyll of pre-cultural harmony. Accordingly the *ekphrasis* ends on a note of extreme social division:

> I think the painting offers these gifts of hospitality to the master of the farm, and he is taking a bath, having perhaps the look in his eyes of Pramnian or Thasian wines, although he might, if he would, drink the sweet new wine at the table here, and then on his return to the city might smell of pressed grapes and of leisure, and might belch in the faces of the city-dwellers.

Instead of the gifts of food circulating between different social rôles and positions in order to equalise them and minimise their friction, the food depicted in the second image is described as an offering to *the master of the farm*, that is, to the one who already owns its surplus. The picture therefore acts as a mirror of affluence, a multiplying mirror that now adds to the wealth of the farm the representation of that wealth in the form of the painting. The text is no longer in the orbit of mutual hospitality, with individuals exchanging food, together with the rôles of host and guest. Actually no food is exchanged: nothing passes from hand to hand in the generosity of the gift. In a sense the phrase 'gifts of hospitality' functions ironically, in that the master of the farm lavishes its riches only on himself: strangers are excluded from this private hoarding of affluence and pleasure. This is the point of the ludicrous (and textually gratuitous) scene of the master of the farm in his bath, his eyes glazed with Pramnian or Thasian wine: the master does not even get drunk on the wine of the farm, the sweet new wine at the table we see in the picture; with the profits of the farm he imports rarer wines from elsewhere.

The principle of self-sufficiency had been a primary stress of *Xenia* I: if a basket held the grapes, it was to be woven from

the same vine which produced the fruit; there was a forceful negation of systematic economy, of any network of functions and exchanges that might disrupt the absolute proximity of the ecosystem. But the master of the farm refuses his own wine – as the picture refuses honey and milk in favour of spices and confections. The topos of the drunken bath, used so vividly by Juvenal to convey the idea of vitiated appetite, points to a depravity in the management both of the body and of the *oikos*. The wealth of the farm, which in the idyllic picture of plenty stays always within its confines and acts there to satisfy natural need, has generated a negative abundance that culminates in the perverse use of wealth. The food does not circulate among strangers, binding individuals together in a flow of shared hospitality; it converges on the master of property, as physical glut. This is what the bath-scene conveys: isolation at the heart of the household, loss of human interchange in a private hedonism that walls itself in solipsistic pleasures. A monetary nexus turns the products of the farm into exchange commodities. The final sentence portrays the conclusion of this degenerative transformation: the master of the farm, in the city, and surrounded by strangers, is imagined belching in their faces. Hospitality, *xenia*, ends as absolute social distance.

The two *xenia* pictures function, then, as type and antitype. Certainly this is how they are presented in the *Imagines* text as a whole: *Xenia* I concludes the first cycle of pictures in the gallery, and *Xenia* II the second.[15] Together they form the termini of a scale that slides between two opposing conceptions of prosperity, from the idyll of nature unadorned, pre-cultural, prior to social difference and hierarchy; through to the portrayal of over-refinement, vitiation of taste, and sharp social division. What is implied in their opposition is a gamut ranging, in literary terms, from pastoral to satire, across a complex set of thresholds or transitions from nature to culture. In diagrammatic form, the underlying structure might be expressed as follows:

Nature		*Culture*	
raw	fermented	cooked	refined
figs	cheese	geese	spices
honey	wine	ducks	*palathè*
milk		bread	
chestnuts			

Analysis of the *Imagines* indicates a first level of approach to Roman *xenia*. But Philostratus says nothing of the paintings themselves. His text is based on the premise, or fiction, that *ekphrasis* is capable of conjuring up in the reader's mind the original scene which the painter copied, and it is this original – not the depiction – to which the writing adheres. As a result one discovers nothing in the text about the construction of the scene as a painted image: no indication of right or left, up or down, near or far; concerning composition, handling, colour-range, tonality, and scale, the writing breathes not a word.[16] The *Imagines* provides invaluable evidence concerning the conceptual field surrounding *xenia*, yet by itself it is unable to address the specificity of the *xenia* as figured depiction. What enables analysis to move inside the *xenia* is the second surviving text in which antique 'still life' is discussed, the paragraphs devoted to the painters Zeuxis and Parrhasios by Pliny in his *Natural History*, to which we now turn.

Pliny's subject is the most celebrated 'still life' of them all, Zeuxis' painting of the grapes, so lifelike that the birds flew down to eat from the painted vine.

> Parrhasios and Zeuxis entered into competition, Zeuxis exhibiting a picture of some grapes, so true to nature that birds flew up to the wall of the stage. Parrhasios then displayed a picture of a linen curtain realistic to such a degree that Zeuxis, elated by the verdict of the birds, cried out that now at last his rival must draw the curtain and show his picture. On discovering his mistake he surrendered the prize to Parrhasios, admitting candidly that he, Zeuxis, had deceived only the birds, while Parrhasios had deceived himself, a painter (*Natural History*, XXXV, 65).

The story has been cited so often in the annals of art history, as a parable of realism, that it is easy to miss its most remarkable feature, the strangeness of the episode's *location*. One can begin to indicate this strangeness by dividing the story into two halves, around its two pictures. The 'still life' of the grapes brings birds out of the sky: perhaps one thinks of the birds as flying up against the painted surface and, so to speak, hitting a pane of glass. Yet the wording of the text has another emphasis: the painted grapes were so successful ('uvas pictas tanto successu') that the birds flew 'up to the walls of the *stage*' ('ut in scaenam aves advolarent'). Zeuxis' picture is in fact an instance of what

the Greeks termed skenography, painting for the theatre. The second picture, Parrhasios' cunning portrayal of a curtain, has a similar twist. One might perhaps think of his painting as appearing to be concealed by a drape, such as the mantles cast over easel paintings by eighteenth-century collectors, or velvet drawn aside to reveal the priceless painting beneath at some imaginary and dramatic unveiling. The use of a curtain or scenic barrier to conjure up the transports of illusion is already theatrical; what makes it doubly so is that the picture showing the false unveiling of a picture is itself unveiled *in a theatre*. It is in a public theatre, not the agora or a picture gallery of the kind we see in Philostratus, that the whole competition between Zeuxis and Parrhasios takes place.[17]

What is striking here is the presence in both components of the story of the idea of the theatrical, and the stress on painting's association with the stage. The topic is certainly illusionism, but it is illusionism of a very particular kind. One is not dealing here with straightforward imitation, in which real object *a* is figured forth in representation *b*: real grapes here, the painting there. Rather the story involves imitation to a higher power, mimesis – as it were – squared. Imagine the flight of the birds down towards Zeuxis' picture. The journey begins in the sky, in the natural world, and presumably the perception of the birds is intended as pre-cultural and asymbolic (which is why Zeuxis' achievement is impressive). Then the birds leave that pre-cultural zone and enter the space of the theatre. There has been a shift in the kind of space involved, a passage from a natural space outside representation to a cultural space that *houses* representation. Then the birds cross a further boundary and fly into the area of the stage itself (*in scaenam*): now the conditions of the real world, the world of the auditorium, are suspended, and the space of reality yields to that of fiction. Finally, the birds fly up to the painted flat or backdrop: here the world of the stage gives way to the world shown in the painting, a space of further fiction set inside the stage space, in the manner of a play within a play.

The pictures Pliny describes are in fact caught up in the most elaborate play of shifts between differing ontological levels or degrees, separated by precise thresholds or boundaries. A first threshold separates the zone of nature (blank, asymbolic) from the general zone of culture (architecture). A second threshold within the architecture of the theatre divides the auditorium from

the stage. A further threshold divides the space of the stage and the interior space of the picture. The trajectory of the story is one of rapid movement across a series of imbricated spaces, each distinguished by its own particular relation to reality and illusion. It is within this trajectory that those two remarkable 'still lifes' by Zeuxis and Parrhasios are constructed. If the story were just about lifelikeness, none of these complicated serial thresholds would have been necessary; yet it is exactly this sense of complication that the story transmits. The same sense of pictures moving across distinct thresholds towards and away from the real is no less striking in Plato's observations on painting, in Book X of *The Republic*.[18] Defining the illusory (and therefore reprehensible) nature of painting as an art, Plato complains that the painter is not at one but several removes from the Idea: the couch built by the carpenter is at only one remove from reality, since the carpenter directly copies the Idea of the couch — but the painting of a couch is representation to a higher degree, since what the painter depicts is merely the object's superficial appearance. Such estrangement from truth is bad enough; but Plato's particular disapproval is reserved for illusionistic painting, the height of delusion: 'Every sort of confusion . . . is to be found in our minds; and it is this weakness in our nature that is exploited, with the effect of magic, by many tricks of illusion, like skiagraphia (painting with cast shadows) and conjuring.'[19]

What the surviving discussions by Philostratus and by Pliny consistently emphasise is exactly Plato's point, the elaborate changes of ontological register as images pass between different levels or degrees of reality, away from a primordially-given real and towards an increasingly sophisticated set of fictions-within-fictions. Whether the argument focuses directly on painting, or takes the form of asides within a work dealing with quite remote and unrelated topics, the images are associated with complex, serial shifts in levels or degrees of reality. Just as the pastoral world, with its pre-cultural harmonies between men and nature and between individuals gradually transmutes into the ironic, satirical world of vitiated appetite and social hierarchy, so the primitive level of reality is surpassed in fictions of increasing complexity and etiolation. The semantic field of *xenia* is emphatically lapsarian. The question now arises: what form does this nexus of ideas assume when figured as depiction, in the *xenia* that survive at Pompeii and Herculaneum?

One must be careful to distinguish between the *xenia* described by Pliny and Philostratus, and those excavated in Campania. For one thing, it must be assumed that the *xenia* of Philostratus are meant as free-standing easel paintings, executed as portable panels on ivory or wood, whereas the *xenia* from Campania are decorative frescoes and mosaics. And even if one supposes that the designs of the surviving *xenia* go back to prototypes of the kind Pliny and Philostratus discuss, those designs have been fully absorbed into the specific intentions and rhythms of the Roman decorators. Nevertheless, it is exactly this process of absorption into the decorative schemes that suggests the continuity between the lost *xenia* of the *Natural History* and the *Imagines*, and those which survive. The Campanian *xenia* push still further both the shifting play with levels or degrees of reality to be found in Pliny, and the interplay between categories of culture and nature which Philostratus describes in the *Imagines*. Xenia suited the Campanian decorators because their transitions between real, theatrical and pictorial registers corresponded exactly to their own aims. Here the *xenia* should be considered in relation to the whole interior ensemble of floor, ceiling and wall.

Prominent in Roman handling of floor design is the goal of producing perceptual uncertainty concerning the depth of field.[20] Patterns are favoured which deliberately confuse the sense of the pavement as an opaque, solid foundation underfoot. The rhythms of contrasting tiles or blocks of *opus sectile*, and repetitions of simple units that seem to vary in direction and configuration, create a dynamic field that expands and scintillates with energy (the Baths of Caracalla, the Pantheon). In the case of patterns which reverse figure and ground, the actual plane of the paving may be rendered uncertain. A later example vividly states this ambivalence (illus. 4): if black is taken as figure and white as ground, then an abyss seems to open up beneath the floor, over which the black tiles are superimposed as the only solid support; the same is true if white is taken as figure and black as ground – now the void beneath is dark. Either way there is a sense of the floor growing transparent and revealing behind it a spatial plunge, like a well. When the patterns are selected specifically to render dark and light interchangeable this sense of downward recession is enhanced, and in the moment when the pattern 'reverses' all sense of ground is taken away: the entire surface seems to open down into a void. The same

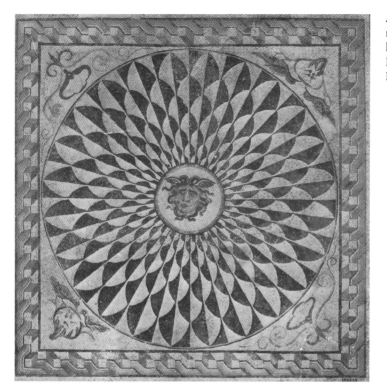

4 Roman floor
mosaic with the
head of Medusa.
Museo delle Terme,
Rome.

effect is present in figurative mosaic: either the *tesserae* are
treated as a surface pattern of coloured stone, or as a kind of
painting that opens onto fictional space; interplay between these
is often the generative principle of the design. In the case of
floor mosaic the effect of fictional space is perhaps even stronger
than in the case of the wall, in that the viewer is physically in
contact with the plane which demarcates the boundary of the
fictive space: walking directly upon (or within) it, rather than
contemplating it across an interval.

A similar drive to open up a fictional space beyond the limits
set by architecture is present in Roman conceptions of the ceil-
ing. At Pompeii many ceiling designs stress now the actual
parameters of the vault and now the unfixing of the vault as
the true boundary of the chamber. The ceiling dissolves into
another, aerial space – the dome of the sky, or the sky as implied
by a canopy (in the frigidarium of the Stabian Baths there appears
a heavenly vault, scattered with ornamental stars).[21] Evident in
such cases is the idea of the ceiling as opening on to a space
vaster than architecture, a dissolve into infinity. The ceiling

mediates between the palpable, sensible limits of local space and another, illusory, more expansive space rising up beyond it (Suetonius records that at Nero's 'Golden House' the ceiling was decorated with stars and planets, and that it slowly revolved, in the manner of a planetarium).[22] Spatial expansion of the wall is not, then, an isolated feature of the Campanian schemes. Rather, the entire enclosure of the chamber on all of its sides – floor, ceiling and walls – is integrally handled so as to produce a dissolution of each boundary and a negation of the confines of actual space. Yet it is, of course, the wall that carries out this programme to the full. August Mau's designation (in 1882) of the 'four Pompeian styles' is doubtless unsatisfactory and open to revision,[23] yet its general lines seem sound, and as one follows the four mural styles in succession, a remarkable consistency of purpose emerges: in each style what is actual (the experience of local interior space) is invaded by a principle of irrealisation or fiction.

In the First Style, the idea of a copy usurping the place of an original is already fully elaborated. The physical reality of the wall yields to a representation of the wall in *faux marbre*, paint handled so as to suggest various types and colours of marble (illus. 5). This appears the least engaging of the four

5 House of Sallust, Pompeii.

styles, and one may want to hurry past it to the vertiginous complexities that follow: it seems a simple case of real versus copy, a mimesis with two terms. But just as the grapes of Zeuxis turn out to have existed in complex relation to the motif, the *faux marbre* of the First Style lies at several removes from the marble original. Its patterns do not actually simulate marble with the intention of deceiving the eye, and of passing off an inexpensive wall decoration as costly stone. Rather they renounce direct imitation by using colours that are clearly artificial and fantastic: greens, reds and purples without veining.[24] As much as they imitate marble they dramatise their status as independent form. Which is to say that three degrees or levels of representation are in play, not just two: the surface of the actual wall, made of plaster; polychrome marble, the substance whose simulation is both approached and renounced; and painting itself, the tracing of lines and the filling in of colour patches that have their own autonomy, in a median space between the poles of original and copy. This creation of an intermediary zone or interval placed between reality and representation is the First Style's peculiar achievement: everything that follows will be a development of this intercalated space. No less basic is the strategy whereby the copy is juxtaposed directly against its original (in the Pompeian gardens, real and depicted vegetation exist side by side).[25] This is an important move. When a representation is placed alongside or against the original, representation is raised to a higher power: it becomes 'simulation'. After all, that something can be accurately represented need have no bearing on the status of the original: representation does not *necessarily* produce of itself the idea of competition between the original and copy, or of the copy's independent power. But when the copy stands adjacent to or in the place where one would expect the real thing, something more is involved; the original loses its autonomy, it becomes the first in a series that also includes fictions. What the First Style announces is that instead of the original object mastering and subsuming its copies, it is absorbed into them to become, in a sense, their satellite: instead of the chamber drawing the simulated space back into its own boundaries it opens out expansively onto the fictive space beyond. The narrow parameters of the room, its floor, ceiling and walls, are drawn into a larger space: *representation absorbs the house*. It is this possibility which the later styles energetically pursue.

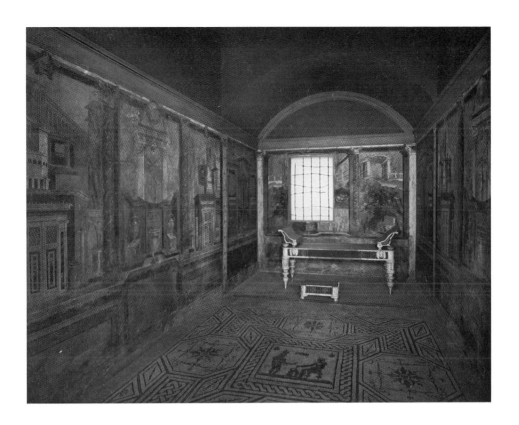

6 Cubiculum from the villa at Boscoreale. Metropolitan Museum of Art, New York.

The Second Style is far more spectacular in its assault upon local space. Probably its clearest expression is the room known as Cubiculum M, from the Villa of Fannius at Boscoreale, discovered in 1900 and superbly displayed at the Metropolitan Museum in New York (illus. 6). Here the idea of the simulated space as taking over from the real space is particularly compelling, since what is painted draws on the essential components of the site of the villa itself. In the panels of the side walls the actual architecture of the villa comes back in the form of architectural pastiche, as a fantastic country house surrounded by balconies and towers irrationally heaped together (illus. 7). The landscape and gardens surrounding the villa similarly return transformed, as the grotto, hill and trellised arbour in the panels of the outside wall (illus. 8). It may be that the window cut into this rear wall is not a later addition but part of the overall design;[26] if so, one literally looks out on the original, the gardens surrounding the villa, through the copy, the painted grotto scene. Deep within the house the side walls show the house

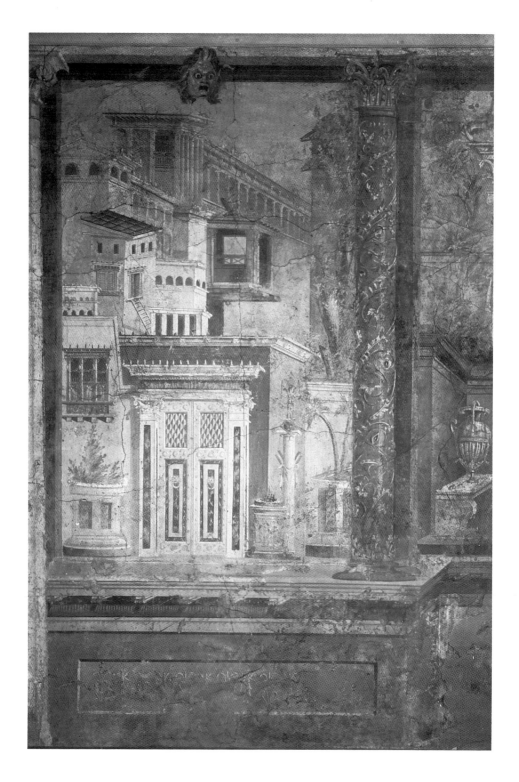

7 *left*: Wall
painting from the
cubiculum of the
villa at Boscoreale.
Metropolitan
Museum of Art,
New York.

8 *right*: Wall
painting from the
cubiculum of the
villa at Boscoreale.
Metropolitan
Museum of Art,
New York.

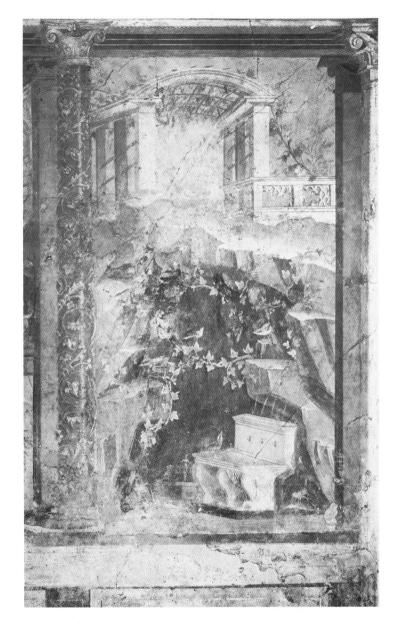

from the outside; through the opening in the rear wall the garden
is framed and viewed by its own representation: outside and
inside, original and copy, change places.

What is striking here, and strikingly close in conception to
the structures of *xenia* painting, is the systematic nature of the
transitions between reality and simulation. One starts with the

true local conditions — a real landscape, a real villa, and the boundaries of the actual chamber. Then a shift occurs and forms which belong to the real chamber pass over into a painted version of the room: in place of an actual dado or actual pilasters one finds these transposed into paint. Above the dado things change again. On the side walls the columns rise from their bases on the dado to capitals that reside in *another* space: masks suspended between the capitals establish this as the proscenium arch in front of a stage (illus. 9). Then there is a further break and the eye enters on-stage: behind the masks, between the proscenium columns, one sees the stage-rafters overhead. Finally, vision reaches the *scaena*, the architecture or landscape held within the backdrop. Yet not even this is the journey's end, for the *scaenae* generate a dizzying series of almost exact mirror reflections, with panels reappearing, laterally inverted, both within each wall and on the wall on the opposite side.

9 Detail of the wall painting from the cubiculum of the villa at Boscoreale.

Space	Threshold
(1) real villa, real chamber	
	– dado, pilasters
(2) painted version of chamber	
	– masks
(3) theatre proscenium	
	– rafters
(4) *scaena*	
	– *scaena* frame (concealed)
(5) fictional villa and land-scape	
	– lateral inversion
(6) mirror reflections	

The movement back and forth across the series of degrees or levels of reality is not ponderous or measured but as rapid as possible, and various 'rhyming' devices speed it up. The two termini – the real and the fictional versions of the villa and the landscape – are twinned as transformations of each other: (1) and (5) quickly form a bridge or liaison. The opposing walls duplicate one another: (5) and (6) change places. Uniform handling of the colour pulls or telescopes all the planes together: *scaena*, proscenium and chamber wall are frontally parallel, as close as cards in a pack. Columns appear in all the principal spaces, uniting them. The result is a swift and repeating serial oscillation from (1) to (6): a rhythm or pulse that beats between what is irreducibly real and what is, to the maximum degree, simulated. The real and the simulated come together, beat together: everything is at the same time pure depth and pure façade.

The Third Style renounces its predecessor's dramatic perspectival recessions in space but preserves the structure of ontological levels and their mutual insertions. In the Black Room from Boscotrecase (illus. 10, 11) the device of the dado supplies the familiar link between the chamber and the scene 'beyond' its

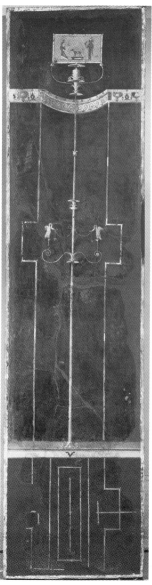

walls, only now the space 'behind' the dado is built up through subtler means than perspective lines and plunges.[27] Its expansiveness is conveyed by freeing the fictive space from the force of gravity. Columns become tendrils and weightless stalks made of a substance half way between vegetable life and metal. In this cage-like space hover birds – swans, but also parakeets and griffins; it is an aerial space, free of the earth, where columns

10, 11 Black Room, panels, Boscotrecase. Metropolitan Museum of Art, New York.

rise not as stone but as sap. Forms merge into each other without obstruction from the logic of combination or scale: 'reeds are put in the place of columns, fluted appendages with curly leaves and volutes are put instead of pediments, candelabra support representations of shrines, and on top of their pediments are numerous tender stalks and volutes growing up from the roots, with human figures . . . seated upon them; sometimes stalks having only half-length figures, some with human heads, others with the heads of animals'.[28] The barrier of an insistently coloured flat surface (black on black) dissolves in a cancellation of the very idea of the plane. One knows that the black is conceived as a *mural* surface, twice over – both on the actual plaster of the chamber and on the 'walls' implied by the fantastic architecture 'behind' it; but the irrational coordinates of the fictive space suggest the plane only to undo its influence. Then there is an ontological threshold, and vision moves from the impalpable and insubstantial blackness (or redness, in the Red Room) to images set at some indeterminate distance within it: pictures within pictures, bucolic landscapes and Egyptian scenes (illus. 14). Determining the distance of the painted scene is impossible: it may be on the wall of the chamber; it may be on the wall of a surreal niche; it may be floating at some greater distance, lost in space. Since normal grids are absent, space itself becomes immeasurable: behind the chamber wall is figured the end of space, limitless not in its scale but exactly because scale has been abolished, together with weight and distance.

In the Fourth Style, the breaking open of the wall and the expansion into fictive space are achieved once more by skenographic means. In the fragment from Herculaneum the wall opens first onto an imaginary theatre, complete with proscenium and curtain, and then onto a colossal skenographic architecture of soaring columns and broken pediments; these are not presented frontally but from along a slightly oblique axis, with the implication that the baroque splendours of temple-front and portico extend back far beyond the buildings which are directly glimpsed (illus. 12).[29] There is an almost exclusive concentration on the frame as the basic unit of space; essentially the chamber wall is treated as only the first in a series of frames leading to further frames – arches, windows, colonnades – one behind the next, to infinity. It is a property of such frames to charge the space they contain with a quality of intense visibility: as soon as an object is set in a frame it becomes something to be looked

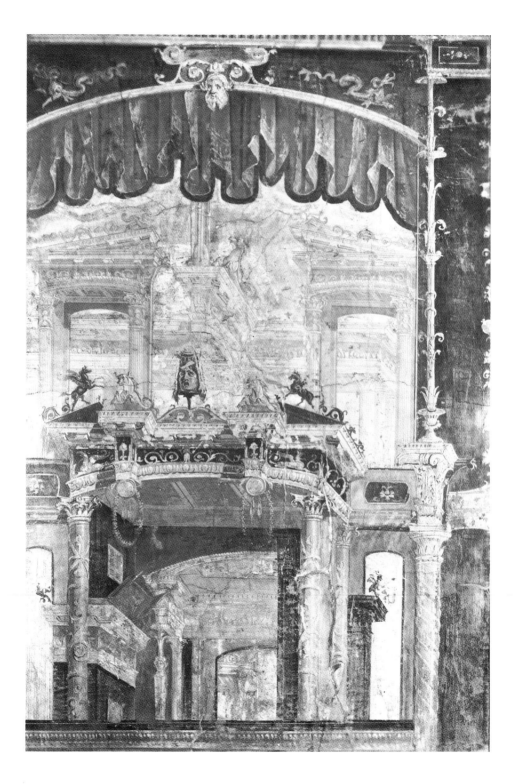

at, and when the frame is set inside a further frame this charge
intensifies. In the Fourth Style the charge is increased to a point
of saturation, but not in order to present any notable object:
the frames *contain nothing*, except their own space. The accumu-
lated charge built up by all the component sub-frames is not
deflected or 'earthed' by any privileged or spectacular object;
instead it travels to the wall itself, investing the space of the
chamber with an extreme charge of theatricality. The actual
room becomes a set, and to stand within it is to be on stage.
Reality is playfully invaded by its fictions; the room is gathered
and absorbed into the space of simulation.

When Mau originally divided the Campanian paintings into
the Four Styles, he was following the chosen goal of art history
in his own time: to produce a narrative of development that
was also a teleology, moving from beginning (the First Style)
to middle to end (the culmination of the Fourth Style). Behind
his division lay the organic metaphor which dominated the dis-
course of German art history in the nineteenth century (and
beyond), with each style absorbing the features of its prede-
cessor and elaborating these causally along a continuous path
of complexification and linear development. That commitment
to causal narrative and the organic metaphor had the effect of
obscuring other features that emerge at once if the model of
organic development is abandoned and a more synchronic
analysis is undertaken, as here. In particular it becomes clear that
though formally so different, all four styles are structured around
a shared aspiration, to negate the physical limits of the room
– floor, ceiling and walls – in order to break past the parameters
of the real and allow actual space to be penetrated by a fictional
expanse beyond it. Fans of *Dr Who* will know of the Tardis,
the paradoxical vehicle which from the outside possesses the
small dimensions of a police telephone-box, but inside houses
a vast interior. What the designers of the Campanian program-
mes aim for is something like a 'Tardis effect', the dissolving
of actual boundaries into a limitless space of fiction. It is an effect
that depends to a considerable extent on the fact that these are
tiny rooms. Although the architects were under no technical or
budgetary constraint to do so, they created spaces that are
cramped, windowless, compressed. The internal pressure built
up in such claustral interiors has no outlet except through the
fictional vistas that surround the viewer on all sides.

The constraints and limitations of the real world disappear

in stages and by degrees, across distinct thresholds. In the Villa of the Mysteries, the progression is ceremonially charted, from the preparations for the rite, still taking place in the real world, across the attendants as they approach the mystery, to the break-through moment at which consciousness, modified by the ritual, opens on to other dimensions, and the divinities (partly theatri-cally, partly supernaturally) make their appearance. *Xenia* find their place in such programmes because this structure of move-ment from the real to the unreal, across a series of precisely designated thresholds, is exactly the principle of their own con-struction. Pliny's stories of the grapes of Zeuxis and the curtain of Parrhasios, like each of the Four Styles, move between extremes of nature and culture, across the thresholds marked in the stories by the birds, the stage and the *scaena*. And this, too, is the movement attributed to *xenia* in the *Imagines* of Philostratus: the range covered by *Xenia* I and *Xenia* II starts in a state of pure nature (figs, honey, chestnuts, milk), travels across the categories of food fermented, prepared and cooked, and ends in the stage of over-refinement represented by spice, *palathè*, and Pramnian and Thasian wine. It is a movement which begins in the Golden Age and ends with the vision of the master of the farm reeling through metropolitan crowds. For Plato such pictures connote the power or representation to take over from the real and to sublimate the sense of the real through higher and higher stages of unreality; for Philostratus, *xenia* bring to mind the whole narrative of culture's progression from primitive conditions, creatural satisfaction, and simple equality before nature's abundance, on to the complexities of affluence and leisure, social difference and estrangement.

With Pliny and Philostratus in mind, let us go back to a *xenia* that remains *in situ* within its decorative scheme, the bowl of fruit standing on a balustrade on the rear wall of the Cubiculum from Boscoreale (illus. 13, 15). The designer has connected it with the most rustic of the panels, not scenes of extravagant villa architecture or sumptuous gardens but a natural landscape, a grotto or hollow apparently away from civilisation (illus. 8). The place suggests seclusion and primitive simplicity, and it is filled with birds (one remembers here the sparrow in *Xenia* I, and the illusion-free birds of Zeuxis). The bowl of fruit mediates between this idyllic locale and the room's interior: it is as though the bowl has brought the wholesomeness and freshness of the grotto inside the house (illus. 13). Yet immediately below the

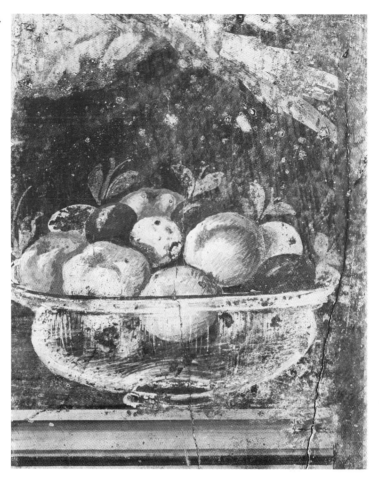

13 Detail of illus. 15,
Bowl of Fruit.

glass bowl, on the supporting wall, appears an image in yellow that represents a far more complex world (illus. 15), a city made of bridges, towers and colonnades; and it is a representation in stylised colour, not the natural hues of the fruit but a kind of yellow *grisaille* painting that foregrounds its own artifice of construction. Here themes of wealth and poverty emerge, imposing on the figures a division of labour and a social hierarchy in which some individuals – the fishermen near the bridge – are obliged to work, while apparently others – the four figures standing on the summit of the hill, contemplating the view – are not. The whole value of the *xenia* now begins to change. Despite its look of unspoilt simplicity, the grotto is actually an elaborate piece of landscape gardening: the fountain is

not a natural spring but an artificial *nymphaeum* (we even see its tap, and presumably its plumbing travels back under the hill). And though no masks hang suspended above the panel, as the masks of theatre hang suspended above the scenes on the other walls of the Cubiculum, the whole scene is arguably yet another stage-picture, a *scaena* in the satyric mode, 'with trees, caverns, mountains and other objects delineated in landscape style':[30] country life put on and *performed* for city-dwellers. Which takes us to the inhabitants of the Villa at Boscoreale – not farmers but Roman patricians on their country estate (Lucretius remarked on the boredom that drove the rich from city home to country house and back again). By the time of the Late Republic the *villa rustica* had changed from a place for supervising agricultural production to a pleasant retreat, still within striking distance of the town (Neapolis); the actual productivity of the farms had become less important than the pleasure and diversion to be found there.[31] The *xenia* represents an idea of rustic simplicity that is entertained, then, only on condition that the actualities of agriculture and farm life are shed; or rather simulated, trans- formed into theatre.

Nothing could be further from the patrician sophistication of Boscoreale than the crass ostentation of the ex-slave Trimalchio in the *Satyricon* of Petronius, a work roughly contemporary with the Fourth Style. Yet it is worth considering the forms which affluence takes at Trimalchio's feast, if only to ascertain the dif- ferences from the forms of affluence at Boscoreale. The banquet pushes to their limit the tendencies towards over-refinement evident in Philostratus' *Xenia* II. The basic rule would seem to be that no dish served at the banquet may refer to the actual source or material from which it is made.[32] There are quinces, but in the shape of sea-urchins; when a boar is carved thrushes fly out; eggs in their shells turn out to contain sweetmeats; black damsons and red pomegranates are arranged like flames over charcoal. Everything appears disguised as something else: a hare is served with wings like Pegasus; what appears to be a goose surrounded on a platter by fishes and birds is in fact a food- sculpture made entirely of pork; bronze donkeys carry olives in metal baskets; twelve dishes make the circle of the zodiac, and so forth. What can never appear are natural ingredients, directly presented (at the feast no *water* is served); there must be the greatest possible contradiction between the way a thing seems and what it actually is. More precisely, there is a radical

14 Detail of illus. 11, Black Room, panel, Boscotrecase.

disappearance of substance under signs, for what is served at the banquet is not so much food as signs, heaped up and edible; the banquet is a chaos of signs separated out from the contexts in which they originally make sense, descending onto the food to transform it. The original is lost in the representation, until the whole meal is a farrago of imitations. It seems not even death can arrest the proliferation of replicas or their autonomous energy: at Trimalchio's own table sits a silver skeleton with joints that can be twisted into lifelike postures, for the amusement of the living guests.

What Trimalchio's banquet points to is an understanding of affluence as the capacity to surpass and trample upon the limitations of actual function (appetite, food) and to create a milieu where signs, simulations and replicas take over from reality and generate their own spectacular life. The local target of Petronius' satire is the ostentation of new money in the person of an ex-slave turned billionaire, and the text is written from a point of

15 Wall painting
from the cubiculum
at Boscoreale.
Metropolitan
Museum of Art,
New York.

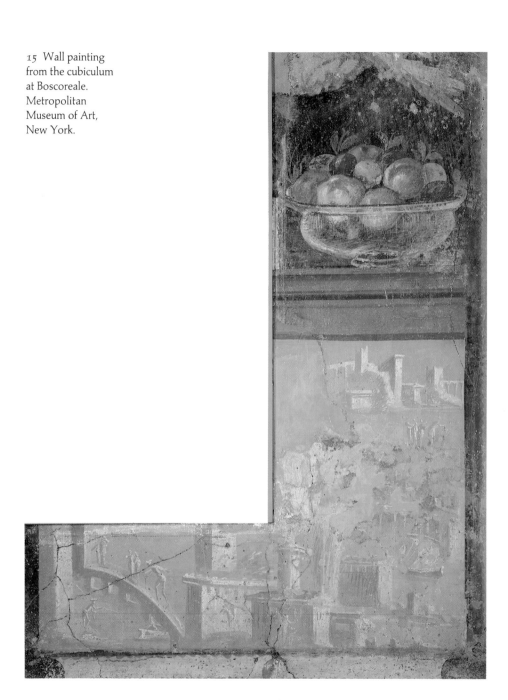

view which looks down on the specific class limitations of the Roman merchant order, of which Trimalchio is the absurd representative. Yet in its gross and parodic form Trimalchio's feast also delineates the dominant ideas visible in the Campanian frescoes, with their patrician and Imperial patrons: delight in the exuberance of simulation, in the power of representation to go past actual boundaries into a more expansive space and ontology. Here Petronius' text widens the scope of its reference beyond the local attack on a lower, rapidly rising social group and gives satirical form to ideas of consumption and display also evident, in however restrained and muted a fashion, in the more established aesthetic cultures of the period. The Cubiculum from Boscoreale, no less than the triclinium of Trimalchio, allows reality to be invaded and subsumed by simulation, and in this invasion its *xenia* is an important element: the centre of a semantic field that is defined in terms of movement from the primitive and rustic towards urbanity and (over-) refinement, it participates in and reinforces the movement of the decorative programme as a whole between these extremes.

The difference is that at Trimalchio's feast the process is totally out of control: signs, replicas and the principle of simulation take over from the real entirely. Petronius portrays Trimalchio as a kind of sorcerer's apprentice. In the Campanian fresco cycles, too, simulation comes close to absorbing the real: behind real walls stand walls in *trompe l'oeil*; at the very place in the room where one might expect to find a bowl of fruit there appears its painted copy; the walls surrounding an actual garden display a painted garden, idealised and streamlined, as though the essence of the garden manifested more in the copy than in the real thing. In both cases wealth accumulates to the point where actual needs are long since satisfied; economic force shifts from production to overproduction, and the economic focus becomes the problem of coping with that overproduction. But with Trimalchio the problem of overproduction is essentially insoluble: he has no idea what to do with his wealth; everything he touches turns to gold, and once in motion the engine of consumption goes faster and faster, without brakes. The Campanian painting cycles deal more successfully with the problem of overproduction; essentially the field is regulated by a precise economy. Both representation and wealth are understood to have the Trimalchian capacity for exceeding the real and for creating a fictional expansion that transcends the limitations of

appetite, the parameters of space, and the ontology of the actual world. Wealth and representation function here as cognate terms, so that to adorn the chamber with *xenia* and *trompe l'oeil* is to display not only one's wealth but the very principle of that wealth: the outstripping of necessity and limitation. But visual ideology organises this excess of wealth and of representation by creating visual structures that permit the return from even remote regions of unreality and simulation, back to the limits of the given world: the movement is not one of headlong flight away from the real, as with Trimalchio, but of carefully graduated transitions and liaisons between reality and representation.

One can think of the *xenia*, then, as simultaneously inhabiting both ends of the simplicity/sophistication spectrum. Evident in Philostratus is the residue of simple piety in his descriptions, the religious tone still active in his conception of hospitality: *xenia* properly bring to mind thoughts of Zeus, the god of hospitality ('not bare, by Zeus', 'Zeus' acorns'), and of Dionysos ('you will certainly hymn Dionysos'), the god of conviviality. Vitruvius, too, associates *xenia* with the tradition of ritual exchange of gifts from host to guest, where hospitality is conceived not merely as the observance of social etiquette, but as sacred obligation. To the hellenophile Romans who resided in the villas in Campania, *xenia* apparently had not altogether lost the religious meanings they originally possessed in the Greek world. Yet at the same time *xenia* are part of a sophisticated Roman cultural milieu and aesthetic in which they summon thoughts not only of hospitality but of luxurious art. For Vitruvius *xenia* are not, in fact, the gifts of food but *pictures* of foodstuffs, exchanged in the context of a 'Greek luxury' that stretches to extra dining rooms for the guests; for Philostratus also, *xenia* are essentially art-works for the connoisseur. In the Roman world such pictures are signs of a cultivated appreciation of Greek culture and art, and they belong to the whole cultural movement whereby Rome selectively took over from Greece the older society's religious structures, as well as its patterns of refinement and luxurious consumption. Increasingly the historical problem for Rome would become how to control and regulate principles of luxurious consumption which, when transported into the Latin context, acquired there a scale and intensity that far outstripped the Greek model. The Imperial economy generated colossal, uncurtailable accumulations of capital, which

by the reign of Nero were setting in motion patterns of consumption unprecedented in their excess (and megalomania). There seems no reason to doubt that the Campanian *xenia* sincerely invoke the earlier, still religious, Greek ethos of hospitality; but then they move on to explore the Roman aesthetic of secondariness, belatedness and excess in relation to Greek culture and art. They are not just pictures of food, but Roman pictures of Greek pictures of food; not just representation, but representation raised to a higher power, where Greek art is absorbed into Roman patterns of luxury consumption. In this doubling or multiplying of mimetic distance, the *xenia* participate in the lavishness and extravagance of the Roman economy; they provide images of consumption itself, as it moves in the Roman world between the poles of simple need and exuberant – delirious – excess.

What relations are present here, between social power, wealth and excess in the sphere of representation? The question is too complex to be answered by this discussion; but in the *Satyricon* there occur a number of episodes that may help to clarify some of the issues. At one point slaves enter Trimalchio's banqueting hall and spread on the couches tapestries embroidered with nets, spears, and the paraphernalia of hunting. Then the hall is invaded by a pack of hunting dogs that run around the table, to the bewilderment of the guests. A roasted boar of immense size is brought in, wearing on its head the *pilleus* of the freedman (since it is now in noble company), while a servant dressed as a huntsman ('bearded, wearing leggings') proceeds to carve an opening in its side with a hunting-knife. As the knife slices in, a flock of thrushes fly out, and are immediately caught by bird-catchers with nets. In a second episode, a boiled pig is served, but it seems as though its entrails have not been removed prior to cooking. The cook is called in to account for himself and is about to be punished for his oversight: Trimalchio has him stripped for flogging on the spot. But at the last minute the cook is allowed to slice into the animal, and out pour fully-cooked and sumptuous puddings and sausages (a scene brilliantly visualised by Federico Fellini).

What both episodes underline is the absolute nature of the agencies of power in Trimalchio's world. The subtending social relations are those of pure violence: Trimalchio has the power to punish his slaves in full view of the guests, and the text is constantly punctuated by slaves pleading against summary

punishment (a wine-server for dropping a goblet, an acrobat for falling, a valet for loss of a robe). The guests, too, are abject before the wealth of their host: one has not been able to afford a mouthful of bread that day; another is financially ruined; crop-failure and starvation are the prevailing conditions just beyond the edges of the scenes we see (Trimalchio, by contrast, is currently thinking of buying *Sicily*!). The talk at table is of gladiatorial combat, or of the Emperor's instant execution of the glass-blower who announced he had the secret of unbreakable glass (a technique the Emperor decided would upset the gold economy). Written into the dealings with the gross bodies of animals at the feast are the dealings between masters and slaves: those without wealth and power are subjects in total abjection, their masters are vortices of unimaginable domination.

But what the episodes also dramatise is the transformation of relations of pure violence (master/slave) into spectacle: the transmutation of domination into theatre. The motor for that conversion is illusionism, but illusionism of a very specialised kind: illusionism throughout the *Satyricon* acts as *the plot of pretended violence*. The hunter and the hunted reappear in disguise, both wearing masks: the huntsman becomes a cook in costume, the boar wears a *pilleus*, and the hunt itself is aestheticised as a decorated tapestry. In the gladiatorial games which the guests avidly discuss, the violence of man and beast and of man against man is turned into plot and staged as representation, as the show or drama of violence. Trimalchio's punishment of the negligent cook turns out to be just a charade, put on for the entertainment of the guests. The careless acrobat is forgiven in public, in a display of forgiveness where theatre steps in as the instrument for converting violence into spectacle, staged before an omnipotent gaze. The flight of the birds from out of the belly of the boar signals the moment of transformation, the jump of level from the unmediated power relations of master/slave to the mediated culture of representation and staging (once again it is birds that indicate a change or break in reality, in a culture where bird-lore and bird-magic belong to the religious sphere).

What the episodes turn on, then, is a definitive civilising moment when structures of artifice and aesthetic play take over from pre-culturality and 'barbarism'. At the moment when the birds are released at the banquet, there is a jump from the violence of the hunt to the civilisation of hospitality and the table.

It could be said of the *Satyricon* as a whole that its governing trope is the conversion of the relation *master/slave* into the higher relation of *host/guest*. And accompanying that central conversion are the myriad minor transformations that make up the texture of the *Satyricon*'s writing; the re-expression of that central move, from master/slave to host/guest, in a thousand details; the transformation of hunting into tapestry, sadism into martial art, punishment into practical joke, raw into cooked, meat into sweetmeat.

If the *Imagines* are our best guide to the aesthetic framework of the *xenia*, the *Satyricon* is perhaps our best guide to the wider place of such programmes within the culture. Like the *xenia* themselves, Petronius' text is only a fragment, and the light it can shed is necessarily fleeting and intermittent. But it is a text that gives remarkable expression, albeit in satirical form, to a certain ideology of culture, as that ideology existed in one specific place and time. It deals with the way in which the ruling culture understood itself *as* culture, and defined what it took to be the essential moments and processes in cultural production. That definition possesses a highly specific historical form: cultural work is defined as mediation and artifice, representation and simulation. Power is thought of as the capacity to control reality by shifting it from level to level, from a primally given real, across a series of distinct thresholds within representation, into pure simulation. In the definitive civilising moment, power turns part of its own violence into the force which governs the movement from the real to the simulated; power is conceived as expressing itself in the sphere of representations as that which *controls the automaton* of simulation. For Trimalchio the banquet is the height of refinement, the expression of the ex-slave's triumph over blind poverty and dependence, and his self-transformation into patron of the arts and society. And for proof that such an understanding of cultural production is not confined to ex-slaves but exists also in Imperial and patrician milieux, one need look no further than Pliny's description of antiquity's largest and most megalomanic image, the portrait Nero ordered to be painted of himself, on canvas 'of colossal proportions, one hundred and twenty feet tall': power *as* theatre. Or the villa at Boscoreale, where country life is put on and staged for city-dwellers and the landscape is refashioned to resemble a natural grotto, glimpsed through a window of simulation.

The Campanian frescoes give visual form to this ideology

by staging elaborately precise transition points between the real and the artificial. To some extent it is an aesthetic that loves to play with its own controls, and to allow the game of artifice to get nearly out of hand. One can find almost surreal discontinuities of scale and logic. In the Second Style, Lilliputian figures appear before gigantic temples. In the Third Style the *xenia* are clearly only pictures, in contrast with the real objects next to them (cups, candelabra, musical instruments, masks); but these 'real' objects are all miniaturised and brilliantly depicted in sharp focus, as though standing for reality, but reality seen through the wrong end of binoculars. In the Fourth Style the *xenia* are grossly enlarged, with giant objects (mushrooms, birds) dwarfing their nominal referents.[33] In the Triclinium at Boscoreale the mirror-like repetition of the side walls comes close to hallucination. Yet compared with the excesses of Trimalchio (or, for that matter, Nero) the Campanian schemes have the appearance of moderation and orderliness: they plot the liaisons from the real to the simulated with a precision which suggests that finally the ideology carries conviction; it is not pushed to the point of breakdown.

If this *regulation* of representation could be stated in the form of a rule, that rule might be: that in the Four Styles the objects chosen for depiction are given the primary function of *shifting* the level or degree of reality (or artifice) present in the representation. The emphasis lies on objects which, however interesting in their own right, are represented if and only if they effect a change of some kind in the level or degree of reality in the surrounding field. Consider Pliny's narrative of the competition between Parrhasios and Zeuxis. Each object in the story marks a step from one ontological level to the next: the auditorium, the proscenium, the stage, the curtain before the picture, the picture itself. The action of the story consists in moving a narrative agent (the birds in the first part of the story, Zeuxis himself in the second) across these physical thresholds which are at the same time ontological thresholds or breaks. Or consider Plato's narrative of the couch: here the thresholds are marked first by the picture of the couch, then the carpenter's couch, and then the Idea; whereas the painter and the painter's audience cannot see past the level of mere appearance the philosopher is able to make the full journey across all the breaks or transitions, and reach the Idea itself. With the same narratology in mind consider the representations, for example, at Boscotrecase: in the Black

Room the eye moves from wall (real) to wall (fictional), then across the transition marked by the candelabrum to the new reality signalled by the frame of the picture, on to the mythological scene it contains. In the Cubiculum from Boscoreale vision moves from the natural-seeming grotto to the *xenia* to the sophistication of the *grisaille* townscape (rear wall), or from chamber to theatre to *scaena* (on the side walls). Unless the object effects such a shift or threshold, it does not feature in the representation: the loyalty is not to objects themselves, but to the system of calibrated levels and degrees of reality which give rise to – precede and determine – the object that is depicted.

It may be that our own habits of viewing seek to isolate the Campanian *xenia* as free-standing images, sliced out from the walls and larger schemes to which they belong. A measure of this tendency is the actual excision of individual panels, at its most destructive in cases where panels have been literally carved out from their walls and transported to the museum (the same tendency is present rather more insidiously in the photographic practice of masking the surrounding wall to emulate the appearance of easel paintings).[34] Thus abstracted, it may seem that *xenia* are self-contained images, and that their fascinating lifelikeness expresses a loyalty to the truths of visual experience and to an aesthetic of *vraisemblance*. But if the *xenia* are in fact governed by a rule which selects the objects for depiction in order to designate them as 'shifters' in a narratological sense – transition points between different levels of reality and artifice – the nature of their illusionism changes. *Xenia* and the objects they depict take their places in an iconography that also includes, and in the same class: *scaenae*, fantasmatic architecture, dadoes and pilasters, figure/ground reversal in floor mosaic, and markers of sky or heaven in ceiling design (canopy, birds, stars, gods). It is a visual repertory that also embraces candelabra, architectural frames, pictures-within-pictures, masks (and here one should remember that masks are not only signs of theatre, but attributes of Dionysos, the god presiding over shifts and transformations in consciousness and perception). To this list one might add, finally, the interest in blown glass, and in seeing objects through glass. The material itself was new to Campania; its visual fascination must have been intense. To represent water or fruit *through* glass is to change the level of their appearance: things lose their substance and become image, *images of themselves*, perfect duplicates.

The selection of such things as fruit, jars of water, shells, sea-food, birds, vases (illus. 16, 17), is directed by a flow of connotations which link these simple elements, across the *nature/culture* series, with their antitypes, the objects of refinement and over-refinement: pictures-within-pictures, theatre-sets, *faux-marbre*, griffins, *grisaille*. The illusionism of the *xenia*, their mastery of shadow and foreshortening, is not simply the response to 'visual experience', but a necessary condition of the whole representational system of imbricated degrees of reality. Virtuosity in illusionism is a prerequisite of a visual economy that obliges its painters to make legible and unmistaken distinctions between degrees of realism and simulation; illusionistic skill, here, is a precondition of the system rather than the *xenia*'s specific objective. Let us say that in figurative representation, the objects in an image stand for their counterparts in the real world. If so, the *xenia* are counter-figurative or dis-figurative images: when

16 Peaches and Glass Jar half-filled with Water, Herculaneum. Museo Nazionale di Napoli.

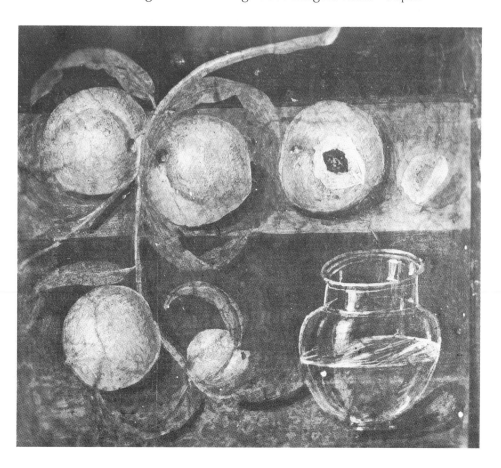

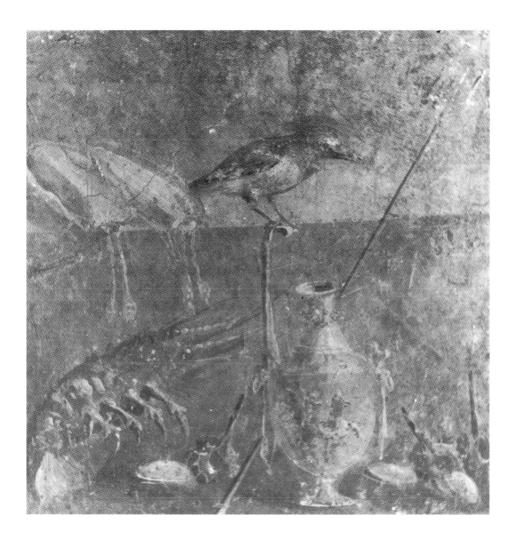

17 *Shells, Lobster, Vase and Bird,* Herculaneum. Museo Nazionale di Napoli.

they refer most faithfully to the reality of the world, they at once shift away from that world into transitions and thresholds which culminate in the opposite of figuration – irrealisation, artifice, the simulacrum. What is distinctive about *xenia* is their installation, right at the heart of figurative technique, of a counter-strategy to figuration, an abolition of figuration at the very moment when 'realistic' technique brings figuration to fulfilment: a form of image-making which is committed to the deletion or erasure of the depicted object at the exact moment when depiction takes place.

2 Rhopography

The *xenia* of antiquity share a striking and defining feature with all the later forms of still life painting: exclusion of the human form. Still life has never been pursued as the only available category of image-making: it has always been part of a field of genres that include portraiture and history painting, but existing in opposition to these as the genre where the human figure is deliberately avoided. In history painting we see the figure more or less idealised, and in portraiture we see the human figure more or less as it is, and both of these genres address the part of our imagination which builds and affirms the sense of human visual identity – what Jacques Lacan defines as the Imaginary.[1] But in still life we never see the human form at all. Still life negates the whole process of constructing and asserting human beings as the primary focus of depiction. Opposing the anthropocentrism of the 'higher' genres, it assaults the centrality, value and prestige of the human subject. Physical exclusion is only the first in a series of negations of the kinds of human-centred dignity we are used to finding in the other genres. Removal of the human body is the founding move of still life, but this foundation would be precarious if all that were needed to destroy it were the body's physical return: the disappearance of the human subject might represent only a provisional state of affairs if the body is just around the corner, and likely to re-enter the field of vision at any moment. Human presence is not only expelled physically: still life also expels the values which human presence imposes on the world.

While history painting is constructed around narrative, still life is the world minus its narratives or, better, the world minus its capacity for generating narrative interest. To narrate is to name what is unique: the singular actions of individual persons. And narrative works hard to explain why any particular story is worth narrating – because the actions in the story are heroic or wonderful, or frightening or ignoble, or cautionary or instructive. The whole principle of story-telling is jeopardised or paralysed by the hearer's objection: 'so what?' But still life loves

the 'so what?' It exactly breaks with narrative's scale of human importance. The law of narrative is one of change: characters move from episode to episode, from ignorance to knowledge, from high estate to low or from low to high. Its generative principle is one of discontinuity: where states are continuous, homeostatic, narrative is helpless. But still life pitches itself at a level of material existence where nothing exceptional occurs: there is wholescale eviction of the Event. At this level of routine existence, centred on food and eating, uniqueness of personality becomes an irrelevance. Anonymity replaces narrative's pursuit of the unique life and its adventures. What is abolished in still life is the subject's access to *distinction*. The subject is not only exiled physically: the scale of values on which narrative is based is erased also.

Perhaps one may draw on the distinction made by Charles Sterling between 'megalography' and 'rhopography'.[2] Megalography is the depiction of those things in the world which are great – the legends of the gods, the battles of heroes, the crises of history. Rhopography (from *rhopos*, trivial objects, small wares, trifles) is the depiction of those things which lack importance, the unassuming material base of life that 'importance' constantly overlooks. The categories of megalography and rhopography are intertwined. The concept of importance can arise only by separating itself from what it declares to be trivial and insignificant; 'importance' generates 'waste', what is sometimes called the preterite, that which is excluded or passed over. Still life takes on the exploration of what 'importance' tramples underfoot. It attends to the world ignored by the human impulse to create greatness. Its assault on the prestige of the human subject is therefore conducted at a very deep level. The human figure, with all of its fascination, is expelled. Narrative – the drama of greatness – is banished. And what is looked at overturns the standpoint on which human importance is established. Still life is unimpressed by the categories of achievement, grandeur or the unique. The human subject that it proposes and assumes is anonymous and creatural, cut off from splendour and from singularity. All men must eat, even the great; there is a levelling of humanity, a humbling of aspiration before an irreducible fact of life, hunger.

In the *xenia* from Campania, this principle of lowering human life to a level of primitive dependence and routine is strictly balanced against its opposite, an elevation of human life to the

greatest degree of refinement, elaboration and removal from nature. We saw in the last chapter that the *xenia* are incorporated into decorative schemes which move in carefully plotted stages between images of rusticity (bounty of nature, social harmony of man) and extreme sophistication (pictures within pictures, reality turned into theatre). And in the *xenia* described by Philostratus that, too, is the structure: the pictures move between a vision of pre-cultural simplicity, in which there is apparently nothing to do but eat what nature generously provides (*Xenia* I), and the more complex portrayal involving urban life, social stratification and the wealth of individuals (*Xenia* II). *Xenia* are bounded by the dual structure of megalography and rhopography, as these interpenetrate. Careful checks and balances ensure that the idea of the humble life, of creatural necessity and dependence on nature, is countered by its opposite, the power of capital and of representation to break away from what is creatural and replace it with what is artificial or simulated. One effect of this dual structure is to hold in check still life's capacity to explore the 'world without importance' for its own sake: what prevents that is precisely the commitment to the presentation of culture as circulating between luxury and necessity in a continuous cycle. An ethical view grounded in *sophrosyne*, the avoidance of extremes, constantly reminds sophistication of the place that must be granted to an earthy

18 Juan Sánchez Cotán, *Still Life*. Musée des Beaux Arts, Strasbourg.

19 Juan Sánchez Cotán, *Still Life with Fruit and Vegetables*. Hernani Collection, Madrid.

reality, directly apprehended, and at the same time reveals to a rustic version of life the possibility of overcoming necessity through cultural organisation, refinement, and symbolic play. The fuller development of still life depends on the disappearance of this classical balance and moderation. It is in the monastic culture of seventeenth-century Spain that rhopography's potential for overturning the scale of human importance is first revealed.

The kitchen pictures or *bodegónes* of Juan Sánchez Cotán (1561–1627) are conceived from the beginning as exercises in the renunciation of normal human priorities. They exactly reverse the scale of values in which what is unique and powerful in the world is the pre-ordained object of the gaze, while that which lacks importance is overlooked (illus. 18, 19).[3] The work of Cotán is an inversion of the kind of vision one finds, say, in Velázquez' *Las Meninas*. There, the visual field is entirely obedient to social hierarchy: at its apex are the King and Queen, who as possessors of absolute power also have dominion over sight, and feature as the sovereign gaze surveying all of the court; below them is the Infanta, privileged spectacle of the

court, the centre of all attention, and then the various court functionaries, including Velázquez, who fill lesser rôles in this drama of observer and observed. Cotán makes it the mission of his paintings to reverse this worldly mode of seeing by taking what is of least importance in the world – the disregarded contents of a larder – and by lavishing there the kind of attention normally reserved for what is of supreme value. The process can be followed in either a 'descending' or an 'ascending' scale. From one point of view, the worldly scale of importance is deliberately assaulted by plunging attention downwards, forcing the eye to discover in the trivial base of life intensities and subtleties which are normally ascribed to things of great worth; this is the descending movement, involving a humiliation of attention and of the self. From another point of view, the result is that what is valueless becomes priceless: by detaining attention in this humble milieu, by imprisoning the eye in this dungeon-like space, attention itself gains the power to transfigure the commonplace, and it is rewarded by being given objects in which it may find a fascination commensurate with its own discovered strengths.

Cotán's paintings aim to persuade vision to shed its worldly education – both the eye's enslavement to the world's ideas of what is worthy of attention, and the eye's sloth, the blurs and entropies of vision that screen out everything in creation except what the world presents as spectacular. Against these vices of fallen vision, Cotán administers his antidote: hyperreality. It would not be enough simply to record the fruit and the vegetables and the game as they are: mere realism would not bite deep enough into vision to dislodge the habitual vanities and blindnesses which lurk there. The surplus of appearances in Cotán, his excess of focus and brilliance, reveals a conception of vision as inherently wayward, yet capable of correction. Left to its own devices, vision is assumed to be the opposite of what the paintings emphasise; it overlooks ninety per cent of the world in order to follow the tracks laid down for vision by the world's definitions of spectacle, and by its own desires. Fallen vision is a half-lit place of blurs and glimpses, shifting quickly, easily led. The *bodegónes* of Cotán have an apotropaic function: to ward off this labile, unfocused imagery, to remove the interference of worldly attraction and to awaken vision to a sense of its own powers.

The paintings show the same suspicion towards un-

reconstructed imagination as the *Spiritual Exercises* of St Ignatius. Before coming to the retreat and learning the exercises in visualisation, the subject's mode of vision is assumed to be passive: desire pulls the eye this way and that; no object emerges clearly, since before it can do so it is already darting to the next form that seduces it; the images which appear are in a constant state of eclipse and fading. Vision has no internal resources to assert against the permanent tug of desire: sight is ensnared in the world, caught in pathways it cannot get out of, following tracks laid down in advance by the world's show. Against this passivity, the *Spiritual Exercises* propose an active imagination that re-collects vision, and the self, around the brilliant, incandescent images which the *Exercises* builds up, slowly, during the period of the retreat. These greater images focus all the senses – sight, smell, hearing, touch: imagining Hell, the subject must think of its fires, its screams, its sulphur, its acid tears; all of the channels of sense converge on the work of visualisation to cathect the image. Above all, the visualisation must be sustained: the *Exercises* specify for how long an image is to be held in the mind without wavering (for the duration of three Ave Marias, three Paternosters, and so forth).[4] Through this powerful, carefully assembled imagery the vagaries of fallen imagination are brought to an end; the strong, centrally organised images banish the dispersed and fitful field of ordinary vision to the shadows. With Cotán, too, the images have as their immediate function the separation of the viewer from the previous mode of seeing, vision in dispersal and disarray: they decondition the habitual and abolish the endless eclipsing and fatigue of worldly vision, replacing these with brilliance. The enemy is a mode of seeing which thinks it knows in advance what is worth looking at and what is not: against that, the image presents the constant surprise of things seen for the first time. Sight is taken back to a vernal stage before it learned how to scotomise the visual field, how to screen out the unimportant and not *see*, but scan. In place of the abbreviated forms for which the world scans, Cotán supplies forms that are articulated at immense length, forms so copious or prolix that one cannot see where or how to begin to simplify them. They offer no inroads for reduction because they omit nothing. Just at the point where the eye thinks it knows the form and can afford to skip, the image proves that in fact the eye had not understood at all what it was about to discard.

The relation proposed in Cotán between the viewer and the foodstuffs so meticulously displayed seems to involve, paradoxically, no reference to appetite or to the function of sustenance, which becomes coincidental; it might be described as anorexic, taking this word in its literal and Greek sense as meaning 'without desire'. All Cotán's still lifes are rooted in the outlook of monasticism, specifically the monasticism of the Carthusians, whose order Cotán joined as a lay brother in Toledo in 1603. What distinguishes the Carthusian rule is its stress on solitude over communal life: the monks live in individual cells, where they pray, study – and eat – alone, meeting only for the night office, morning mass and afternoon vespers. There is total abstention from meat, and on Fridays and other fast days the diet is bread and water. Absent from Cotán's work is any conception of nourishment as involving the conviviality of the meal – the sharing of hospitality present in the antique *xenia*. The unvarying stage of his paintings is never the kitchen but always the *cantarero*, a cooling-space where for preservation the foods are often hung on strings (piled together, or in contact with a surface, they would decay more quickly). Placed in a kitchen, next to plates and knives, bowls and pitchers, the objects would inevitably point towards their consumption at table, but the *cantarero* maintains the idea of the objects as separable from, dissociated from, their function as food. In *Quince, Cabbage, Melon and Cucumber* (illus. 20), no-one can touch the suspended quince or cabbage without disturbing them and setting them rocking in space: their motionlessness is the mark of human absence, distance from the hand that reaches to eat; and it renders them immaculate. Hanging on strings, the quince and the cabbage lack the weight known to the hand. Their weightlessness disowns such intimate knowledge. Having none of the familiarity that comes from touch, and divorced from the idea of consumption, the objects take on a value that is nothing to do with their rôle as nourishment.

What replaces their interest as sustenance is their interest as mathematical form. Like many painters of his period in Spain, Cotán has a highly developed sense of geometrical order; but whereas the ideas of sphere, ellipse and cone are used for example in El Greco to assist in organising pictorial composition, here they are explored almost for their own sake. One can think of *Quince, Cabbage, Melon and Cucumber* as an experiment in the kind of transformations that are explored in the branch of

20 Juan Sánchez Cotán, *Quince, Cabbage, Melon and Cucumber*. Fine Arts Gallery, San Diego.

21 Caravaggio, *Basket of Fruit*. Pinacoteca Ambrosiana, Milan.

22 Paul Cézanne,
Still Life with Apples.
Museum of
Modern Art, New
York.

23 Jean-Baptiste-
Siméon Chardin,
The Smoker's Case.
Musée du Louvre,
Paris.

mathematics known as topology.[5] We begin on the left with the quince, a pure sphere revolving on its axis. Moving to the right, the sphere seems to peel off its boundary and disintegrate into a ball of concentric shells revolving around the same vertical axis. Moving to the melon the sphere becomes an ellipse, from which a segment has been cut; a part of the segment is independently shown. At the right the segmented shapes recover their continuous boundary in the corrugated form of the cucumber. The curve described by all these objects taken together is not at all informal but precisely logarithmic;[6] it follows a series of harmonic or musical proportions with the vertical co-ordinates of the curve exactly marked by the strings. And it is a complex curve, not just the arc of a graph on a two-dimensional surface. In relation to the quince, the cabbage appears to come forward slightly; the melon is further forward than the quince, the melon slice projects out beyond the ledge, and the cucumber overhangs it still further. The arc is therefore not on the same plane as its co-ordinates, it curves in three dimensions: it is a true hyperbola, of the type produced when a cone is viewed in oblique section. It is the same with the even more austere *bodegón* in Granada (illus. 24). The vegetable stalks are analysed as a collection of extraordinarily complex curves riding from staggered bases and tending towards separate asymptotes, within a general hyperbola falling from right to left.

24 Juan Sánchez
Cotán, *Still Life with
Vegetables.* Museo
Provincial de Bellas
Artes, Granada.

The mathematical engagement of these forms shows every sign of exact calculation, as though the scene were being viewed with scientific, but not with creaturely, interest. Geometric space replaces creatural space, the space around the body that is known by touch and is created by familiar movements of the hands and arms. Cotán's play with geometric and volumetric ideas replaces this cocoon-like space, defined by habitual gestures, with an abstracted and homogeneous space which has broken with the matrix of the body. This is the point: to suppress the body as source of space. That bodily or tactile space is profoundly unvisual: the things we find there are things were reach for – a knife, a plate, a bit of food – instinctively and almost without looking. It is this space, the true home of blurred and hazy vision, that Cotán's rigours aim to abolish. And the tendency to geometrise fulfils another aim, no less severe: to disavow the painter's work as the source of the composition and to re-assign responsibility for its forms elsewhere – to mathematics, not creativity. In much of still life, the painter first arrays the objects into a satisfactory configuration, and then uses that arrangement as the basis for the composition. But to organise the world pictorially in this fashion is to impose upon it an order that is infinitely inferior to the order already revealed to the soul through the contemplation of geometric form: Cotán's renunciation of composition is a further, private act of self-negation. He approaches painting in terms of a discipline, or ritual: always the same *cantarero*, which one must assume has been painted in first, as a blank template; always the same recurring elements, the light raking at forty-five degrees, the same alternation of bright greens and yellows against the grey ground, the same scale, the same size of frame. To alter any of these would be to allow too much room for personal self-assertion, and the pride of creativity; down to its last details the painting must be presented as the result of discovery, not invention, a picture of the work of God that completely effaces the hand of man (in Cotán visible brushwork would be like blasphemy).

The still lifes of Francisco de Zurbarán (1598–1664) share with those of Cotán the same Ignatian mission of reproving and refining worldly vision through a transfiguration of the mundane. Yet their procedure is quite different. In Cotán there is little sense that the objects shown in the painting have any relation to bodily contact: knives and plates, pitchers and cups

make no appearance, and in general touch is presented as though it were a source of contamination. But Zurbarán is more interested in the artefacts surrounding food than in food itself. What engages him is the sense of touch and the action of hands upon matter. In the painting of *Metalware and Pottery* in the Prado (illus. 25) every vessel records and dramatises the history of its manufacture.[7] In the earthenware vessels there is a strong sense of the potter's wheel turning and, as it turns, of the hands cutting notches and rims in the soft clay. It is the softness, even the slipperiness, of the clay that is registered in the loose, flopping curves of the handles. The body of the jar on the extreme right has been pressed when wet with a tool that makes gentle, even depressions in its thin walls. The long-necked pitcher to its left has been elongated and widened towards its top by fingers skilful enough also to carve a series of steps or bands without toppling the clay on the wheel. The rim of the full-bellied pitcher to its left has been shaped by the action of the thumb pinching the clay into a scalloped curve. And the bowl on the extreme left announces the more exacting manual procedures of wrought metal: carving, chasing, burnishing. They are forms which, passing from one set of hands, carefully direct the hands of those who will later touch and lift them. Imagine that you do so: the fingers, wrist and arm are obliged to find very different kinds of purchase on each object.

Still life is in a sense the great anti-Albertian genre. What it opposes is the idea of the canvas as a window on the world, leading to a distant view. Although its techniques assume a mastery of perspective, even in *xenia*, nevertheless perspective's jewel – the vanishing point – is always absent. Instead of plunging vistas, arcades, horizons and the sovereign prospect of the eye, it proposes a much closer space, centred on the body. Hence one of the technical curiosities of the genre, its disinclination to portray the world beyond the far edge of the table. Instead of a zone beyond one finds a blank, vertical wall, sometimes coinciding with a real wall, but no less persuasively it is a virtual wall, simply a cutting off of further space, like the outer boundary in medieval maps of the world. That further zone beyond the table's edge must be suppressed if still life is to create its principal spatial value: nearness. What builds this proximal space is gesture: the gestures of eating, of laying the table, but also – in Zurbarán – the gestures which create the objects out of formless clay and metal. The basic co-ordinates are not supplied by

calibration and mensuration, as the piazzas of Renaissance Italy or the floors of Dutch interiors supply the standard measurements of space by means of flagstones or tiles. Rather its units are bodily actions, specifically those of the upper body, the torso and arms. As a result, it is a space that is full of the idea of gravity, a sort of Einsteinian field in which distance and mass intersect. The eye not only reads for contour and volume, it weighs things: here the instruments are the muscles of the arm and hand. And the eye also registers the textures of things as part of their being, inseparable from their weight: the relative roughness of earthenware, the feel of a glaze, the hardness and coolness of metal; here the sensing instruments are the fingertips. The unit of direction is not the line, as in Albertian or perspectival painting, but the *arc*, since bodily movements always curve. And the unit of interval is less linear measure than relative degrees of rotation: gesture is always a matter of *turning*. Consider the constant change of the angles in which the double-handled vessels of *Metalware and Pottery* are seen, and the metal plates on either side: what they establish is the idea of form as something rotary, and in the end the product of a body continually dependent on the movements of muscles and joints. In the Zurbarán the angles of rotation are calculated to the finest interval, but depth and distance, with which perspective painting is preoccupied, are virtually eliminated.

Metalware and Pottery (illus. 25) and *Lemons, Oranges, Cup and Rose* (illus. 26) are set in this 'haptic' space to a far greater degree than the still lifes of Cotán, with their negation of proximity and their interest in homogeneous, mathematical space. One is much more aware of the human hand in establishing the scene. The latter painting highlights the careful placement of the fruit and the sprig of orange-blossom, and invokes the fragrance of the rose and the aroma of the chocolate once these are lifted from their places and savoured. Since everything lies at equidistance along the same line, there is no sensation of the scene receding into space. The depth of field is shallow to a degree, and indeed contradictory clues make it difficult to construct the scene in depth at all (the front part of the flat rim of the pewter plate is excessively narrowed in relation to the rim of the chocolate cup, which therefore appears irrationally to tilt forward). The atmosphere is thoroughly tactile or kinaesthetic. Such space is normally 'dark', in the sense that gesture structures it with only partial reference to the eye: gestures, which depend on

26 Francisco de Zurbarán, *Lemons, Oranges, Cup and Rose*. Norton Simon Museum, Pasadena.

repetition and routine, can operate without constant monitoring, and for this reason theirs is the preterite domain of the 'overlooked'. But Zurbarán floods this normally darkened and non-optical space with brilliant, raking light. This is the device whereby vision is to be aroused from its habits of sloth and inertia, and made to see. A perfectly coherent tactile space is subjected to brilliant illumination, as though the lights had been switched on in a darkened room.

Chiaroscuro is important in Zurbarán because the profiles it builds along the dividing edge between dark and light create shapes for the eye that correspond to nothing known by the hand. To the fingers, the cup is smoothly continuous, but Zurbarán's high contrast cuts it into the two sides which are opposed. The citrus fruit recall the experience of texture with peculiar intensity – the familiar waxiness, the pores, the resilience of thick pith are all emphasised; but the harsh tenebrist lighting produces for the eye shapes which are unfamiliar and unpredicted. Imagine the scene lit softly: touch would reign. Chiaroscuro elicits from these objects a dramatic object-hood that is for the eye alone. There is a move to separate the starkly revealed visual forms from a tactile space which is also fully established. The subtle assault on tactility continues in the striking composition, where everything is laid out on a perfect line. Normally, composition invites the eye into a picture by establishing a path of entry, nearby objects leading to others that recede, and a path of circulation around the surface, through devices of low leading to high and back (the compositional pyramid favoured by the High Renaissance is a guarantee of accessibility to viewing, a mark of welcome). But these works of Zurbarán provide the viewer with no way to access their interior world: the equidistance of the objects from the viewing position instead pushes the viewer out and keeps the objects at arm's length. Between the eye and the forms it seeks to contact stretches a gulf which nothing traverses. And again this opposes the normal order of tactile space, where everything that appears can be reached, touched and moved around. Here, nothing can be touched at all: touch would do violence to the scene. The precarious balance of the rose on the edge of its plate, and of the blossom-sprig on the oranges, discourages any idea of reaching for the fruit or lifting the cup to sip its contents. The frontality of the composition shows that there is full awareness of the viewer's presence, and the composition is theatrical in the sense that everything moves towards the spectator. In fact it is hard to imagine a composition that more self-consciously *expects* the spectator's gaze, or more advertently turns towards it. Yet this awareness of the viewer's presence is unaccompanied by any sign of welcome, or of ushering in. Hence the feeling of impassiveness, of a protocol of distance. Tactile space is generally in constant movement: things are moved about, jammed together, lifted and carried informally, and the concept of motionless com-

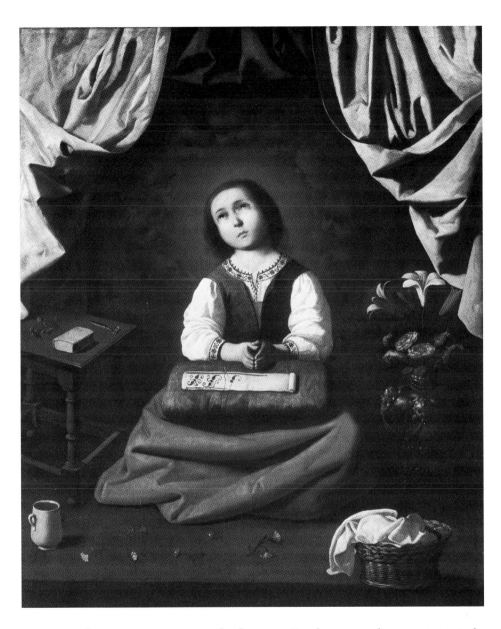

27 Francisco de Zurbarán, *The Young Virgin*. Metropolitan Museum of Art, New York.

position is entirely alien to it. But that motionlessness is precisely what Zurbarán's objects insist on. Their placing has been calculated, in the words of Martin Soria, with hair-fine draughtsmanship; the least alteration would upset the harmonic ratios between the forms and ruin their perfect alignment. Only by forgetting ideas of tactile or kinaesthetic space can the viewer approach the painting without intrusion.

Zurbarán first creates a scene which greatly depends on ideas
of touch and the memory of hands, and belongs to the visually
lazy or sightless journeys of the body through its immediate
envelope of space. Then he floods the stage with light, separates
visual from tactile form, and offers the eye – alone – a spectacle
so immaculately self-contained that the only appropriate
response is to disown the tactile reflexes as crude and ham-fisted.
As with Cotán, there is a sense of reproof and correction offered
to a mode of vision that inhabits the world benightedly, in the
shadow zone of gestural repetitions and muscular routines. The
painting is severe in its demands on perception: the flooding
of the darkened world with light is painful as the eye is stung
into action, and disused optical pathways are re-opened and
switched to current. But the strain is necessary, if vision is to
rise above the fallen world. The ability to see what is insignifi-
cant with clarifed vision is presented as a spiritual gift, and in
The Young Virgin the still life objects (flowers, book, scissors,
embroidery, chocolate cup, linen basket) are attributes of saint-
hood, signs of grace and purity (illus. 27, 28).

The work of Cotán and Zurbarán reveals considerable ambi-
tion for rhopography as a genre: it is treated with the same
gravity of purpose as the religious paintings to which Cotán
devoted himself after entering the Carthusian order in 1603, and

the paintings of monks, priests, popes, saints and evangelists which Zurbarán executed throughout his career. The spiritual rationale for their elevation of rhopography to a level comparable with sacred painting is clear if we compare their work in still life with that of Caravaggio (1573–1610), as represented in the *Basket of Fruit* discovered by Lionello Venturi in 1910 and kept in the Ambrosiana, Milan (illus. 21). Caravaggio is concerned, as they are, to remove from his composition the sense of tactile familiarity, and by this means to present the eye with heightened, defamiliarised forms. But it is hard to discover behind this procedure the spiritual rigour that is so vividly present in the Spanish paintings. Caravaggio's work is conducted in the antique spirit of the *xenia*, as an exercise in simulation or *trompe l'oeil*; one moves from considerations of desire, and its correction, to connotations of theatre, and aesthetic – rather than monastic – detachment.[8]

It is the attack on three-dimensional space that gives the *Basket of Fruit* its peculiar intensity; its scherzo-like character comes from pushing as far as it will go the experiment of effacing all clues concerning depth.[9] Anyone who has spent time with cameras will know what happens to depth of field when a zoom lens is used: all the planes of a scene collapse together. That is precisely what happens here. Much of the effect is due to the blank background, all the more striking in a scene which elsewhere is highly detailed and apparently aims at faithful naturalism. Everything behind the basket of fruit is eliminated, even shadows. There is no way of knowing how far back in space the basket and its contents are supposed to go. This would be confusing enough, but the painting so lowers its viewpoint, coming down to the height of the table, that the ledge on which the basket rests is also eliminated; this makes it impossible to know how deep is the table, let alone the space beyond it. Instead of perspective lines travelling into depth, there are only planes, all of them perpendicular to the eye; there are no diagonals, and nothing tilts inward. Information concerning the distance of one plane behind another is systematically blocked. Profiles are cultivated, to the detriment of depth. Though we are shown the basket in all its details, down to the last woven reed, it is a moot question whether the basket's form is circular or oval; it does not 'turn', in the sense teachers of drawing give to this word. The leaves themselves are pure silhouettes – the two vine-leaves to the extreme right, and the grapes hanging from their

stalk nearby, are hardly filled in at all, but left as blank as the background behind them. A similar stencilled look comes from the gaps left in the high, central leaves by the work of insects, and from the channels between different segments of vine- and fig-leaves. One of the properties of silhouettes is to trigger the instant recognition of a form while supplying no data concerning relief; it is a powerful device, well known to the street artists who at the corners of buildings paint a human outline in black against the wall – an outline which any paranoid urban passer-by is quick to fill in. Here, the device is used to create the feeling of forms so real that they leap forward, positively projecting into the viewer's space rather than emerging slowly within their own.

This inhibition of depth extends to Caravaggio's handling of colour, which also works against establishing a sense of volume. If a painter is to render convincing the particular volumes of fruit, the way they feel to the hand that closes round them, the solidity and rotundity of their curves, it can be helpful to choose fruits whose colours are especially even and uniform – apples that are entirely green or all red, fruit without marks – for then all the graduations of their hue and tone can be read by the eye as indications of contour. But Caravaggio chooses fruits with complex markings on their skin – an apple that is thinly striped, figs which have cracked; fruit with blemishes – the larger and smaller wormholes in the apple, the pock-marked surface of the pear. Moreover, he denies the fruit the fullness of volume they would have when seen completely, when their entire edge is shown and their global form is disclosed: each fruit overlaps with others, and not even the basket is allowed its complete outline. A principle of heaping obscures the particularity of individual form and mass. To this Caravaggio adds the difficulties of isolating objects under conditions of chiaroscuro. When lighting is even, and no extremes of light or dark prevail, it is easy to grasp individual objects because all their edges show; but when there is high contrast and middle tones are played down, the image breaks up into areas of light and dark that are independent of contoured form. Here, the light yellow of the lemon on the left merges with the yellow of the apple without a break, the black grapes fuse together into a single patch of dark, and at the right of the basket the stark contrast of the basket's edge against the brilliance behind it produces a cut-out, an effect of flatness and not of receding curves.

All of these strategies remove the still life from the familiarities of tactile apprehension. The third dimension is taken out, and the image seems strangely monocular: it is a painting which supplies to both eyes open the look the world has when seen with one eye closed. And in this respect it is close to the work of Cotán and Zurbarán, who similarly drive a wedge between the tactile and the visual, and thereby estrange what is familiar and everyday. But there is an important difference, which is that Caravaggio's painting makes no reference to a mundane space, now lit up and transfigured. All of Cotán's still life has as its *mise-en-scène* a larder, an absolutely real and ordinary space (and though his *cantareros* may look peculiar in the north, they are still to be found in good working order in the southern part of Spain, from Toledo to Andalusia to Extremadura).[10] It is vital to Cotán's aim of deliberately humbling vision, in order to chasten it and shake its pride, that the eye is led back to a place it knows is there, but has ignored. And in Zurbarán, too, however radiant the objects become, they are still part of ordinary space and an everyday world: there is nothing dramatic or exceptional in the basket of linen or the cup of chocolate near Mary's chair. Zurbarán's whole point is the interpenetration of what is ordinary and unassuming with what is exalted and sacred so that, handy-dandy, the mundane and the supramundane change places. But Caravaggio gives his basket of fruit no worldly context at all. All signs that the place is indoors, in a particular house and room, have been erased; even the table ceases to be a table – to the right of the painting it becomes an abstract band, part of the background. Cotán and Zurbarán bring vision down deep inside the material world, among the pots and pans: what they seek is the *bathos* of vision, an end to artificial splendours and inflated grandeur; against the vision of the Court they propose that of the monastery. But Caravaggio deliberately abstracts his still life from any mundane location we can recognise. This renders impossible the kind of switching between levels of reality, from humble to exalted and back, which Cotán and Zurbarán pursue. If this play of reality levels is somehow lost in Caravaggio what, then, is the aim of his painting?

Perhaps one can draw here on Stephen Bann's distinction between *representation* and *presentation*.[11] Representation would involve mimesis, the repetition of what is already there, a re-presentation of realities already known. Cotán and Zurbarán are representational in this sense: they never cease referring to

things generally familiar, and their refusal to depart from what is already given is part of their conception of painting as the exercise of humility. This art does not invent things for its own sake, or indulge in fantasy or caprice. The constant return to familiar things is a mark of sobriety and self-restraint, a refusal to enter into flights of imagination; on the contrary, their aim is to dispel illusion and remind vision of its actual place and powers (it should go without saying that one is dealing here with a *rhetoric* of realism, with 'reality-effects', regardless of the actual presence of a previous model). But in the Caravaggio, the reality that is shown exists *only inside the painting*. Its spatial co-ordinates are not the three dimensions that make up the known world, but the two dimensions of the painting's surface. This is the significance of Caravaggio's reversal of the Albertian gaze. When the painting is thought of as a window, leading the eye through to vistas behind it and beyond, the canvas is self-effacing in the representation or resurrection of prior things: it pretends to disappear, or to turn to glass, before the reality which lies out there beyond it, and which it merely relays or transfers to the space of viewing. Caravaggio breaks with this fenestral conception of the canvas: instead of receding, objects come forward, as though the vanishing-point were not 'behind' the canvas, on some internal horizon, but in front of it, in the space where the viewer stands. The *Basket of Fruit* does not recede: it projects. And as it does so, it announces that the only space where the objects reside is in this projection that is sent out from the canvas towards the spectator. The painting shows objects that exist there, and only there – not in some prior, receding space that is neutrally copied or transcribed. The basket of fruit and the fruit are presented, not represented; they come into being on the canvas for the first time, not as transcription but as originary inscription.

The *Basket of Fruit* marks a return to the *xenia* of antiquity in its themes of theatricality and simulation: no less than the grapes of Zeuxis or the curtain of Parrhasios, its wish is to deceive the eye. And in fact this may have been its literal intention. The canvas shows the marks of nails, as though originally it had been fastened directly into the wall without a frame, so that placed at eye level it might beguile the eye into thinking it a real basket, real fruit.[12] It is eminently skenographic painting, in that its space is not that of reality but artifice, theatre. Where Cotán and Zurbarán stress an earthly plane of existence which

can be sublimated by purifying attention, the Caravaggio deliberately cuts still life's ties to the earth; if there is transfiguration here, it comes from art. The basket of fruit is of no value in itself; it gains its value from what art is able to do with this insignificant and unpromising material. This indicates a quite different purpose for rhopography as a whole. In the case of Caravaggio's work in the 'higher' genres, art is always subordinate to the religious narrative it illustrates; but when what is depicted lacks that importance, then art can display *itself*. The *Basket of Fruit* shows art's capacity to raise the insignificant to its own heights — and it needs the insignificant to demonstrate those heights. The rhopography of Cotán and Zurbarán has a radical edge to it that wants nothing to do with the megalographic, with art as a form of grandeur, or magniloquence, but in the Caravaggio still life the interest lies exactly in the power of art — and of this artist — to raise an intrinsically humble branch of painting to the level of the heroic. The impersonal demonstration of the power of art shades here into a form of aggrandisement unthinkable in Cotán and Zurbarán. Caravaggio wants hyperbole, not bathos; by means of unaided technical skill he is able to turn dross to gold. It is of no consequence if, in the process, the reality of the still life as part of an actual world is sacrificed, and indeed that sacrifice is necessary if painting is to move from representation to presentation, from a stage of transcribing reality to a stage where the image seems more radiant, more engaging, and in every way superior to the original — which the painting can dispense with.

Still life's potential for isolating a purely aesthetic space is undoubtedly one of the factors which made the genre so central in the development of modernism. The *Still Life with Apples* by Cézanne (1839–1906), for example, makes no attempt to refer its arrangement of fruit, bowl and table to any aspect of a recognisable meal, or scene within a house (illus. 22). On the contrary, it aims to remove itself from function altogether: the fruit are disposed with no rationale except that of forming a compositional armature for the painting. The table-cloth and linen have been creased and rumpled not to suggest the aftermath of a meal but rather to display the fruit as aesthetic spectacle. Imagine the present arrangement of the fruit on a table left bare, without these strangely crumpled linens: the contrivance of the composition would be patent and discordant; there would be a clash between the real spatial co-ordinates of

a table, where objects are usually placed according to domestic function, and the elaborately staged *mise-en-scène* that has been set up to make the painting. The creased folds of the napkin and the arching, billowing table-cloth serve the purpose of suppressing the table as a familiar object in a household and of abolishing its four-square, cubic co-ordinates, which would give to the fruit, bowl, glass and pitcher too firm an anchorage in their own space (one notes the way the plane of the table surface is broken and denied, the right side placed much lower than on the left, where it joins the frame). The linens have a euphemising function: through their association with the casualness of a meal now come to an end, they help pass off the artifice of the composition as natural. And they have a dislocating function: they hide the space where the objects might exist for their own sake and convey them into aesthetic space, where they become objects uniquely destined for the gaze. In place of their own geometry, they are reconstructed in terms of the painting's internal rhythms: the oscillation of arc and circle, the play between tan and lemon, the contrasts of yellow and green against brown and russet red.

Presentation, not representation: as with Caravaggio, what is shown comes into being only inside the picture. The integrity and separate visibility of each dab of paint foregrounds the work of the brush in building the scene, over the scene itself. The thin application of pigment, and the fact that the canvas shows through in almost all areas (where it is not actually left blank), imply that we are able to follow all of the painter's stages of construction step by step, with nothing having been concealed. Even the preliminary outlines round the apples remain visible. No erasure: everything that was painted remains on view. The method of construction is slow, as though there were a pause for reflection between each stroke of the brush, and this suggests the continuous and unwavering exercise of compositional judgment. Each move is the outcome of previous moves, and anticipates those which follow: Cézanne's hundredth stroke takes into account the previous ninety-nine, and prepares the way for the next to come. Each stroke is saturated with self-reflexive attention, so that what is presented in the end is not the objects but the consciousness that builds their (re)presentation. In a very limited sense this is theatrical painting: every stroke that makes up the scene turns away from any reality which the scene might have in independence from the activities of painting and of view-

ing, and towards the spectator (first Cézanne, then us). But where the word 'theatricality' suggests a pursuit of dramatic effect and sudden impact, here the theatrical relation of viewer to scene is subsumed in the slow, grave concentration of building the painting stroke by stroke out of nothing. There is even a curtain, the classic sign of theatre: and it is a painted curtain, whose design of leaves and fruit is so continuous with the table composition that its own principle of theatricality enters the still life proper and completes its irrealisation, its Parrhasios-like turn from reality towards artifice. But the removal of the reality principle is necessary if the painting is to display in the purest form the unbroken series of aesthetic judgments by which it is constituted.

Still life's capacity for moving across different levels of reality and artifice is probably the basis of its interest to Cubism, particularly in those phases of the latter's development when the release of painting from its mimetic rôle was felt to be best demonstrated through a structure of serial thresholds from the real to the represented.[13] *Breakfast* (1914; illus. 29) by Juan Gris is fascinated by the way an image can engage simultaneously with quite different modes of interaction between signs and what they represent, and it playfully runs through a whole gamut of modes (index, icon, symbol), like semiotics on vacation. The inclusion of fragments from the real world – newspapers, wallpaper, a manufacturer's label – plays with the ancient connection between still life and *trompe l'oeil* by pushing illusionism over the edge into actual quotation from the world. Of particular interest to Juan Gris is the way a small area of the image can rapidly jump from one level of reality to another: the Eugene Martin label at the top of the painting is tied into a 'parcel' by strokes of crayon that seem, just over the label, like *trompe d'oeil*, but towards the edge of the parcel peter out as obvious crayon lines. The area around the newspaper brings together something real (newsprint), something obviously represented (the wooden mouldings), something half way between (*faux bois*), and something that refuses to represent at all (pure black). It takes what is usually the one element that lies outside visual representation, the artist's signature, and makes it part of the composition; next to that it draws on the *faux bois* a shape reminiscent of a picture frame. The wit of the painting comes from the speed with which it darts from one level of reality to the next, and from the paradoxes of occupying one (or more) levels at the same point.

And however vertiginous the painting's ontology becomes, its play with shifting modes of illusion is grounded in the familiar reality of tables, cups and saucers. It is the security and dependability of that routine space which allows the metaphysical transformations to take off and soar.

Cubism relies on the forms of still life to provide stable, legible anchor-points for the fragmented planes and spatial torsions it cultivates. For this reason it tends to reduce its forms towards the minimal schema of recognition – the point at which, without further elaboration, the viewer recognises the lines as representing bottles, tables, glasses (illus. 30). It practises a glyphic reduc-

30 Georges Braque,
Violin and Palette.
Solomon R.
Guggenheim
Museum, New
York.

tion in which the painting can elicit from the viewer a sure
recognition of such things while making the least possible com-
mitment to describing their space. The merest sketch of an *f*-
curve is enough to establish a violin, or a scroll curve the top
of a guitar – and without these the space quickly becomes inco-
herent. Even in analytical Cubism, the interest is less in 'abstrac-
tion' than in the *pull* between the forces of abstraction and the
gravity and inertia of still life's familiar forms. The 'blind' routines
of hands around a table, or the more intricate movements of
fingers on a musical instrument, anchor the transformations of
optical space in a space of tactile familiarity that is strong enough

to bind together even impossible facets and smithereens. At that level of creatural habit and routine, the eye usually follows only the gross visual cues of things – we do not normally sit at our breakfast table in rapt contemplation of the cups and spoons. Forms are edited and streamlined to the basic minimum (in this sense Cubist still life may, after all, be realist), and Cubism does nothing to re-complicate or enhance those basic, compelling formulae. Looking at Cubist still life one discovers nothing one does not already know (indeed one may find less than one knows). This indicates a rather problematic relation to the whole idea of 'rhopography'.

The problem concerns the relation which still life proposes between the viewer and the everyday world, the world trampled underfoot to make way for what is of importance – whether in life or art. The works by Caravaggio, Cézanne and Juan Gris indicate one way in which rhopography can actually avoid the challenge which low-plane or quotidian reality poses for painting. Caravaggio and Cézanne, in very different ways, are fully prepared to sacrifice the actuality of what they portray in order to show something else, the power of art to ennoble and elevate even a humble basket of fruit, or the capacity of art to embody and dramatise the detailed workings of aesthetic consciousness. In the case of Juan Gris, everyday reality is reduced to a glyphic outline in order to support and stabilise a metaphysical *jeu d'esprit* which takes mundane reality only as its starting point. What is shown is art itself, as something which in the presence of an everyday world always grows *impatient*; it is not content to be subservient to that prior world, and seeks autonomy and escape. And though what is painted remains humble and commonplace, in its state of restlessness and self-assertion, there is only one place rhopography can go – *megalography*. The Caravaggio still life structures itself as though it were an heroic history painting: the rhythms and ratios of its forms have the same amplitude and breadth as a major composition, and though physically the painting is small (47 × 64.5 cm), it feels monumental in scale. Similarly with the Cézanne there is less interest in the actual colours of fruit than in the clashes which pigment can produce between acid green and ochre; less curiosity about the actual shape of lemons than about volumetric rhymes they can be persuaded to yield if they are treated as variations on a sphere. The goal, to make great painting ('From Giotto to Cézanne'), enormously exceeds the depicted subject. A contradi-

tion emerges between the life of the table, the unexceptional nature of its routines, the creaturely anonymity of eating, and the pursuit of the image which is in everyway remarkable, the unique expression of its individual creator, the breakthrough work or style that will move European painting into a different era. In the world of low-plane reality that still life actually inhabits, because there are no events, there is none of the drama of history; because at this mundane, creaturely level we are all more or less the same, there is no distinction. But the Caravaggio and the Cézanne still lifes are convinced of their power to break with painting's history, and to remake it; they are megalographic in every sense.

In Cotán and Zurbarán megalographic ambitions are of course singularly absent, and everyday life is confronted without evasion. Their sense of painting as a spiritual discipline, bound up with self-negation and the reduction of ego, leads them to still life as a branch of art particularly suited to a vocation of humility. The problem which everyday reality poses for painting does not exist for them spiritually, but (so to speak) technically. In its quality of attention, still life possesses a delicate and ambiguous instrument. Its whole project forces the subject, both painter and viewer, to attend closely to the preterite objects in the world which, exactly because they are so familiar, elude normal attention. Since still life needs to look at the *over*looked, it has to bring into view objects which perception normally screens out. The difficulty is that by bringing into consciousness and into visibility things that perception normally overlooks, the visual field can come to appear radically *un*familiar and estranged. Consider again Cotán's *Quince, Cabbage, Melon and Cucumber* (illus. 20). The attention invested in its objects certainly brings forth their reticent visibility, and the beauty or extraordinariness it finds there could hardly have a location more mundane (one can think of the *cantarero* as an early kind of refrigerator). But precisely because the location *is* so ordinary, the quality of attention brought to bear on the objects stands quite outside normal experience and the normal domestic round. Defamiliarisation confers on these things a dramatic objecthood, but the intensity of the perception at work makes for such an excess of brilliance and focus that the image and its objects seem not quite of this world. In the routine spaces still life normally explores, habit makes one see through a glass, darkly; but when the object is revealed face to face, the departure from the habitual

blurs and entropies of vision can be so drastic that the objects seem *un*real, *un*familiar, un-creatural. The objects depicted by Cotán belong less to the cocoon of nearness than to a kind of eerie outer space (Charles Sterling said of the quince and cabbage that they 'turn and glow like planets in a boundless night'[14]). Similarly, Zurbarán's *Lemons, Oranges, Cup and Rose* (illus. 26) shows a visual field so purified and so perfectly composed that the familiar objects seem on the brink of transfiguration or (the inevitable word) transubstantiation. Standing at some imminent intersection with the divine, and with eternity, they exactly break with the normally human.

Such contradictions point to a problem of distance from the everyday which seems always to be present in rhopography. Cotán and Zurbarán plunge vision downwards to a level of creaturely simplicity where the human subject is authentically humbled and reproved, yet the world revealed at this level is also altered by the re-education of vision. Appetite, tactility, the body, are all chastened, and to this extent one is dealing with a quite specialised sense of everyday life, the routines of monastic discipline. The lines of Théophile Gautier point to a way in which the rejection of bodily appetite in Zurbarán is closely bound up with the sense of guilt:

Moines de Zurbarán, blancs chartreux qui, dans l'ombre
Glissez silencieux sur les dalles des morts,
Murmurant des Pater et des Ave sans nombre,
Quel crime expiez-vous par de si grands remords?[15]

And in Cotán there seems to be an obscure equation between spiritual worth and the refusal of food. Vision is forced to become materialist, in opposition to the idealisation that operates in the 'higher' genres, and painting is made to confront material life directly; but the world which then emerges is also to some degree rejected. Though situated at a creaturely or bodily level, vision will not participate in a creaturely relation to what it sees. It is divorced from tactile space and sensuality: food enters the eye, but must not pass through touch or taste; there is retention of the purity of the body's internal spaces, a refusal to yield and open the body to the rest of the material world. The inside of the body is a dark void: this may be one of the metaphorical connotations of Cotán's empty *cantareros*.

When driven to extremes, hyper-attention not only produces an interval between the perceiving self and objects; it separates

the self from other selves. The subjects *stares* or *glares* at the world. Still life can hardly avoid quickening attention, but beyond a certain point the self becomes enclosed within itself, saturated with perceptions now of a manic or obsessional intensity. This is true not only of Cotán and Zurbarán, but of the still lifes of Caravaggio and Cézanne as well: the Caravaggio *Basket of Fruit* is hyper-real in its focus and micro-relief, and Cézanne's *Still Life with Apples* suggests an exhausting feat of compositional calculation, indefinitely prolonged (like Flaubert, Cézanne has no *facility*). The kind of attention provoked by still life isolates both painter and viewer from the rather hazy, rather lazy visual field the subject normally inhabits. This isolation runs counter to the actual scene which still life always centres on – food, and the table, with their inevitable associations with conviviality and hospitality. The whole thematic of the meal points in the direction of civil society, where the self re-experiences its grounding in the social field, together with others; at table the subject is re-embraced by human fellowship. Defamiliarising the table, whether through a surplus of appearances (Cotán, Zurbarán) or through a maximising of aesthetic distance (Cézanne) takes away the warmth of this solidarity and its embrace.

The quickened attention which rhopography brings to the familiar space of eating can end by creating a sense of estrangement from the social field in the very situation where people purposively come together. And still life's adjustments of the relative forces of defamiliarity and familiarity in the social field can become a matter of extraordinary delicacy. If the balance is right, a harmony can be created in which the still life supplies a mode of clarified vision, yet without disrupting the sense of membership in civil society, and the self is experienced in terms of fellowship but also of perceptual revelation. *Dessert with Wafers* by Lubin Baugin (c. 1611–1663) is able, perhaps, to build and show such harmony, together with all the tensions that produce it (illus. 31).[16] Pushed further and its incipient hyper-reality, the fastidiousness of its composition and its love of the immaculate, would cut the self off from the social field and its conviviality; raised to a pitch just a bit higher and the intensity of its perceptions would generate a manic glare, and disconnection between the self and the social world around it. Baugin resolves the tension by proposing a social field which, though welcoming, still insists on the formalities. A certain distance between individuals is proposed which respects the isolation

implied by the perceptual intensities, yet the distance is tempered by a sense of inclusion. The dessert is not primarily intended as nourishment, but as social pleasure – the wafers tilt out towards the viewer, as though inviting the viewer to take one and join in the hospitality. Baugin balances the solitude of perceptual illumination against personal interaction, and the painting implies a milieu careful to integrate aesthetic and social distance with social connectedness and pleasure. There is some measure of return to the ideas of the antique *xenia*, as described by Philostratus: an awareness of relations between guest and host, of food as a means of ensuring social interaction and circulation. This awareness includes recognition of the social distance between persons, of hospitality as an affair also of prestige and the display of refined taste, and of a tension between prestige and intimacy.

Because rhopography is committed to looking closely at what is usually disregarded, it can experience extraordinary difficulty in registering the everydayness of the everyday – what it is actually like to inhabit 'low-plane reality', without departing from that into a re-assertion of painting's own powers and ambitions, or into an overfocused and obsessional vision that ends by making everyday life seem unreal and hyper-real at the same time. The central issue is how to enter into the life of material

reality as a full participant, rather than as a voyeur, and how to defamiliarise the look of the everyday without precisely losing its qualities of the unexceptional and unassuming. It is here that one can place the significance of Chardin (1699–1779). Chardin's solution to the problem of defamiliarisation is to cultivate a studied informality of attention, which looks at nothing in particular. He shows no signs of wanting to tighten up the loose world of the interiors he presents. On the contrary, his own intervention is unassuming, and seems so ordinary as to *relax* rather than heighten attention. Often still life composition involves a staging of the scene before the viewer, a spectacular interval or proscenium frame between the scene and the spectator. We have seen the way in which Zurbarán places his objects along an exact geometric line, and the feeling of distance and of proscenic barrier this creates. In the Caravaggio *Basket of Fruit* the scene does not belong to the real world so much as to a space of (re)presentation, a space where *figuration is destined to appear*.[17] And in the Cézanne *Still Life with Apples* there is a radical departure from the ways in which everyday objects really appear on tables, in order to maximise the sense of aesthetic distance and to establish the mode of depiction, rather than what is depicted, as the painting's primary concern. Even with relatively unassuming still life paintings, such as the *Dessert with Wafers* by Baugin, when the painter has hit upon a satisfying arrangement of the elements on the table, three-quarters of the work of composition is already done: the placement of the wafers, for example, is calculated with immense and evident pains, and as with Zurbarán the least alteration of the motif would disturb the hair-fine symmetry and balance. But in Chardin, compositions of this self-conscious kind are avoided. He does not, of course, neglect the arrangement of the motif (quite the reverse), but he works hard to remove the feeling of a proscenic barrier or of spectacular distance between the viewer and what is seen. He seems to want not to disturb the world or to re-organise it before the spectator, as though to do so would be to keep the viewer at arm's length and to push the viewer out from the scene, when what is valued is exactly the way the scene welcomes the viewer in without ceremony, to take things just as they are found.[18]

For this reason his canvases tend to avoid priorities. Even blank background – which, for example, in Caravaggio is left uniform and eventless – is filled with incident, with mysterious

flickers and sparks of colour that can be as engaging to the eye as any of the presented objects. No single square inch of the painting has been declared unimportant, and the objects are not intrinsically more significant than the areas between them. This is an extraordinarily difficult technique, since it involves activating and energising areas of a scene which vision is normally quick to pass over, and what is impressive is that this investment in blank or empty areas of the canvas does not end by overcharging the scene with interest – the problem, again, of estrangement and alienation. The canvas is treated as uniformly eventful, as though to suggest otherwise would be to upset the evenness of regard (Chardin's, and then the viewer's) as it moves with equal interest and equal engagement across the entire visual field. Chardin undoes the hierarchy between zones of the canvas which the whole idea of composition traditionally aims for – the regulating and directing of the gaze from what in a painting is of primary to what is of secondary or tertiary importance. He gives everything the same degree of attention – or inattention; so that the details, as they merge, are striking only because of the gentle pressures bearing down on them from the rest of the painting.

For the same reason, all the forms tend towards blur – perhaps Chardin's most significant innovation, as though he were trying to paint peripheral rather then central vision, and in this way to suggest a familiarity with the objects in the visual field on such intimate and friendly terms that nothing any more needs to be vigilantly *watched*. In his fascinating essay on Chardin, Michael Baxandall has traced the influence of Lockeian ideas concerning perception, and of medical theories concerning the eye's angle of vision and focal length, as these gained popular currency in the eighteenth century and in Chardin's milieu.[19] Chardin takes from these sources the idea of making painting a record of the actual impression which sight might form of the objects before it, the adventures of the eye as it travels across the scene from perch to perch. In certain Chardin still lifes one sees that some points are in greater focus than others, as if what were depicted were the vagaries of the glance in 'real time'. In fact, modern research into the muscular movements of the eye has shown that the paths it follows is a tangle of lines, with many recursions and re-takes, guesses, revisions and apparently haphazard probings of the visual field; and probably a painting which took upon itself to portray the world as it appears to

the 'saccadic' leaps of the eye would look nothing like Chardin. But Chardin's fiction of how the eye moves from one point to another (never more than few points emerging as 'focused') is convincing enough, and it conveys the idea of vision moving in unhurried fashion over a familiar scene; not tensely vigilant (Cotán, Zurbarán, Caravaggio) but with a sense of having enough time to take the scene in without strain. It is hard to find before Chardin convincing evidence in painting of this strategy of portraying vision in time, as a narrative, and the presence of narrative should bring his work into the category of anecdotal or history painting – megalography. But in these narratives which tell only of brief journeys across a corner of everyday life, nothing significant happens: there is no transfiguration or epiphany, no sudden disclosure of transcendence. The eye moved lightly and without avidity: it is at home.

What secures the ease of the eye's movements, and its licence to blur the scene before it, is Chardin's acute understanding of the nature of tactile space. The objects in *The Smoker's Case*, for example, have been placed so as to suggest an informality largely unconscious of appearances (illus. 23). What binds the space is gesture, the habitual movements of taking a lid from a cup and laying it down – exactly where is not an issue – and of lifting and pouring from the pitcher. The long-stemmed pipe is one of those forms which divide smokers from non-smokers: to those who only look at its shape, it seems bizarre, but held in an accustomed hand it directs a whole repertory of satisfying gestures, actions of filling and stoking, rebalancings of its weight, minor adjustment and flourishes. In the puppet theatre of Japan, the pipe and its box are conspicuous stage properties because they permit the manipulator such an expressive range of movements, movements all the more revealing of a figure's character because largely below the threshold of awareness; the props can be useful in comedy because of the automatism of such gestures, their demonstration (not least to non-smokers) of enslavement to habit. In *A Basket of Plums* (illus. 32) the fruit have been placed with no particular sense of their final form, which seems to have emerged unplanned. Where the lemons in Zurbarán's still life are laid on the dish with every attention to angle, projection and profile, here the form is in a sense ludicrous, or rustic; the hand has simply dropped the fruit where they fall, with the same partial inattention as in reaching for a glass it knows is there. The blur in Chardin is not simply optical,

though theories of focal length and aperture may well have influenced it; it is the blur that comes from manual override, when the hand takes over from the eye and lets it off duty.

Objects are arranged informally: they can be crammed together or moved about as required. Chardin allows a certain casualness of inattention to loosen his paintings and give them air. Tasks are not rushed: they succeed one another in a gentle rhythm of co-operation between hand and eye, in a low-plane reality of quiet duties and small satisfactions. And interpenetrating the tactile space inside the painting is the tactility of the painting itself. In his lifetime Chardin shrouded his technical procedures in secrecy – there is no record of anyone having seen him at work, and it was rumoured that he applied the pigment with his fingers. Which may well be true: paint in Chardin is trowelled and stroked, it mimics the texture of terra-cotta or of glaze, it dribbles; its texture is buttery, or like cream cheese, it is an almost comestible substance which everywhere announces that it has been *worked*.[20] Inside the painting, one sees objects which are constantly being touched: polished metal,

32 Jean-Baptiste-Siméon Chardin, *A Basket of Plums*. The Chrysler Museum, Norfolk, Virginia.

familiar plates and cups, linen freshly pressed and tables swept and cleaned. The space is built from routines that are efficient, though not to a point of strain; between people and things a placid harmony reigns. And the worked surface of the canvas suggests a continuation of that internal harmony out into the space of the painter, and of the viewer. Chardin does not work erratically or by inspiration; the level of his output is unerringly even, and even though he has the reputation of raising French still life by sheer force of technique to the heights reserved for history painting, there is little in his work that suggests megalographic ambition. Instead of using still life to bring out a brilliance and focus which painting, with its superior mode of vision, can see in things that normal perception overlooks, Chardin deliberately returns pictorial vision to the ordinary facts of looking. As he does so, he presents his work as unassuming craft or *métier*, its skills visible in every area of the canvas, but not displayed at the expense of his subject-matter. On the contrary, the casualness of the Chardin interior, its modesty and sense of ease, are qualities which he maintains in the way he presents his own activity. He seems to paint in his own house, not in a studio, and his work is part of the house, taking its rhythms from the domestic space around it.

In the work of Chardin, rhopography directly enters into the material world. Its wish is to participate in low-plane reality, not to purify it or render it spectacular. It accepts the material fate of living in a creaturely universe, subject to limitation and routine; there is no protest against that, only against modes of painting that seek to break out of creaturely limitation into more exalted forms of art and perception. The degree of its immersion in materiality can be measured in the way it accepts vision anatomically, as a matter of the eye's apparatus, its muscles and lens. Chardin's work assumes that the way the eye naturally sees its world needs no reproof or enhancement, and in this its feeling for human equality is evident as much in the way sight is presented, as in the themes of human fellowship and interaction which still life is able to express through the symbols of food. But even Chardin is caught in a field of power and class that considerably complicates rhopography's vision of equality. Which brings us to the problem of display.

3 Abundance

In the industrialised countries we are used to overproduction. We have made societies of abundance since at least the time of the Industrial Revolution. So many generations have passed in which conditions of oversupply have prevailed that it requires a certain cultural dislocation to think back to the period when overabundance was something historically new − or to think outwards towards the non-industrialised or semi-industrialised countries of the Third World today. Perhaps one can draw a distinction between abundance before and after industrialisation. In pre- or proto-industrial societies, luxury is inseparable from ideas of prodigality and waste. For as long as societies and economies are inexorably limited in their growth, bound to agrarian cycles of famine and plenty, and incapable of generating the surplus necessary to finance the development of industry, the deflection of surplus wealth into luxury and display represents an authentic destruction of goods, a sheer squandering of resources whose bounds cannot be increased.[1] In Europe, the luxury of the *ancien régime* is the brilliant, irrational and anti-economic burn-up of a surplus that cannot and will not grow. As a result, the *ancien régime*'s understanding of luxury is bound up with a discourse that measures sufficiency and insufficiency by a standard of ethics. Bernard de Mandeville's insight, in *The Fable of the Bees* (1714), into the economic and social usefulness of luxury ('Private Vices, Publick Benefits') represented, in the *ancien régime*, a dangerous and perverse point of view, one that deeply shocked Mandeville's contemporaries. But with industrialisation the old discourse of ethics, which measures wealth according to moral conduct, is obliged to co-exist alongside a newer perception which substitutes for the term 'luxury' the term 'affluence'. 'Luxury' can never shed its ties to its medieval past, to the idea of psychomache, the battle of the soul against the deadly sins, *luxuria, superbia, vanagloria, voluptas, cupiditas*. 'Affluence' is neutral on this subject : it transfers the phenomenon of surplus wealth from ethics to aesthetics. Affluence assumes that expenditure is not a matter of morals but of style. It pro-

poses that for individuals, and for society at large, the utilisation of wealth in the pursuit of pleasure works to the economic good of all. The problem posed by wealth is now that of finding the best – which is to say at the same time the most pleasurable and the most profitable – paths and patterns of expenditure. One can think of nineteenth-century Paris as an enormous social machine, whose goal is to recycle surplus wealth back into the economy through a manipulation of desire that knows no obstruction from moral categories: the new architecture of pleasure, the boulevards and arcades, the department stores and the Universal Exposition, the new spaces of entertainment, the cafés and the race-tracks and the theatres, all these instruments of affluence have as their aim the harnessing of pleasure to consumption, conceived now as an integral and indispensable part of the general economy.

Industrialisation makes it impossible any longer to distinguish with certainty between luxury and necessity, and the old polarity of dearth and surfeit dissolves. Aesthetic culture, which now takes up the slack from ethical culture, resolves the problem of overproduction by indicating general models for managing the superabundance of goods. Such models exist at all social levels, and are subject to radical change. With the Victorians, for example, the interior of the house consists of rooms crammed with objects, the space divided and subdivided so as to multiply the available places for the display of innumerable worldly goods; walls are given elaborately detailed mouldings and covered with densely patterned wallpaper, for individual objects complex frames and casings are found, in a general *horror vacui* which copes with the problem of overproduction by absorbing it into the household, or by allowing the house to be absorbed by commodities and their profusion. The modernist house opts for the opposite solution: instead of space subdivided to make endless local niches for the display of possessions, the barriers between compartments of space are thrown down and space re-unifies in an open plan bounded by white and empty walls; the modernist interior resolves the problem of overproduction by carving out from the general profusion a secluded emptiness that marks an escape from the teeming and seething pool of commodities. The visibility of goods becomes an embarrassment and must be screened, making of culinary space, for example, a vacant stage surrounded by concealing doors; those few possessions which are displayed are chosen to make the surrounding

33 Giorgio
Morandi, *Still Life
with Bottles and
Vases*. Museum
Boymans-van
Beuningen,
Rotterdam.

space vibrate with its own emptiness.[2] Modernist still life knows
this space well: the work of Morandi (1890–1964) is made up
of such vibrations in vacancy, of 'seeing solid in void and void
in solid', and of interresonating intervals eventually so fine that
it takes a lengthy viewing to analyse their discriminations (illus.
33).

The first European society to experience the problem of mass-
ive oversupply is that of the Netherlands, in the period of its
ascendancy from 1608 (when the Netherlands broke from
Spanish rule) until the late 1660s, when the commercial edge
began to be lost to rival powers, Britain in particular.[3] During
this period the Netherlands became the richest nation the
Western world had yet seen. Its economy was still pre-industrial,
a primarily commercial empire deriving its immense wealth from
trade, its near-monopoly on European shipping, its colonial pos-
sessions in the East and West Indies, the success of its banks
and stock exchange in Amsterdam, and the energy of its small
population. As a pre-industrial nation, the Dutch did not yet
possess the full machinery for integrating consumption into the
general economy, as would become standard with the Industrial
Revolution. But equally they lacked the mechanisms for the
absorption of surplus wealth possessed by other societies, both
inside and outside Europe. For one thing, the Netherlands pos-
sessed no established traditions of court life, of the type that
would make Versailles such a major channel for the surplus

wealth of France, or which in contemporary Japan kept half the population of Edo working to supply the needs of the Japanese nobility.[4] The Netherlands was no less lacking in the traditions of civic munificence that made brilliant the Italian city-states: the outlay on its town halls and municipal offices is meagre by Florentine or Venetian standards. And the Reformation had ended the power of the Church to divert national wealth into its own coffers and its own programmes of artistic patronage. As Simon Schama has shown in his remarkable work on the Netherlands in the seventeenth century, Dutch society was in the curious position of having acquired an immense surplus of national wealth, but with few cultural traditons that permitted its expenditure.[5] Those traditions concerning the uses of surplus wealth which it did possess dated from its immediate past, the ancient discourses on wealth which interpreted riches through the categories of morality; perhaps it is the absence of alternatives that accounts for the persistence and centrality of the ethical discourse on wealth through to the close of the period of Dutch economic ascendancy, and not least in painting.

The outlines of this traditional interpretation are starkly evident in a work by Pieter Brueghel the Elder (c. 1525–1569), *The Battle between Carnival and Lent* (1559; illus. 34). The agricultural cycle has not yet developed to the point where it generates a permanent, year-round surplus: its rhythm is seasonal, and the difference between seasons of shortage and of plenty can be managed locally. The population can cope with both deprivation and excess by regulating its communal expenditure; the solution to the seasonal fluctuation of resources is social observation of the calendar. Feast days of Rabelaisian indulgence, followed by grey periods of abstinence, can mop up the brief surplus and stretch things over the lean times. On the cart supporting the figure of Lent are pretzels and a few dry loaves of bread; Lent's jousting spear is a griddle plate decked with two miserable-looking herring. Opposite Lent, astride his cask, sits Carnival, armed with a roasting skewer and crowned with a pie, while behind him a woman sits furiously making pancakes. The 'battle' between them is simply the moment of Mardi Gras when Carnival has its brief reign, after which the rigours of Lent take over.[6] The year is regulated by a cycle of indulgence and rationing which ensures that the earth's fruits are evenly spread, whether trowelling piles of food onto the groaning boards or eking out a meal of herring and bread.

One can see why the ethical approach to the phenomena of need and abundance could be so persuasive in this agrarian world: the margins between too little and too much are sufficiently slight for a single term to be enough to even them out: appetite. The welfare of the society depends on its capacity to submit to a general morality of consumption and abstinence. And it is evidently a communal ethic rather than a private one. When abundance comes, it is that of the land, for the people who live from the land; a banquet of the world, rather than the affluence of private tables.[7] Much of the complexity in Dutch still life will come from the collision between this traditional and community-based ethic, revolving round shared wealth and poverty, and the private ethic of the individual owner of property.

But the moral perception present in Brueghel's image goes rather deeper than the primary issue, the battle between austerity and greed. It would be interesting to know how the peasantry depicted in the battle might have responded to their representation by Brueghel, yet the painting is hardly destined for the houses of the figures it shows, but for a superior class; and what remains uncertain (richly so) is the implied attitude of that 'higher' class towards the peasants themselves. Affection, or con-

34 Pieter Brueghel the Elder, *The Battle between Carnival and Lent*. Kunsthistorisches Museum, Vienna.

tempt? There are traces of both. Brueghel presents his figures as a kind of botched humanity, close to a par with the animal life that lives so close by; deformed, unlovely in its every movement, ruled by its appetites, incapable of aspiration or achievement. It is humanity seen through the eyes of class condescension and even class hatred. At the same time, however, there is the possibility that this life of appetite and creaturely dependence may be presented in the image as a universal state, one which as much concerns the superior viewing class as it does its peasant figures; there is intimation that at a certain level of existence, namely that of hunger and food, all people are equally comic and degraded.[8] In the caricature of this pre-humanity there is a truth which cannot be eradicated from any class, however much it refines its table and complicates its aesthetic culture, that creatureliness is not a voluntary condition. All of Brueghel's signs of class condescension and antipathy are replayed here in another key: the more the figures are presented as an alien class, far below on the chain of social being, the greater the shock of recognising in them the lineaments of a common humanity – and the greater the need for administering that shock. Brueghel reverses the direction of Italian painting, with its urge to make the human image sublime; there is deliberate counter-sublimation, a plunging of vision downwards towards an image of humanity that insults grandeur and erases distinction.

Wealth separates humanity into classes, and among other things Brueghel's painting is an exact record of class division: the superior viewing-class peers down through the painting at the diminutive insect life of the peasantry far below. They are ridiculous, but happy; there is even a sense of bucolic charm in their gross communal life. Since theirs is in any event a robust, Netherlandish culture, the spirit of patriotism can turn a blind eye to its weakness – and solidarity with the lower ranks will be necessary when it comes to dislodging the rule of Spain.[9] Brueghel's image does everything that might flatter a governing class into conviction of its own superiority and right to oversee a population which, though absurd and unruly, at least presents no threat to its own existence. But at the same time Brueghel sufficiently enters into the authentic spirit of carnival, which for its brief duration erases social distinction and abolishes social hierarchy, that from the picture of class division and rank there emerges another picture, of the downward levelling of human-

ity, and its equality in the face of need. This is the subtlety and inclusiveness of vision in the *Battle*, and of the traditional discourse on wealth that comes to Dutch painting from its immediate past. It recognises and affirms both social impulses: a worldly acknowledgement of class separation co-exists with a creatureliness that turns onto class aspiration and class difference a mocking laughter of the earth. It was hardly possible for such traditional wisdom, rooted in the long historical experience of agrarian conditions, to survive the massive accumulation of capital that took place in the Netherlands in the seventeenth century. Its conception of human need and appetite is too rooted in the seasonal cycles of shortage and surplus to survive into an economy where surplus makes the quantum leap into permanent affluence and plenty. Nevertheless, in a culture singularly lacking in developed institutions of luxury the ethical discourse on wealth enjoyed a long after-life, into conditions remote from its origins and in a sense hostile to its survival.

35 Pieter de Hooch, *Interior*. National Gallery, London.

For the mounting tide of capital, the Netherlands could provide only one major outlet: domestic space. And the transformations of the Dutch interior in this period are nothing short of spectacular. Abroad, the stereotype of the Dutch was 'frugal to an eggshell': Josiah Child referred to 'their parsimonious and thrifty living which is so extraordinary that a merchant of one hundred thousand pounds estate will scarce spend so much per annum as one of fifteen hundred pounds estate in London.'[10] But according to Mandeville, who knew them better, the Dutch

> are extravagant to folly. In other countries you may meet with stately courts and palaces, which nobody can expect in a commonwealth where so much equality is observed as there is in Holland; but in all Europe you shall find no private buildings so sumptuously magnificent as a great many of the merchants' and other gentlemen's houses are in Amsterdam, and in some of the great cities of that small province, and in the generality of those that build there, lay out a greater proportion of their estates on the houses they dwell in than any people upon the earth.[11]

In paintings of the 1650s by Pieter de Hooch (1629–1684) one still sees the traces of abstemious living: simple tiles,

whitewashed walls, few objects on display; clothes are modest, and personal accessories unobtrusive (illus. 35). In de Hooch's *The Card Players*, from the 1670s (illus. 36), the floor is no longer made of tiles but of marble inlay; whitewashed walls have given way to gold Spanish leather. The rug draped over the table is a costly Near Eastern import; the fireplace is flanked with full-length marble columns, and the woman next to it wears a brilliant costume in the new French style, complete with pearl earrings and elaborate coiffure.[12]

Dutch still life painting is a dialogue between this newly affluent society and its material possessions. It involves the reflection of wealth back to the society which produced it, a reflection that entails the expression of how the phenomenon of plenty is to be viewed and understood. Perhaps one may begin with a fairly simple case, that of flower painting. What is immediately striking in the *Bouquet in a Niche* by Ambrosius Boschaert (1573–1621; illus. 49) is that while there is a sense of abundance – the vase could scarcely hold one stem more – the abundance is, surprisingly, not that of nature. There is a notable absence, here and throughout the tradition of Dutch flower painting, of flowers that are *wild*.[13] When wild flowers are cut and taken indoors, one of the cultural meanings of the bouquet can concern the generosity of nature in general, and the particular form which that generosity takes at certain times of the year and in certain places. In the garden paintings at Pompeii, for example, one sees represented on the walls exactly the flowers and trees which one would find in the same landscape today: oleander, lemon, olive, salvia.[14] The result is an essentially pastoral view of nature and of man's place within nature: as in the *Xenia* I of Philostratus, it is a question of gathering the plenty which nature produces by itself, of gratefully garnering what is already provided – the honey, figs and grapes which require no cultural work or supervison. Dutch flower paintings are non-pastoral and even anti-pastoral in that the flowers chosen for depiction are those which require for their existence a high level of horticultural sophistication. They are not pastoral but georgic: it is all work. The paintings do not lead the mind to associations with a particular season: on the contrary, they conspicuously yoke together varieties that flourish at different times of year. The painters are closely dependent on their contacts in the great botanical centres, and it is from the gardeners that the painters learn when a particular flower is about to bloom,

and worth studying and sketching. The final painting is a gathering together of often many separate studies, a miscellany that could never exist or have existed in nature. One detects here a certain refusal of natural time and of seasonality that cuts the paintings off from a whole potential lyric register. All the flowers in the Boschaert exist at precisely the same moment in their life-cycle, when their bloom becomes perfect. The simultaneous perfection of so many flowers from different seasons banishes the dimension of time and breaks the bond between man and the cycles of nature. Which is exactly the point: what is being explored is the power of technique (first of horticulture, then of painting) to outstrip the limitations of the natural world.

Boschaert's bouquet is equally opposed to the idea of the *locus amoenus*, the place on earth which climate, or the gods, particularly favour: no Arcadia or Vale of Tempe will be found. One difference between the medieval herbals and the compendia of botanists such as Clusius or Johan van Hoogelande is that while the plants of the herbalists remain within the orbit of the cloister, the plants of the Dutch botanists are drawn from a vast colonial network: the tulip, new star of the Dutch gardens, is only the latest arrival, from Turkey.[15] Though one still sees the medieval flowers, iris, lily and rose, the flowers of Mary and of the Annunciation,[16] these now have to make room for the exotics – dahlias from Mexico, fritillaries from Persia. The space of the vase draws on enormous distances; the idea of a particular place, and of man as limited by space, is negated. When combined with the feeling of seasonality, the feeling of locality points to human frailty, and the boundaries of space and time that frame human life; increasing the viewer's awareness of that frame of limitation can constitute a whole didactic dimension of flower arrangement, as it does in Japanese *ikebana*. Conversely, when the framework of space and time is effectively neutralised, there is an elevation of human powers over creatural limitation: in the paintings of de Gheyn and Boschaert lurks a certain Faustian ambition. Between the bouquet and the landscape behind it, no connection can be discovered (illus. 49); what the landscape provides instead is exactly the idea of a space that is expansive and limitless, yet can be mastered by a prospect; and the further idea of a sudden leap from far to near. The space is centripetal: the flowers fly to this vase from many lands. And it is distilled: all the greater spaces are concentrated in this one, sovereign space. This is one of the meanings of the shells perched on the

ledge of the niche: the smaller shell is *nerita versicolor* (from the West Indies), and the larger one *murex endivia* (from the East Indies).[17] The shells compress into their narrow ledge the space of two continents, and the oceanic distances between them. And so we do not fail to grasp the point, Boschaert is careful to juxtapose the profile of the shell on the right against the distant vista beyond it: what is vast (promontory, archipelago) is miniaturised and dwarfed by what is small, in a play of interruptions of scale and space that ends in complete dis-location, the abolition of place.

No less striking than the ban on wild flowers is the convention whereby flowers tend not to be repeated. This is not an absolute rule, and it can be broken, for example, in order to highlight certain variations within a single strain, or to demonstrate the way in which the petals of a particular flower open out, or to show the same flower in different profiles. But certainly in comparison with our own conception of flower arrangement, there is a resolute avoidance of mass: accumulations of the same variety hold no interest. Again, this qualifies the impression of abundance one may initially receive. What engages the eye is the difference *between* flowers, at the levels of their architecture and colour strains; what is sought is not abundance but the Specimen, viewed through the lens of scientific naturalism. Although the complex botanical descriptions of Linnaeus lie a century ahead, already the flowers are subject to investigation by taxonomic intelligence, attuned to the construction of the flower's identity through its differences from other specimens. The repetition of flowers would be redundant here, representing as it would no positive increase in information. Of particular interest are the differences that can be produced by cultivation within the same botanical family, and flower paintings are magnetically drawn to strains that can be persuaded to produce unpredictable variations (in certain cases, Dutch flower paintings are literally botanical portraits of the rare varieties achieved through forcing).[18] Which explains something of the curiously flattened space that prevails, especially in the first decades of the seventeenth century. It is a space of diagrammatic clarity, of *tabulation*. This is the reason why flowers, shells and specimens of insect or saurian life enter into the same scene (with, to our eyes, such surreal results). All are subject of the labour of classification, in an era of natural history when taxonomy is the dominant mode of producing scientific knowledge.[19] This is not,

37 Rachel Ruysch,
Flower Still Life.
Toledo Museum of
Art, Ohio.

of course, to deny the persistence in Dutch flower paintings of the Renaissance mode which sees in such things as butterflies and dragonflies emblems of human ephemerality – or sees in the common housefly, making its way across the ledge in Boschaert's painting, a reminder of the corruption that mortal flesh is heir to. As the work of Foucault emphasises, several modes of knowledge production can co-exist in a single era (and a single work). But Dutch flower painting takes its place in the same theoretical space which also produced the *Kunst- und Wunderkammern*, the first museums, those cabinets of natural curiosities whose function was to produce knowledge by arraying objects in a taxonomic or diagrammatic space designed to reveal variation against the background of underlying structure and type.[20] For seventeenth-century Dutch collectors –

bourgeois descendants of the manic imperial collectors at the courts of Vienna and Prague[21] — shells, scientific curiosities and paintings all inhabit the same tabular and panoptic space (in which, one day, an art history will develop).[22]

Finally, flower paintings exist in economic space, or rather they inhabit several economic spaces at once. The first of these is the botanical garden, the paintings' immediate source. Originally developed through the patronage of the European courts, botanical gardens took a long time to lose their association with royal and state largesse (still alive, for instance, at Kew or the Chelsea Flower Show). The construction of such gardens was an undertaking so colossal that only a prince or the state could find the resources to fund it, and what such patronage brought with it was a symbolic association between horticulture and political power that conferred on Dutch flower painting a high value of social prestige (and the supporters of the earliest flower painters were decidedly more courtly than bourgeois).[23] The second economic space is that of speculation — of the connection between flowers and actual cash, as opposed to their value as 'symbolic capital'. Much has been written on the subject of the great tulip mania which gripped the Netherlands in the 1620s, and the story will not be rehearsed here.[24] But the taste for flower painting is closely involved with the market's focus on rarities, and what the market valued, the painters also pursued — flamboyance and complexity of colour, irregular stripes and markings, flowers with a high rate of variation: tulips, hyacinths, roses, carnations. Unlike, for example, Spanish still life, Dutch still life tends to see in the objects depicted a source of value for the painting itself, and the value of the one passes into the other; in the case of flowers, and tulips above all, one is not dealing with indifferent or value-free subject-matter, but precious items which, at the height of the tulip and hyacinth manias, were changing hands for very serious money indeed. The third economic space is that of painting itself. Flower painting is labour-intensive to a degree that exceeds other still life genres: short-cuts are technically impossible.[25] As a result, it can flourish only when the demand for painting is sufficiently buoyant to permit the necessary and considerable outlay for the painter's labour.[26] What the paintings therefore display, at a level distinct from their content, is the sheer skill and effort of their production, and the economic value and investment which this represents. This could be considerable, especially with the first generation

of flower painters, who necessarily looked to the nobility as the only class able to afford their work. For a picture by Boschaert that displayed no less than seventy different types of flower, the Cupbearer to the King was prepared, in 1611, to part with 1000 guilders – a small fortune at the time.[27]

The flower pictures reveal a good deal about the ways in which the Dutch viewed and understood the affluence their culture was able to produce. The feeling is evident that not much is owed to nature. At Pompeii there exists a small wall painting ('Flora') of a woman seen from behind, walking with a basket of flowers; it is an image that implies relaxation, and a harmony between natural and human beauty – nothing could be further from the Dutch flower pictures. The motif of the basket, with its suggestion of flow between nature and the domestic interior, is comparatively rare; and one notes, too, the names that the tulip-growers gave to their most prized varieties, Semper Augustus, Viceroys, Admirals, Generals – as though the flowers embodied some ideal of male power.[28] Even the shells take on the connotation of craft, existing as they appeared to do on the borderline between nature and art, as a form of 'natural artifice': the shells have the look of having been crafted by man, and as such are valued.[29] Everything we see in Boschaert and

38 Balthasar van der Ast, *Still Life with Shells*. Museum Boymans-van Beuningen, Rotterdam.

de Gheyn comes from labour, nothing is accepted as a gift of nature. The labour of horticulture, the forcing of varieties, and then the long hours of the painter's craftsmanship – it is as if the value of the flowers were created by human effort alone. Production, production! Of new flowers, of knowledge, where nature is commodified by market forces, along with human work. In a sense the paintings are the height of luxury and break all ties with utility: what could be more useless than flowers, or flower paintings? Yet there is no shortage of good reasons for the paintings' existence: the intrinsic value of the depicted objects, their worth as scientific specimens, the value of the painter's labour, the canvas as a sound financial investment. The paintings build a strong case for themselves without once having to invoke visual pleasure. Pleasure is disavowed, hidden by production; what replaces it is strain, effort and the work imperative.

The strain is greatest in the place where the opportunities for pleasure are concentrated, in the prime locus of affluence, the interior of the house. In the seventeenth century the market in luxury goods appears to have been more highly developed in the Netherlands than in any other European country. The shops in Amsterdam were stuffed with Persian rugs, Chinese porcelain, Japanese lacquer, Venetian glass, Spanish taffeta, Italian maiolica. Fokkens's guide to Amsterdam, a sort of shopper's handbook, positively salivates on reaching the Herengracht:

> Within, the houses are full of priceless ornaments so that they seem more like royal palaces than the houses of merchants, many of them with splendid marble and alabaster columns, floors inlaid with gold, and the rooms hung with valuable tapestries or gold- and silver-stamped leather worth many thousands of guilders . . . You will also find in these houses valuable household furnishings like paintings and oriental ornaments and decorations so that the value of all these things is truly inestimable – but perhaps fifty or even a hundred thousand.[30]

The household in *The Concert* by Jan Vermeer (1632–75; illus. 39) does not give much impression of squeamishness concerning consumption: in the room before us are assembled finely-crafted chairs, a harpsichord painted on the underside of the lid, two impressive-looking paintings, a rare Turkey rug; the floor is tiled with marble, and the women are wearing the ruinously expen-

sive costumes of the 1660s.[31] Yet what is evident in Vermeer's picture is the emphasis on absolute domestic order, the internal harmony of the household which is expressed in its music-making; it is as though the affluence of the house could be justified only if domestic virtue kept strict pace with prosperity. All surfaces emit signs of vigilant attention – the gleaming picture frames and the polished wood of the cello, the immaculate clothing, the floor scrubbed and pristine (foreign visitors were surprised to find that on entering Dutch houses they were obliged to change their shoes for slippers). Time is used well, making music, and behind the music lies the background of household routines managed to efficiency and over-efficiency: the well-ordered Dutch home is a place of constant monitoring and ablution, as though the least negligence of domestic chores were a mark of moral pollution. However they may have functioned in practice, in visual representation the interiors of houses are

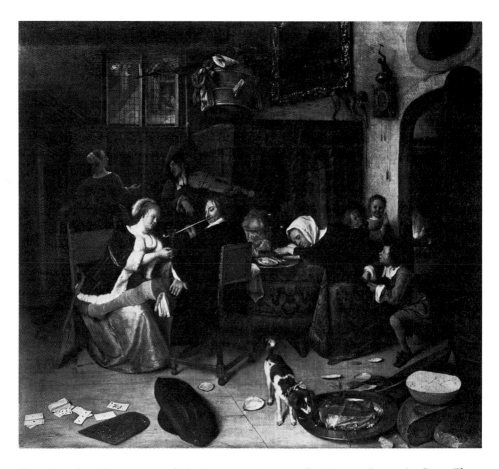

thought of as the crossroads between extremes of virtue and depravity. Vermeer shows the dream of order, Jan Steen (1626–1679) the nightmare of the household totally gone to pot (illus. 40).[32] The place is in an uproar. The mother, guardian of household purity, slumps in a torpor before a plate of sinful oysters whose shells litter the floor. The paterfamilias has given himself over to the devil's weed and the attentions of a guitar-playing hussy. The eldest child filches his mother's purse and his younger siblings gleefully count the coins. Matter is radically out of place, with cheeses and platters strewing the floor, along with fallen playing-cards and the father's discarded hat. Overhead hangs not a chandelier but a tub of dirty linen, ready to crash. And it is only five in the afternoon!

Still life of the table is structured around the same anxious polarity, with vice and pleasure beckoning at one end, virtue and abstention admonishing at the other. As represented by

40 Jan Steen, *The Disorderly Household*. Apsley House, London.

112

Pieter Claesz. (1597/8–1661) in *Still Life with Stoneware Jug, Wine Glass, Herring and Bread* (illus. 50) the meal is a grave and silent affair.[33] Its elements are of the simplest – a roll or a loaf of bread, herring, a *roemer* of wine, a tankard of ale. The pewter plates are unostentatious, and the outlay for the whole meal is modest. It is consumed alone. Though austere, the meal knows something of the pleasures of the table, the feel of a crisp crust of bread, the oily tang of the fish, the refreshing coolness and brilliance of the wine. As with Chardin, staged-looking composition is avoided, and although the design is tightly unified it appears informal and unaware of the viewer's presence: the fiction is maintained that the place of eating and the place of viewing are one and the same, and through that fiction comes the idea that at this level of simplicity persons are interchangeable, and equal. As the viewer joins this space, solitude becomes intimacy; and Claesz. is close, however changed the circumstances, to Brueghel's perception of creatureliness as a benign levelling of human life, one which generates empathy and the recognition of mutual dependencey and solidarity.

Though idyllic, Claesz.' sombre still lifes reveal a certain anxiety concerning material consumption in the equation they suggest between virtue and modesty of means. It is as if the intimacy proposed by the painting depends on wealth being absent, and as if the atmosphere of consecrated calm can be sustained only amid conditions of bare sufficiency. The implication is that any excess beyond the basic thresholds of need, any swerving at the table towards display or indulgence, would disrupt harmonies that may be elicited only from simple things. In a sense the harmony requires a certain degree of *forcing*, and this is very clear in Claesz.' use of 'monochrome' technique. In fact the objects chosen for the still life in themselves have a broad tonal range, from the white of the linen to the black handle of the knife, and they also have a wide chromatic spread; but Claesz. deliberately evens out tonality and expands the middle range of greys, while at the same time filtering all colours through a distinctive brown-green. The natural tones and colours of the objects are keyed to the translucent bottle green of a glass beaker or *roemer*. A certain measure of forcing is also evident in Claesz.' mode of composition. In the early decades of the seventeenth century Dutch still life had been painstakingly transcriptive, and high prices reflected the many hours needed to produce the high finish of a de Gheyn or a Boschaert. But

as the demand for paintings grows and the market's capacity to absorb more works increases, a new style emerges, one less committed to the visible labour of transcription, a style that is broader, more painterly, and above all, more quickly produced.[34] Claesz.' work pioneers this new style, which abandons high-fidelity transcription of the outer world in favour of a new goal, unity of the design. Objects in the image are related to each other through rhythms arising within the four sides of the frame (one has no sense of arbitrary cropping); harmonies of tone, colour and composition build an order internal to the work that makes the earlier still life images seem in comparison naive and lacking in syntax. Claesz. produces immensely satisfying designs, where the relations between the elements of a still life are so finely planned that − despite the air of informality − the least alteration would break the rhythm of the whole. This is the kind of formal achievement which might be unimportant in itself, were it not for the seriousness and gravity which the monochrome technique is thus able to impart to its subject. The design's unity, the weight of its masses and the added significance which the rhythm confers on each element, affect the still life's meaning: though entirely un-spectacular and lacking in

41 Pieter Boel and Jacob Jordaens, *Vanitas*. Musées Royaux des Beaux Arts, Brussels.

intrinsic worth, the meal has nobility, the nobility of ordinary things.

The virtues of bare sufficiency: Claesz.' paintings insist on them, even at the cost of somewhat forcing the image into the mould of noble calm. They occupy the admonitory or censorious end of the Dutch still life spectrum, and represent at any rate one solution to the problem of affluence: absolute refusal of material excess. As sermons on the rejection of worldly seduction they may seem at first sight rather more successful than the branch of still life painting to which this task is officially entrusted, the category known as *vanitas* (illus. 41, 42).[35] There is no doubt that *vanitas* pictures can be dazzling pieces of design – but that is precisely part of the difficulty. As rhetorical injunctions to resist the temptations of material pleasure, the *vanitas* can seem to modern eyes to be flawed by a serious, perhaps fatal, contradiction. It is one thing to hear from the pulpit, or read in scripture or in Calvinist commentary that, vanity of vanities, all is vanity, that man born of woman endures but for a moment ('He is like the beasts that perish'), that his flesh is as grass ('as a flower of the field, so he flourisheth'), that his days are consumed like smoke, and so forth. It is quite another thing

to encounter the same sentiments in the form of a work of art. In Calvin's commentary on Isaiah the luxury of households is a primary target, and specifically those merchants' houses where pictures hang on the walls:

> For it too often happens that riches bring self-indulgence, and superfluity of pleasure produces flabbiness as we can see in wealthy regions and cities where there are merchants. Now those who sail to distant places are no longer content with home comforts but bring back with them unknown luxuries. Therefore because wealth is generally the mother of extravagance, the prophet mentions here expensive household furnishings, by which he means the Jews brought God's judgment by the lavish way they decorated their houses. For with *pictures* he includes expensive tapestries like Phrygian embroidery and vases moulded with exquisite art.[36]

However much *vanitas* pieces may try to deny it, they cannot escape being pictures, that is, indulgences. There is no argument from need that can possibly justify the decoration of houses with framed paintings, however cheap they might be (and some *vanitas* pictures could be costly in the extreme). Certainly there might be justification as investment, and one reason Dutch painting flourished so dramatically in its economic golden age was that to their purchasers pictures represented a kind of gilt-edged security. But the argument from investment is obviously incompatible with the message of the *vanitas*, which is world-rejection. And in other circumstances, pictures can be justified as visual pleasure – but that can hardly apply in this case. Presented in less absolute terms, the message of world-rejection might have been able to find a way to co-exist with a certain measure of indulgence; for example, if the rejection were partial, or along the lines of 'Render unto Caesar . . .'. But the *vanitas* speaks of a *total* refusal of the conditions of earthly life. And how otherwise can it be taken? Its exhortation permits of no degrees. Either one rejects the world or one does not. And decorating the house with framed pictures suggests one is not even going to try.

It would seem, then, that the *vanitas* is a category of image permanently undermined by internal contradiction; noticing the contradiction, the modern viewer may prefer the sombre breakfast-pieces of Claesz., as rhetorically more persuasive. Yet it is exactly at this point that one needs to recover a sense of the cultural remoteness of the *vanitas* from the modern viewer;

the interest of *vanitas* pieces may in fact lie in their fully self-conscious acceptance of their 'internal flaw'. The genre changes at once if we begin with the hypothesis that the *vanitas* is *deliberately* built on paradox, and that the conflict between world-rejection and worldly ensnarement is in fact its governing principle.

Here we need to touch on the prehistory of the *vanitas*, and the radical changes brought about by the Reformation in the relations between images, texts and devotional experience. One index of the divergence between Catholic and Reformation visual régimes is the stark opposition evident, for example, in discussions of devotional visualisation by Ignatius and by Calvin. For Ignatius, the image is the crucial instrument for galvanising the soul's force: the *Spiritual Exercises* have as their aim the slow building up of images that will focus subjectivity entirely. Contemplating the Crucifixion, this is how the exercisant is to proceed:

> *Application of the hearing.* Listen to the discourse of the people; the blasphemies of the soldiers; the words of the bad thief who insults Jesus Christ, and those of the good thief who acknowledges Him as God; the interior words of Mary, of the holy women, of St John; the seven words of Jesus Christ.
>
> *Application of the taste.* Taste the bitterness of the heart of Mary at the sight of her Son nailed to the cross, and dying in the most cruel and ignominious tortures. Taste, above all, the bitterness of the heart of Jesus, suffering at once from His own sorrows and those of His Mother, and from the rigour of His Father who seems to have forsaken Him.
>
> *Application of the smell.* Respire the perfume of the virtues of Jesus Christ dying; of His poverty, His humility, His patience, His Charity.
>
> *Application of the touch.* Kiss inwardly the cross and the bleeding wounds of Jesus Christ.[37]

The faculty of imagination is the link between spiritual intensity and a biblical text which, without the imaginary enhancements wrought by the *Exercises*, would be unable to rouse the subject from *accedie*, mental sloth. The Word here is sensed as inert, as letter without spirit; visualisation is to breathe life into a text which, though at the nominal centre of the meditation, is

accorded a limited and catalytic role. Now consider Calvin's commentary on Matthew V: 41, Christ's dismissal of the unrighteous:

> *Matthew*: Then He will say also to those who shall be on the left hand, Depart from me you cursed, into everlasting fire, which is prepared for the devil and all his angels.

> *Calvin*: We are therefore taught how desirable it is to be united to the Son of God; because everlasting destruction and the torment of the flesh await all those He will drive from his presence at the Last Day. He will then order the wicked to *depart* from Him . . . (into everlasting fire). We have stated formerly, that the term *fire* represents metaphorically that dreadful punishment which our senses are unable to comprehend. It is therefore unnecessary to enter into subtle inquiries as the sophists do, into the materials or form of this *fire*; for there would be equally good reason to inquire about the *worm*, which Isaiah connects with the *fire*: *For their worm shall not die, neither shall their fire be quenched* (Is. lxvi, 34). Besides, the same prophet shows plainly enough in another passage that the expression is metaphorical; for he compares *the Spirit of God* to a blast by which the *fire* is kindled and adds a mixture of *brimstone* (Is. xxx, 33). Under these words, therefore, we ought to represent to our minds the future vengeance of God against all earthly torments, *which*, being more grievous than all earthly torments, ought rather to excite horror than a desire to know it.[38]

For Calvin, visualisation is the mark of a *failed* reading of the text: those who take literally the words 'Depart from me . . . into everlasting fire', and proceed to visualise the fires of Hell, are missing the inner meaning of the text: that the punishments of Hell are terrible *beyond* sensual comprehension; fire is only a *metaphorical* representation. Ignatius would have the subject of devotion hear the roar, smell the brimstone, taste the tears, touch the flames. Calvin insists that the subject *read* the text; understanding takes place not through visuality but rather through discourse, in Calvin's careful juxtaposition of texts from Matthew and Isaiah. Calvin's loyalty is to the word, not to the image, and so far from providing a direct connection between the subject and eschatological truth, the image of 'fire' indicates only how such truth *cannot* be apprehended in terms of the body, experience or vision.

With Calvin the experience of devotion is necessarily aniconic; images get in the way of the contact between reading subject and sacred word. Vision is under suspicion; figuration must be subdued and directed by figures *of speech*. *Vanitas* painting of the seventeenth century grows out of the deep internalisation of this priority of the word over the image; instead of word and image fusing in the white heat of Ignatian imagination, they are divided, the better that the word may rule. As the branch of painting devoted to eschatological truth, the *vanitas* accordingly installs the greatest possible distance between visibility and legibility. *Only* a visual lexicon can disclose the connection between, say, the Resurrection and its visual tokens: the snake, the dragonfly. Without that input from a textual source, nothing can instil the visual form with its destined meaning; in itself the arbitrarily chosen *representamen* is helpless, semantically null. Distance between image and meaning is the sign of the abjection of images before the word that masters them by supplying their missing *raison d'être*.

This great divide between image and lexical charge can be described in semiotic terms as a deliberately staged conflict between the *performative* and *constative* functions of signs. The constative level of a discourse is that of its statement or message, its (visual or verbal) signified; the performative level is that of the signifier, the material support which carries the statement across semantic space. In the case of the Ignatian image, the signifier is destined to be subsumed and to disappear into the signified: the words of the *Spiritual Exercises* hold no interest except as triggers to visualisation, and as the exercisant develops the meditation an eidetic space is slowly created that will transport the subject away from the real time and space of reading the book, into the eternal time and space of inward vision. Hence the disappointingly mechanical nature of the *Exercises* as *writing*: the dry use of number, of repeated phrases, paragraph headings and sub-headings, and so forth, ensure that this is not a text to be read, but *lived*. Effacing itself as writing, the text exists only to dissolve into radiant eidetic space (there is nothing given to those who wish to *read* it, except frustration and exclusion). With the *vanitas*, as with Calvin, the exact reverse is true: signified (Judgment, Resurrection, the Last Things) and signifier (image) can never merge; dragonfly or snake are not *parts* of the Resurrection, as the wailing or the heat are parts of Hell. And this is because the Last Things are beyond human compre-

hension; all we know is this world, and the things of this world. We are condemned by the Fall and our depravity to inhabit a material world that can never be transcended; and images will not help us to escape this fate.

The struggle between the 'what' and the 'how' of *vanitas*, between the constative message of world-rejection and the performance of that message as a costly work of art caught in the toils of worldliness, is not then simply a rhetorical misfortune, or the work of hypocrisy. Where Catholic painting opens effortlessly on to sacred scenes and celestial spaces, the Northern *vanitas* has exactly no route towards the transcendental that vision may directly take. Access is broken and oblique; the right angle detour of the image through the word is the expression of an ensnarement in the world which nothing can overcome, and least of all the business of making pictures. Albertian painting is built on access to the constative level: the picture plane is always a window opening on to another kind of space; the vanishing point unfailingly conveys the viewing subject, as the *Spiritual Exercises* convey the reading subject, to infinity. But the *vanitas* knows nothing of this escape into other worlds: its purview cannot get beyond the nearest objects. The cocoon of nearness, that 'dark' space of touch and creatural repetition, harbours a force of gravity and inertia nothing can escape. The transcendental can be sensed only in the inability to reach it, and in that conflicted, agonistic relation between the constative (sacred truth) and the performative (the inertia of *things*, ensnarement by things) the representation embodies its own failure and *vanitas*.

Understanding *vanitas* pieces in this way may therefore entail taking a certain distance from a current art historical war, the one waged between the Pan-Allegorists and the Anti-Allegorists of Dutch painting: the former insisting on an absence of naturalism and a saturation of the image by lexical codes, and the latter (brilliantly led by Svetlana Alpers) arguing for the absence of coding and an understanding of Dutch painting as a semantically neutral art of description.[39] Forced to choose which of these paths to take, the present essay must say: both, or neither. When the disagreement between them is seen from the viewpoint of semiotics, things shift: the interest becomes the *relation* between allegory and naturalism, the oblique, deflected passage from image to word, and the semantic charge which that passage possesses in itself (as distinct from the question of the presence or

absence of allegorical coding). From this perspective what counts is that when allegorical messages are present in *vanitas* pieces (which may be less often than the Allegorists suppose), it is not enough simply to invoke an iconographic 'equals sign': the pomegranate equals Ecclesia, the melon equals temperance, the artichoke equals heavenly Majesty, and so forth. The equations are also *blocked*: x may stand for — *but cannot otherwise relate to* — y, except by way of an abrupt change of gear from performative to constative and from image to word. A mechanical application of the 'equals sign' (though much of the art-historical discussion of these paintings is nothing but that) exactly misses the agonised relations between the verbal and visual discourses which make up these pictures and their semantic field.

The middle zone of the still life spectrum, halfway between the *vanitas* piece and the enticements to pleasure offered by Jan Davidsz. de Heem (1606–1684) or Willem Kalf (1619–1693), is occupied by the still life of disorder, poised between harmony and catastrophe. Interestingly, the degree of disorder seems to increase in proportion to the level of affluence the table indicates as whole. Is it silver that causes the upheaval? In the piece by de Stomme (*d.* 1664) in Copenhagen (illus. 43) things have gone horribly wrong, and there are Steen-like signs of household mayhem. One of the *roemers* has been smashed to smithereens. The meal has shifted down from its proper place over the linen and begins to spill all over the table. The plate with the glass fragments has been dumped carelessly over the crumpled cloth, and

43 Maerten Boelema de Stomme, *Breakfast Piece*. Statens Museum for Kunst, Copenhagen.

indeed all the plates seem dangerously close to the table-edge. There is much interest in ruined form: broken bread and nutshells, half-carved meat, shapeless wax, and of course the cut lemon, ubiquitous in Dutch still life and versatile in its meanings; here its dangling peel goes with the other signs of precarious balance. Again in Willem Claesz. Heda (1594–1682; illus. 44) one sees the table strewn with litter, messy nuts and oyster shells, an overturned tankard, plates tilting and overhanging the edge. In scenes of this kind the table behaves in much the same way as the floor does in Jan Steen, showing material which has lost its place, and with that, the peril of a household losing its moral grip. Lids gape open, cutlery lies scattered about, and wholesome food has turned into débris. Making all due allowance for the slow improvement of European table-manners, it still looks as though the meal has been consumed by bears. What makes the disorder all the more reprehensible is that the objects manhandled and knocked about in this fashion are so conspicuously crafted; there is a clash between the careful attention of those who make, the craftsmen and the painter, and the negligence of those who enjoy. It is as if production were thought of as intelligent, purposive, culture-building, and con-

44 Willem Claesz. Heda, *Breakfast Piece*. Musée Mayer van den Burgh, Antwerp.

sumption as stupid, anarchic and blind. Production is a delicate web that runs between craftsmen, painter and viewer, consumption is a tear in that web; and the tear can only be repaired if the virtues of production and craft are restated in the image itself, covering the tear over and making the fabric of production seamless again.

At the far end of the still life spectrum pleasure beckons in the form of the *pronkstilleven*, the 'banquet-pieces' perfected by (among others) Jan Davidsz. de Heem and Willem Kalf.[40] And it seems that nothing could be further from the anxious self-restraint of Pieter Claesz., or less inhibited about the pleasures of touch, taste, sight and possession. At last the natural world re-appears — grapes, plums, peaches, lobster; one has moved away from the sanctum of purely man-made abundance. As in the classical *xenia*, these are foods requiring little or no preparation, and one sees the lobster cooked but intact; as though to underscore this new pastoral relaxation, de Heem introduces the motif of leaves and tendrils, indicating a flow between the abundance of the table and that of nature (illus. 45). Nevertheless,

45 Jan Davidsz. de Heem, *Still Life with Lobster*. Toledo Museum of Art, Ohio.

the access to nature is of a special kind, the sort of privileged pastoral return available only to the very rich. In the Dutch national diet (fish, cheese, bread, *hutsepot*) fruit is a luxury, not a staple, and the hamper of costly southern delicacies has a significance rather different here from the naturalness and regionality the same fruit convey in, say, Caravaggio. It marks an access to continental resources, a breaking with regional limitation. Yet these fruits are not the real stars of the show. What counts in de Heem and even more in Kalf are artefacts, and the peculiar competition they open up between the skills of painting and of the other crafts.

There had existed in antiquity the *topos* of painting's superior yet limited understanding of the crafts, exemplified in the story of the cobbler who dared to criticise shoes painted by Apelles on the grounds that the laces were wrong; Apelles corrected the fault, and elated by this the cobbler the next day went on to criticise the painting of a leg — and was reprovingly told by Apelles to 'stick to his last'.[41] The story elevates the art of painting beyond the mere work of artisans, and proof of painting's greater status is that it has no need for anything more than a superficial acquaintance with the other crafts, preoccupied as it is with higher things. Kalf works entirely against this tradition of painting's exalted ignorance. His goal is to produce designs for plate that are finer than any silversmith's, goblets more elaborate than any glass-maker can create; he puts in a high bid for painting as the art or craft which subsumes all the others.[42] As a result, there is an exuberant interplay between the labour concentrated in the depicted objects, and that embodied by the painting. In part, the value of the painting comes from the value of the objects, which puts the painter's labour in the lesser and dependent position. But in as much as painting outstrips and subsumes the other crafts, it establishes its own labour as superior, and from that position of superiority confers on the crafted objects its own greater worth. The rivalry between representation and its objects is at its most dramatic when the latter are already at a pinnacle of accomplishment, and in *Still Life with Nautilus Cup* (illus. 46) Kalf takes on a number of masterpieces: a Ming sugar-bowl, a complex-patterned Persian rug, *façon de Venise* glass, and the challenge of the nautilus cup itself. And probably Kalf wins. As Goethe wrote of another Kalf painting: 'One must see this picture in order to understand in what sense art is superior to nature and what the spirit of

46 Willem Kalf, *Still Life with Nautilus Cup.* Thyssen-Bornemisza Collection, Lugano.

man imparts to objects. For me, at least, there is no question that should I have the choice of the golden vessels or the picture, I would choose the picture.'[43]

The competition between painting and other arts or crafts seems to have been conducted at exactly the level Dutch collectors most enjoyed – unarguable virtuosity. Here collectors and

connoisseurs needed no elaborate aesthetic treatises or theories to understand painting's justification or goal, which could hardly be more straightforward (or limited). Nevertheless, in Kalf the intensity of the competition introduces a subtly disturbing note, by rendering the *point* of the virtuosity unclear. It is one thing to display virtuosity through the bloom of grapes or the fuzz of peaches; but when the display concerns artefacts which are already complete and self-sufficient objects of art, the *additional* value conferred by representation has an aspect of the gratuitous or the redundant. The paintings are subject to the paradox of 'the supplement'. If the original objects – the Ming porcelain, the nautilus cup, and the rest – truly are at the pinnacle of beauty, then there should be no room for the supplementary value added by painting. That there *is* a supplement here indicates, rather than a state of completion, one of lack: there is something about these objects which requires that value *continue* to be added to them. The work of ornamentation which produced the silver figure on the cup or the filigree of the gilt has to *go on*, but since these things are already elaborated to the greatest possible degree there seems no point at which ornamentation could ever cease. If these objects are already masterpieces, why should they be repeated in a *second* masterpiece? The duplication of elaborative work begins to point to a process that is as endless as it is without reason; the replica indicates a deficiency in the original object that will not be remedied by the supplement, but contaminates it and so to speak hollows it out.

Kalf's technique is brilliant at rendering the artefacts substantial and convincing, yet it also has the unnerving consequence of suggesting a virtuosity that circles endlessly round a kind of void. Because the copy is allegedly *better* than the original, the point of the original is lost, yet if that is lost, the copy loses its foundation as well. What is in the end most disturbing is that the substantiality of the objects comes under threat: are they real? – did they actually exist in Kalf's studio? Or are they ideal objects, based on the principles of actual objects yet taking off from those into a space of imaginary perfection? In some cases we have the answers,[44] but the questions are not really capable of being empirically resolved; they concern the unstable ontology of the objects within the *logic* of the paintings. What motivates Kalf's images of wealth and consumption at the summit of their existence, and what makes them considerably more interesting than they might be if rested solely on their pyrotech-

nics, is the *dream* of wealth they present. The ontological instability which his technique introduces has the effect of rendering substantiality uncertain, and this opens the doors of fantasy. Kalf paints illusions of wealth, to sell to the merchants of Amsterdam. Is this what they dreamt of at night? And his work touches on the rather more deep-seated and permanent vein of fantasy, the one which sends crowds queuing up to look at the Crown Jewels, Tutankhamen's coffin, the Peacock Throne of the Topkapi, the *Mona Lisa* — or the rocks sent back from the moon. The desire at work here concerns the feeling that this at last is it, this is the costliest, the rarest, the ultimate object on earth. Refracted across the mind of seventeenth-century Dutch merchants, the dream of the pearl beyond price is historically specific, yet still intelligible in its outlines, and if there is any point at which Kalf's work breaks out of its extremely narrow confines of class, it is here.

Kalf's still lifes are disturbing in another sense, in that they tend to provoke the question: *who* is to see all this? What is the social or interpersonal dimension of such images? Despite the label of 'banquet' scenes, in fact there is generally not much sign of conviviality or social sharing. Since Kalf is so preoccupied with objects whose primary function is to be owned, the first viewer proposed and assumed by the paintings must be the collector who commissions or buys them. But the idea of 'the collection' then has a peculiar effect on the paintings' *space*. Even here, still life is to do with proximal space, the space round the body, that of tables and the things within arm's reach. The space of the *Still Life with Nautilus Cup* is as tactile as in any Zurbarán; everything one sees is the product of the hand, from the weave of the rug to the work of the glass-blower to the intricacies of wrought metal. That the space takes its charge from the hand is underscored in the fruit at the right of the painting, and in the lemon with its elegant spiral, suggestive here of skilful turning and cutting. This is still the space of a meal, and all the objects are technically in use. But this tactile and creatural space has shed most of its likeness to the earlier spaces of still life. With the modest Pompeian *xenia*, and the frugal tables of Cotán and Zurbarán, the objects are related through tactility to domestic action, with all of its humanising and stabilising force. But the objects on Kalf's table form a *collection*, which is to say they exist in separation from the routines of ordinary domestic life: they belong, rather, to the space of a *Wunderkammer*. And

this is only the first of their spatial abstractions. The collector's items themselves come from a new and greater space, of trade routes and colonies, maps and discoveries, investment and capital. It is these which bring to the table the porcelain of China and the carpets of the Near East, and the shell which lyrically sums up the wealth of the merchants of the sea. As with the flower paintings, the objects speak of oceanic distances and trade, and this sense of breaking the confines of regional or local space, of flying out towards the far corners of the globe, disrupts the unity and coherence of the tactile, domestic space of the table. And there is a further abstraction; all the objects are items whose price can be exactly known: it is for their costliness that they are valued; and this serves to abstract the scene still further, by converting all of its contents into units, calculable and inter-changeable, of wealth.

Still life of the table is deeply concerned with the issue of tactility because it is the hand and not only the eye which organises its spaces, and the touch of hands in the everyday gestures of eating and drinking which confers upon its objects their human warmth and resonance. Kalf's space is tactile, too, but this value is now in crisis. The combined influences of the art collection, oceanic trading and capital investment operate to undo the cohesion created in tactile space by gesture, familiarity and creaturely routine. This breaking or fracturing of domestic space raises an alarming possibility: that in the world implied by the painting, nothing can be truly *at home*. Because it has lost its bonds with the actions of the body, matter is perma-nently out of place. Its spatial co-ordinates are those of acquisi-tion, navigation, finance: theoretical axes, with which the body can never intersect. The works by Kalf that immediately precede the banquet-pieces by which he is known, the pictures of his so-called Paris period, are explorations of this dimensionless space.[45] The *Still Life with Metalware* (illus. 47) shows the true resting place of the object fully commodified and abstracted: the table is like a bank-vault − or a graveyard. Though worth thousands of guilders, the heaped up objects look like so much junk: the treasure-house is where objects come to die. Divorced from use, things revert to absurdity; anticipating nothing from human attention, they seem to have dispensed with human attention, whose purpose and even existence they come to chal-lenge. And this dimensionless space persists inside Kalf's seem-ingly exuberant *pronkstilleven*, undermining their substance and

hollowing out the dream of prosperity with the insight: abundance generates waste.

Still considering Kalf's *Still Life with Nautilus Cup*, let us return to the question of the kind of sociality the painting assumes. What is the nature of the viewer's gaze? If the primary viewer is taken to be the picture's owner, it is in part the gaze of satisfaction: the man of wealth contemplates the fruits of his industry,

47 Willem Kalf, *Still Life with Metalware*. Musée de Tessé, Le Mans.

and given the Calvinist tradition of thinking of prosperity as the reward of virtue, it is one of contentment. But the painting also questions that gaze. For one thing, it involves an almost total solitude. The picture reflects wealth back on itself, like a mirror, or locks wealth in, like a safe. Or let us suppose that the owner of the picture displays it before others. They, too, may share the dream of wealth, but the dream is one likelier to isolate than to bind individuals together: part of Kalf's dream of wealth is that of the absolute individual, unique in his possessions, as the possessions are themselves unique. Wealth is inseparable here from the ideas of competition and individuation, and where wealth is greatest the individuation is at its extreme. The display of prosperity inserts a new function of separation of people from things and from each other, and we find the still life of luxury at a strange crossroads between the levelling impulse which still life possesses traditionally through its opposition to 'megalography', and the impulse of hierarchy and separation presented by wealth. As still life's aspect of rhopography levels human life and brings it down to its basic encounters with the material world, it describes bonds of familiarity between ourselves, the objects around us, and our fellow creatures; but luxury dissolves that intimate and creaturely environment. The concepts of luxury and display break up the intimate, cocoon-like space round the body and open it on to enormous distances: the distances of trade, but also the social distances between individuals and classes precipitated by the kind of massive and fluctuating economy which, rather than the table, is now the scene's real material support.

It is instructive to compare Kalf's painting with the depiction of surfeit in Brueghel's *Battle between Carnival and Lent* from a hundred years before (illus. 34). There, what holds the peasant figures inside the image and the viewer outside it in their respective social positions is the feudal economy of dearth: material resources have absolute limits set by nature, and nothing will increase them. Human appetite is enough to deal with and adjust the material balance between sufficiency and insufficiency; and it does so by imposing on everyone represented in the scene the same regime of abstention and indulgence. The material conditions of ordinary life draw individuals together and subordinate particular to collective need; the solution to the problem of abundance is solidarity in the face of dearth and plenty alike. In the post-feudal world implied by Kalf's painting, abundance

has gone far beyond the point at which it might still be regulated by appetite. The accumulation of capital can now only be matched by artificial needs, pushed to the extreme where the objects that express and satisfy them now border on the fantastic. At the same time, the rhythms of capital are such as to dissolve rather than strengthen bonds of commonality, and wealth is represented, in *The Nautilus Cup*, as forming crests or peaks scaled by solitary possession. Social fixity and unity are no longer guaranteed by dearth, and the individual is proposed as one who must invent and construct his social position, in conditions of solitude surrounded by economic flux. Painting enters this field as one device among many for supervising abundance and superabundance through discourses that render the flux of plenty coherent, at least in representation. And in this, still life painting has an important rôle to play, since its whole subject is nothing else but the life of people among material things.

In Dutch still life affluence is rarely presented through a neutral inventory of goods, but is coded through discourses that impose on abundance their own principles of intelligibility and control, and ensure that 'affluence' remains in the orbit of 'luxury' in its older sense. What controls the cornucopia is in the first place the idea that ethics and economics are inseparable. At one

48 Willem Claesz. Heda, *Vanitas.* Collection Haags Gemeentemuseum, The Hague.

end, Claesz. portrays the utopia of consumption perfectly matched against resources: his whole 'monochrome' technique works to rid the scene of whatever might be out of place, to banish excess in all its forms, and to unify the elements of the composition so tightly that in its aesthetic self-sufficiency the work may convincingly stand for a morally as well as economically self-sufficient order. In the 'still life of disorder', affluence is presented as a dilemma, a crossroads between harmony and disharmony. As in Jan Steen, the regulation of the home is bound up with the moral fate of individuals (and of the society as a whole): what disturbs the peace is consumption let loose and on the rampage, what restores the peace are the values of production and vigilance, not least as embodied in the painting. In the upper reaches of prosperity, work such as that of de Heem and Kalf supplies an imagery of wealth coded both to pleasure (the exuberance of craft in competition with itself, supported and enabled by wealth) and to the deeper themes of the *vanitas*. Still life forms a range of options; in all its regions, affluence is ethically keyed.

Still life was able to provide its viewers with images in which the historically unprecedented instability and volatility of their material culture could appear as regulated and stabilised. In this work of visual ideology, the discourse of ethics is joined by a force no less stabilising, that of craft labour. Amid the general uncertainty and anxiety surrounding consumption, still life affirms skilled labour as a kind of gold standard that will hold its own through all the vicissitudes of (over)abundance. There are exceptions. When Kalf portrays the fruits of human labour as a kind of mirage, there is a sense in which the painter's own labours are contaminated; at its most interesting, Kalf's work calls into question the whole ideology of productive labour, including within this his own. And the still lifes of disorder by de Stomme and Heda seem as interested in entering into the chaos of consumption as in returning things to equilibrium (illus. 43, 44): the tilting of the plates and overturning of the goblets create a visual tension that the paintings build on, rather than disown: they *want* to explore a bit of disorder – just as Jan Steen enjoys his unruly households, and makes us enjoy them too. Nevertheless, in this craft tradition it is the values stored in the honest labours of painting which preside over the confusing realm of abundance, and return it to rule.

What is remarkable about the Dutch still life painters is that

49 Ambrosius Boschaert the Elder, *Bouquet in a Niche*. Mauritshuis, The Hague.

they work as if they had no desire to produce a personal idiolect or style; where this emerges it does so almost incidentally, not as a central aim. What they do want of their images is that they represent a faithful record of the hours spent in their production. Their labour is apparently not subject to inspiration, but is an even skilfulness, without 'peaks'. It is a dependable, highly professional style, which assumes that because skill is evenly controlled, labour can be quantified and priced, and it does nothing to suggest that this thought makes the painters uneasy. Although the prices of pictures also reflect the demands of the market, the painters behave as though demand could never by itself create a painting's value, which must be fully inscribed on its surface before it can even enter the market-place. Through the lens of this reliable, impassive style, the painters viewed and presented the abundance of their material civilisation: whether the object to be depicted is worth a few pennies or thousands of guilders, it is subject to the same meticulous and unexcited

50 Pieter Claesz., *Still Life with Stoneware Jug, Wine Glass, Herring and Bread*. Museum of Fine Arts, Boston.

134

scrutiny. Working alongside the discourse of ethics, the application of an even, unimpassioned regard subdues the potential disorder of a material culture awash in plenty: *consumption is reabsorbed into production.*

What makes Dutch still life unique is the symmetry between this anonymous, self-effacing technique and the particular range of possibilities afforded by rhopographic painting. Rhopography works against the idea of greatness: while human beings may be capable of extraordinary heroism, passions, ambitions, it leaves the exploration of these things to others, and against megalography it asserts another view of human life, one that attends to the ordinary business of daily living, the life of houses and tables, of individuals on a plane of material existence where the ideas of heroism, passion and ambition have no place. The Dutch painters of still life are true to this rhopographic scale of values in that they make no use of painting as a vehicle for bringing to the world the uniqueness of a personal vision.[46] They are not attracted by still life as a mode of self-expression, or by the possibility of raising their art to Olympian heights. And they are inside the real, mundane world far more than, for instance, Cotán and Zurbarán, in that they have an acute sense that in the world as they find it everything has a price, including the work of a painter. They know that in mercantile society, awareness of class and of the thousand degrees of affluence is as much a part of ordinary and everyday experience as any of the creaturely pleasures of eating and drinking; more precisely, they realise that in the world they actually inhabit, creatural life, the life of appetite and the table, can have no existence outside the field of social and economic power. The viewer is related to the scene not only through a general creaturely sense of hunger and appetite, or of inhabiting a body with its cocoon of nearness and routine, but through a worldly knowledge that knows what it is to live in a stratified society, where wealth nuances everything, down to the last details. They accept these limiting conditions, and their work systematically avoids the megalographic register to which still life painters such as Caravaggio and Cézanne are drawn. But what happens when these two systems of value, these two world views, rhopography and megalography, come to collide?

4 Still Life and 'Feminine' Space

In the section of the *Natural History* devoted to painting in the antique world, Pliny spends less than a paragraph discussing the greatest Greek painter to work in the lower genres, Piraeicus:

> In mastery of his art but few take rank above him, yet by his choice of a path he perhaps marred his own success, for he followed a humble line, winning however the highest glory that it had to bring. He painted barbers' shops, cobblers' stalls, asses, eatables (*obsonia*) and similar subjects, earning for himself the name of *rhyparographos*.[1]

The label could hardly be more dismissive. It is an insult: 'rhyparographer' means painter of *rhyparos*, literally of waste or filth; the association is with things that are physically and morally unclean. Yet, at the same time, Pliny tells us that the paintings of Piraeicus were highly prized: 'In these subjects he could give consummate pleasure, selling them for more than other artists received for their larger pictures'.[2] From Pliny on, the painting of what are regarded as 'trivial' or 'sordid' subjects has been received by Western culture with deep ambivalence. Still life is admitted into art, into the academy, into criticism; it takes its place in the market and commands high prices, it finds its admirers and its connoisseurs. But it is admitted only to be relegated *to the lowest rank*: in the academies the 'painter of fruit and flowers' sits well below the salt; in the academies' debates rhopography is invariably ousted by the superior force of megalography. And in the institution of criticism, still life is to this day generally undiscussed; no theoretical body of work exists at a level of sophistication comparable to that found in contemporary discussions of history painting or landscape; it is to the higher genres, regarded as intrinsically more interesting, that modern art history gravitates. This chapter asks: what is the nature of this ambivalence, and what is its source? And in particular, what connections exist between the terms of this ambivalence and the cultural construction of gender?

First we need to be clear that the decision to regard some levels of human action as exalted and noble and others as trivial or base is the product of a series of cultural pressures; one is not dealing here with the *données* of nature. Every one of us lives our life in the orbit of basic routines of self-maintenance: cooking and eating, shopping, seeing to domestic chores, keeping our creatural habitat in viably good repair. Such activities are objectively necessary for our welfare and respond to inescapable conditions of human life. But how these activities are viewed and appraised — what value is *placed* on the life of creaturely routine — is very much a matter of culture, and of history. Whether these activities are respected or dismissed, valued or despised, depends on the work of ideology. Piraeicus' 'humble line' is humble only within a certain cultural construction; the painting of what is 'mundane' or 'sordid' (*rhyparos*) is negative only from a certain viewpoint, in which the 'lowness' of a supposedly low-plane reality poses a threat to another level of culture that regards itself as having access to superior or exalted modes of experience. And if that humble line is evaluated negatively, we need to enquire what *kind* of threat it could conceivably pose (if it is indeed so lowly), and for whom.

One possible dimension of threat emerges from the peculiar nature of the 'humility' involved. Though humble, the *forms* represented in still life are virtually indestructible. Either because they come from nature, or because they are intended for purposes that do not vary, they are forms which do not change much over long periods of time. Although the paintings at Pompeii showing such things as lobsters, bowls and vases come from a culture entirely remote from that of seventeenth-century Spain or the Netherlands, the objects themselves are materially continuous with those found on the tables of Zurbarán or de Heem. The *xenia* with such things as glass jars, platters and ewers are not fundamentally discontinuous, at the level of their artefacts, from a Cotán or a Heda. The forms of such things as jars, plates, baskets, bowls, glasses point backwards to a long evolution in the culture which produces them. If the only requirement for a bowl or jug were to act as a viable container for solids or liquids, any object of whatever shape could be named and used as these things: their forms could be improvised at every occasion of use. Yet within any culture, certain distinct forms recommend themselves as appropriate, where propriety is not just a matter of bare function but of a whole network of practical

activity, involving all the factors of suitedness to action, to the body, to cost, to ease of manufacture, and to available materials; in short, to an economy of practices which, eliminating what is not suitable, in the end converge on *this* given form, which is then passed on.

Though still life can always be accused of dealing only in odds and ends, in *rhyparos*, débris, the abiding and ancient forms chosen by still life speak of cultural pressures as vast as those which in nature carve valleys from rivers and canyons from glaciers. Even their names seem demeaned – jug, jar, bowl, pitcher – yet the forms of still life have enormous *force*. As human time flows around the forms, smoothing them and tending them through countless acts of attention across countless centuries, time secretes a priceless product: familiarity. It creates an abiding world where the subject of culture is naturally at ease and at home. Without that steadying hand of cultural memory, the subject would not in fact be able to produce for itself the stability of any kind of home ground. Imagine a world where artefacts were created without any predictable pattern: nothing in that world would be recognisable; it would lack all sense of its own duration as a world, or of being a place for human life carved out from matter by the previous generations. The forms of still life are strong enough to make the difference between brutal existence and human life: without them there is no continuity of generations, no human legacy, only an intermittent and flickering chaos; with them, there is cultural memory and family, an authentically civilised world. The repeated shapes of the things in still life have been decided by consensus over many eras, and feel 'right' for the job. As such, they create a cultural field far larger than any single individual, or even any particular generation: those addressed by these ancient and familiar forms are only the present members of a cultural family whose roots travel back into a vast preceding cultural community, which is in solidarity with each of the generations behind and ahead.

The familiar things shown in still life are all material descendants of what George Kubler has called 'prime objects', the prototypes of the series of artefacts called plates, bowls, jars and the rest.[3] Yet even when a series is comparatively recent in Western history (forks, tankards, deep plates) such prime objects have long since disappeared without trace into the boundless mass of subsequent replicas. While complicated tools and technologies are subject to rapid change, simple utensils obey a slow,

almost geological rhythm. In stratum upon stratum the archaeology of Western sites unearths endless variations on the same basic ideas, of storage jar, oil-lamp, beaker, vase. Such objects belong to the *aevum*, time which has a beginning but no end. Their forms keep solutions to particular material problems on permanent reserve, and when the same material pressures that first brought them into being are felt again, they transmit their store of energy along a path that connects past to future need. As such, the forms are in a sense unconscious: they do not need to be re-invented from scratch or thought through from first principles at every new moment of need; the individual creation of the artefacts is overruled by a collective intelligence that bypasses the necessity for invention. For as long as such forms are able to do the job, they propose that human life can best be organised by submitting the requirements of the present to the solutions of the past and by subordinating the impulse of invention to the authority of cultural formulae. All such objects are tied to actions repeated by every user in the same way, across generational time; they present the life of everyman as far more a matter of repetition than of personal originality or invention. As Kubler puts it: 'the cage of routine binds (the individual) so closely that it is almost impossible for him to stumble into an inventive act: he is like a tightrope walker whom vast forces so bind to the cable that he cannot fall, even if he wishes, into the unknown.'[4]

In Brueghel's *Fall of Icarus* (illus. 51), this is exactly what we

51 Pieter Brueghel the Elder, *The Fall of Icarus*. Musées Royaux des Beaux-Arts, Brussels.

see: the impulse to create a new form, wings, perishes without issue along with its maker, while the absolute form of earthly repetition, ploughing, cuts through unvarying tracks from past to future. The image points to one of the aspects of threat embodied in the 'sordid' objects of Piraeicus' humble line, that of a cage of cultural repetitions so binding and confining that all possibility of individual uniqueness and distinction is effectively annulled. Although the time of *aevum* draws all members of a particular cultural family together in a solidarity of past, present and future generations, the force of that collective embrace effaces the individual as an individual and undermines the purpose and scope of any distinctively personal culture or achievement. If the forms of still life were precarious, experimental, Icarus-like, they might command attention and engage curiosity, but their point is that they can be taken entirely for granted, from one generation to the next. They require no attention or invention, but emerge fully formed from the hand of cultural memory; and it is because they store such enormous forces of repetition that they are universally overlooked. When still life painting comes to look at the overlooked, what it can reveal is accordingly the Icarus shock, of the irrelevance and expendability of the individual contribution. Brueghel's image implies that in fact what runs the world is repetition, unconciousness, the *sleep* of culture: the forces that stabilise and maintain the human world are habit, automatism, inertia.

It is here that one might place some of the sinister features of still life's ancient connection with illusionism and *trompe l'oeil*. To further its deception, *trompe l'oeil* pretends that objects have not been pre-arranged into a composition destined for the human eye: vision does not find the objects decked out and waiting, but stumbles into them as though accidentally. Thrown together as if by chance, the objectives lack *syntax*: no coherent purpose brings them together in the place we find them. Things present themselves as outside the orbit of human awareness, as unorganised by human attention, or as abandoned by human attention, or as endlessly awaiting it. Each school interested in *trompe l'oeil* discovers its own particular style of disregarded objects: at Pompeii it is the litter of the kitchen, in *The Unswept Floor*, after Sosos of Pergamum (illus. 52); with Cotán, it is the deserted contents of a larder; in the Netherlands the still life of 'disorder' dwells on the wreckage of the meal. And in the eeriest range of still life one finds the blank hanging sheet of

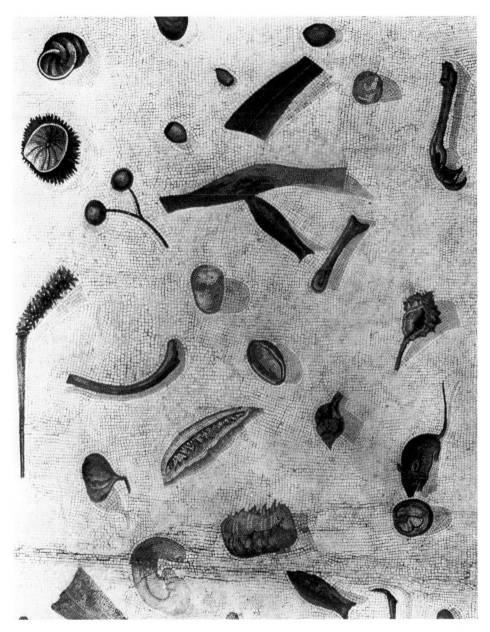

52 Heraclitus after Sosos of Pergamum, *The Unswept Floor*. Musei Vaticani, Rome.

Raphaelle Peale (1774–1825), or the letter rack of Wallerand
Vaillant (1623–1677; illus. 53). *Trompe l'oeil* forms a natural
alliance with detritus of every kind: scraps, husks, peelings, the
fraying and discolouration of paper, or else objects taken up
and looked at only occasionally – documents, letters, quills,
combs, watches, goblets, books, coins. In that effacement of
human attention, objects reveal their own autonomy: it is as
though it is the objects that make the world, and the unconscious
force stored in their outwardly humble forms – not their human
users. Individual attention and conciousness are unnecessary or
at best incidental to their independent life. From the point of
view of an ideology geared to achievement and competitive
distinction, this is the menacing aspect of *rhyparos*, waste, and
it is also the threatening dimension of *trompe l'oeil*. Hyper-real,
trompe l'oeil so mimics and parodies the sense of the real that

it casts doubt on the human subject's place in the world, and on whether the subject *has* a place in the world.[5] For the split second when *trompe l'oeil* releases its effect, it induces a feeling of vertigo or shock: it is as if we were seeing the appearance the world might have without a subject there to perceive it, the world minus human consciousness, the look of the world before our entry into it or after our departure from it.

Normally, painting controls the contents of the visual field by means of a sovereign gaze that subordinates everything in the scene to the human observer. But in *trompe l'oeil* it is as if that gaze had been removed, or had never been present: what we see are objects on their own, not as they are when people are around, but as they *really* are, left to their own devices. One of the wittiest and most bizarre of *trompe l'oeil* paintings makes exactly this point: in *The Back of a Picture* by Gijsbrechts the shock comes from the wholescale elimination of the organising principles that paintings usually impose on the visual field (illus. 54). In *The Four Fundamental Concepts of Psycho-Analysis*, Jacques Lacan talks of the way visual experience is never fully organised by a centralised ego; there is always an excess in vision over and beyond what the subject can master in sight. *Trompe l'oeil* painting unfolds in exactly this area of insufficient control, where instead of the objects' obeying the subject's sovereign gaze, they slip out beyond it and usurp the visual field: they 'look back'

54 Cornelius Norbertus Gijsbrechts, *The Back of a Picture*, Statens Museum for Kunst, Copenhagen.

on the observer, as though there were no right by which human observation takes command of its surrounding world and imposes its own order upon it from a position of visual centre.[6] The veiled threat of *trompe l'oeil* is always the annihilation of the individual viewing subject as universal centre. And this is the threat, equally, of the painting of *rhyparos*. Everything that is presently made is only a replica or variant of a previous object, and so on back into the abyss of time and the rubble of archaeology. The objects themselves dictate to matter the forms of their replication; the individual maker only repeats the prior formula, the individual user only repeats the gestures it encodes. And the objects go on existing outside the field of human consciousness, yet with no diminution of the powers stored within them.

This lowest level of material life is, then, highly ambivalent. With part of its being it offers assurance: the security of living in a well-established culture, whose forms of objects were already old in Greece and Rome. There is the embrace of past generations which lived through similar material conditions and endured, and which send their accumulated wisdom on to the future as an indestructible legacy. Each member of the cultural family is given a set of accessories which carve out from the blank planetary surround a personal habitat exactly suited to the body's local needs, and from the smoothing action of time and the shared use of countless generations, their forms have acquired a certain impressivness and nobility. But the very persistence of these forms, and the immemorial way of life they imply, also reduces human life to a lowest common denominator. When looked at from outside the limited cocoon where they belong, the scissors and combs, books and papers, all the effects that weave the warmth and familiarity of a personal habitat, at once appear pathetic and lost: they have the look of dead men's clothes (illus. 55). Though to each user they are unique, bearing an individual accent and all the distinctness of a personal scent, when glimpsed from outside the nest of habit woven by the body for itself they are simply junk, personal waste. And not just the personal effects, all of the artefacts surrounding the body share this fate of imminent reversion to débris. Though the forms of such things as plates, jugs, pitchers, glasses, and so forth are robust enough to withstand the centuries, individual avatars of the forms are fragile to a degree: attrition, breakage and decay soon convert the noble forms to shards and rubble. The immediate bodily cocoon must constantly renew itself to keep at bay

55 Samuel van Hoogstraten, *Steckbrett*. Staatliche Kunsthalle, Karlsruhe.

the forces of dispersal and ruin. It is subject to a law of entropy that no form can survive. In the fate of the objects around the body is read the body's own creatural frailty and imminent demise. And even before entropy gets to the objects and destroys them, they threaten the uniqueness of the individual and the distinctness of a personal outline. Persons become exactly interchangeable: since the forms in still life address the generic body, they bypass the personal body; because all human beings are destined to the same actions, of appetite or comfort or hygiene, at this basic level of material existence there is no respect for personhood. The very place where personal being takes its stand is overturned, in a radical decentering that demolishes the idea of a world convergent on the person as universal centre.

Exploring the range of ambiguities opened up by the concept of *rhyparos* is the goal of a series of subtle and fascinating images that set 'high' and 'low' planes of reality on direct collision

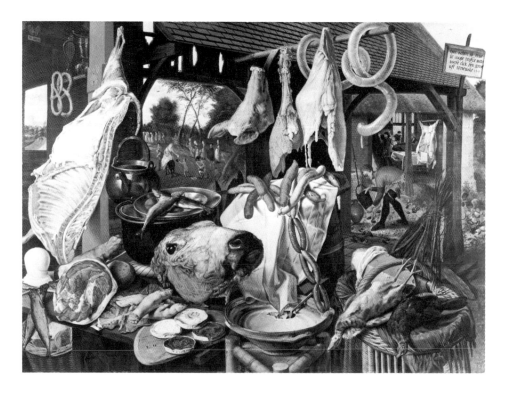

course. They are few in number, and without descendants: basi-
cally the group comprises paintings by two Northerners, Pieter
Aertsen (1508–1575) and Joachim Beuckelaer (b. 1533), and
work directly influenced by them in Spain, by Diego Velázquez.
At first sight Aertsen's *Butcher's Stall* (illus. 56) seems a straight-
forwardly Rabelaisian celebration of creatural plenty – a slither-
ing heap of fish, ham, great strings of sausage, piles of trotters,
baskets of game and shapeless, succulent lumps of fat. It is a
work of rhyparography in the tradition of Piraeicus, painter of
shops and provisions: animal matter in its lowest and least
redeemable aspect. What complicates the picture is the inclusion,
beyond the stall, of a sacred subject, the Flight into Egypt –
that, and Aertsen's extraordinary reversal of scale. While the
seething mass of comestible matter spills out all across the fore-
ground, the scriptural figures are tiny and indistinct. By this sim-
ple means Aertsen sets up a dialogue between high and low
in which each both supports and interrogates the other, in a
semantic field of considerable richness and complexity.

As with the *vanitas* pictures discussed in the last chapter, the
richness comes from the interplay between the 'constative' and

'performative' levels which structure the image. To remind ourselves of the distinction: the constative level of a text or image is that of its content or message; the performative level is that of the enunciation or enactment of that message. At the constative level there appears the literal dimension of a statement, in separation from the local circumstances of its utterance; the performative level embraces the context surrounding the utterance – its speaker, its addressee, its modes of address and reception, its place in the network of communicative acts. For example, the constative meaning of the statement 'money is not everything' remains the same regardless of who utters it; but at the performative level there is obviously a world of difference between the same statement as spoken by a rich man and by a poor man (to say nothing of the beggar and the thief). In the case of the series of images to which Aertsen's picture belongs, we move quickly to their core if we consider the case where the constative and performative levels directly clash, as they do for instance in extreme form with the speaker who declares that 'all Cretans are liars' – and then adds that he himself is from Crete. Here the literal meaning of the statement runs right against the circumstances of the utterance; the performance of the statement, and its truth *as* statement, collide head-on.

There can be no doubt that *The Butcher's Stall* is structured by a group of oppositions clustered round the sacred and the profane, where the sacred is taken as the higher term.[7] If we look closely at the part of the image dealing with the Flight into Egypt we find Mary giving alms to a beggar, and her spiritual work of charity clearly contrasts with the commerce and sensual indulgence embodied in the foreground in the succulent display of meat for sale. The profane is obviously the lower term: the Holy Family passes by outside while the wretched stall-keeper, seen lifting water from a well, resolutely ignores the procession – for him it is business as usual. Similarly in Beuckelaer's *Christ in the House of Mary and Martha* (illus. 57) the background shows Christ taking his place at a feast held to celebrate the raising from the dead of Mary's and Martha's brother, Lazarus. But the solemnity and mystery of the occasion are in stark contrast to the profanity of the foreground, which is given over to the everyday world of kitchen work. Although the master of the house has come back from the dead, those preparing the feast show little awareness of the miracle that is being celebrated in the next room; they busy themselves with

57 Joachim
Beuckelaer, *The
Well-stocked Kitchen
(Christ in the House
of Mary and
Martha)*.
Rijksmuseum,
Amsterdam.

the tasks in hand, plucking feathers, preparing the roast, and generally disregarding the solemn conversation in the noble quarters. Again in Beuckelaer's *Christ Shown to the People* (illus. 58), although Christ is *shown*, the figures in the foreground do not see him; in their hands the loaves and fishes remain totally unmiraculous. The Christian symbols are just dead matter, and the image spells out the forces of creatural inertia and carnal appetite that resist to the end the opportunity of their own salvation.

One is dealing here not only with a theological message – the oppositions between the sacred and the profane, between virtue and vice – but with class issues as well. Though *The Butcher's Stall* is less ferocious than Brueghel's *Battle between Carnival and Lent* (illus. 34) in its caricaturing of lower social groups, country life is still seen through a lens of class difference that looks down on peasant existence from the heights of privilege. The condemnation of materialism issues from the viewpoint of the upper class urban élite for whom such pictures were made, and to whom the activities of the lower orders – retail trade, in fish, meat and vegetables – appear as morally as well as socially inferior. The moral and the social are fused together, and the rural and urban poor are used as figures in a discourse of class humour, in which lower social status is associated with the lower functions of the body (consumption, ingestion), and with the bodies of animals.

The constative level, then, is plainly legible: the sacred is higher than the profane, as educated humanist circles are higher than the trading or servant classes, and as the life of the spirit is higher than creatural or animal existence. What complicates this coarsely simple scheme, however, is the manner in which these oppositions are *performed* by the image. The radical inversion of scale in Aertsen and Beuckelaer keeps intact the constative level of the image (as the message 'money is not everything' remains intact regardless of the speaker), but enunciates it in such a way that the 'lower' terms of the opposition take precedence over the 'high'. When *The Butcher's Stall* comes to enact or dramatise its oppositions the biblical scene virtually disappears. In *Christ in the House of Mary and Martha* the figures named in Scripture as Christ, Mary and Lazarus become impalpable and shadowy, while the image gives itself over to the nameless kitchen workers, vividly represented. In *Christ Shown to the People*, Beuckelaer handles the sacred area of the painting as an

58 Joachim
Beuckelaer,
*Fishmarket: Christ
Shown to the People*.
Nationalmuseum,
Stockholm.

indistinct blur; it is hard even to discern the figure of Christ among the figures of the guards. *As enunciated by the image* the constative level becomes subordinate to a performative level in which the message is inverted, so that the profane is more important to the image than the sacred, the servants are a stronger presence than their master, and what is carnal drowns out what is spiritual.

As with the *vanitas* pictures, this contradiction should be seen not as a rhetorical misfortune (or 'mannerist' perversity) but rather as the images' fundamental semiotic structure. Whereas the Albertian window of Italian painting opens effortlessly onto sacred spaces and transcendental truth, in the Northern context this access to the transcendent is exactly blocked and prevented: transcendental truth does not belong to the realm of the visible; it cannot be simply pictured. The God of the Reformation is a *hidden* God, and where the Catholic vision of Ignatius of Loyola is able to visualise Hell or the Crucifixion directly, Calvin cannot *see* anything.[8] Accordingly, what is sacred or transcendent cannot be *authenticated in vision* by pictures, for vision here has no direct access to things of the spirit. The constative statement 'all is vanity' can only be performed by an image which, paradoxically, is itself a vanity, a bauble. In Aertsen and Beuckelaer the sacred can only be glimpsed – through a glass, darkly – through the medium of a fallen world.

59 Diego Velázquez, *Christ in the House of Mary and Martha*. National Gallery, London.

150

60 Diego Velázquez, *The Black Servant*. Chicago Art Institute.

61 Diego Velázquez, *Woman Cooking Eggs*. National Gallery of Scotland, Edinburgh.

Velázquez' version of *Christ in the House of Mary and Martha* employs the same dual structure used by Aertsen and Beuckelaer, but with greater reflection on the ways the art of painting may itself be implicated in the dialogue between high and low (illus. 59). The inset scene showing Christ, Mary and Martha has been interpreted as an adjacent room – so far, no difference from Velázquez' Northern predecessors; but it has also been interpreted as a mirror hanging on the wall behind the two women (here one must think of the figures in the inset scene as placed behind the spectator), and also as a painting within a painting.[9] The latter possibilities considerably enrich and complicate the subject, taking it into the same region of meditation upon the value and ends of art that is explored in Velázquez' paintings *Las Meninas* and *Las Hilanderas* (illus. 63). What the mirror and the picture-within-a-picture introduce is the idea of a radical disjunction of being between the exalted plane of the gospel protagonists, and the life of unremitting labour to which

62 Wolfgang Heimbach, *Woman Looking at a Table.* Staatliche Gemäldegalerie, Kassel.

63 Diego Velázquez, *Las Hilanderas*. Museo del Prado, Madrid.

the lesser figures are condemned. In *Las Hilanderas* the goddess Athene occupies much of the same uncertain space as Christ, Mary and Martha do here, half way between reality and representation. The goddess of crafts has been challenged by Arachne, a lowly mortal esteemed for her skill in weaving, to a tapestry competiton; Athene wins effortlessly, and in punishment for her *hubris* turns poor Arachne into a spider. The meaning of Velázquez' image has been vigorously debated, and all one need note here is Velázquez' interest in the separation of worlds – divine art opposed to mere craft, the effortless brilliance of court art opposed to the endless work of the spinning wheel.

In *Christ in the House of Mary and Martha*, the two worlds occupy quite different levels of reality. Whereas in Aertsen and Beuckelaer continuity between high and low is supplied by architecture and unified groundplan, here they differ as radically as the real world differs from its reflected image, or from a painting. Such disjunction emphasises the 'negative' side of the dialogue: high and low can never meet. In their lined, tense faces, and in the gestures of an arm so adapted to its mechanical tasks as to be virtually an extension of the pestle and mortar, the women express a life of domestic service and toil so locked into the routines of mundanity that the exalted goings on elsewhere in the house might just as well be fiction, a picture on the wall. Although the doctrine of the Incarnation maintains that Christ's

appearance in the world transfigures all of mundane existence, here the transfiguration seems singularly localised, confined to the strangely lit room where Christ presides: the fragrance of nard is lost in the smells of the kitchen. This is not to deny the reverse reading (and all these images are structured by the figure of *peripateia*, reversal), that the pattern of Christ's life raises and dignifies the world of creatural toil. The strength and sheer presence of these two women dominate the image, all the more forcefully because offset by the mysterious and impalpable scene behind them. Velázquez' balancing of the positive and negative versions of the high/low dialogue is as even and in the end as undecideable as Aertsen's or Beuckelaer's. But what Velázquez adds is the sense that in this dialogue painting contemplates its own fate, divided between the heroic world of court or history painting, and the no less insistent claims of still life.

This is not simply a formal choice between genres, but a genuine crisis in which painting is forced to contemplate two utterly different conceptions of human life: one that describes what is important in existence as the unique event, the drama of great individuals, the disruptions of creaturely repetition that precipitate as narrative; and one which protests that the drama of greatness is an epiphenomenon, a movement only on the surface of earthly life, whose greater mass is made up of things entirely unexceptional and creatural, born of need on a poor planet. At the same time, painting is forced to address two diametrically opposed conceptions of its own place in the world: as high art (Velázquez as courtier) and as mere craft (Velázquez as servant). With this artist this dilemma is never far from the question of class. In *Las Hilanderas* the figures surrounding Athene wear the costumes of the court, Arachne wears the clothes of a worker. In *Christ in the House of Mary and Martha* the elegant gestures of Christ and the pretty features of Mary are placed against the toughness and peasant strength of the women in the kitchen – and it is to them that Velázquez extends the privilege of the gaze back towards the spectator. But the issue of class, and the irrelevance of both high-plane reality and megalography to the classes excluded from narrative and greatness, are sharpest in two remarkable works attributed to Velázquez, both known as *The Black Servant*.

The version of the painting in the Beit Collection (illus. 64) continues the Aertsen/Beuckelaer line. The biblical subject is now the Supper at Emmaüs, the moment when Christ reveals

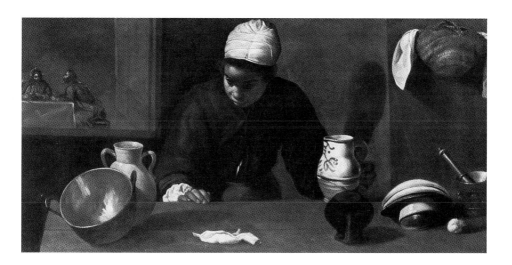

64 Diego Velázquez, *The Kitchen Maid with Christ at Emmaüs (The Black Servant)*. National Gallery of Ireland, Dublin.

his resurrected glory to his followers. Yet the black servant takes no part in this momentous recognition scene. She may be listening; or her face may simply indicate vacancy and exhaustion. But for her, the moment of Christ's self-revelation appears only as a disregarded picture on the wall. Painting is inescapably caught up in this division between mundane and supramundane. The figures behind the servant make up a history painting (and they are painted in the appropriate style, with loose, free brushstrokes liberated from the task of transcribing solid, tangible matter). The objects before her naturally compose a still life (and here the brushstrokes are tight, hard, committed to accuracy). Where do painting's loyalties lie? Do still life and *its* values take precedence in this image over history painting, and the values of history painting? The Chicago version of *The Black Servant* (illus. 60) suggests that they may: the scene at Emmaüs disappears and the wall behind the servant closes over. It is an image of creaturely existence entirely excluded from greatness and from history: still life here tackles the truly overlooked, a woman, a servant, and black, and her life amidst *rhyparos*, waste. Even if we forget all about the connection with the Emmaüs picture and consider the Chicago version of *The Black Servant* by itself, the meaning of the image is still that of the overlooked, both objects and persons. And the painting thinks the link between them through to its inevitable and bitter conclusion: that just as these objects are treated as articles of use, just as they are part of an endless round of need and drudgery, just as they are never truly seen, so is she.

Still life expresses here the suppression and confinement of those outside the charmed circle of history and greatness. This, too, is the charge of the still life included by Jacques-Louis David in his painting of *Brutus*, the basket, scissors and wool placed in a table in the centre of the image (illus. 65). The story is as follows. With the deposition of the Tarquin kings Rome has now become a republic, and Brutus is its first consul. But before long a conspiracy is discovered which aims to overthrow republican government and reinstate the line of kings; and the conspirators turn out to be none other than Brutus' own sons, whom he has ordered to be executed. The painting records the moment when the lictors return the bodies of the sons to their father's house. The scene is depicted as two mutually exclusive domains, that of the Roman state and that of the family. Spatially, the image divides between the great events of history, Brutus and the bodies of his sons on the left, and the eventless continuities of household life, to the centre and the right. While the world of the men gives itself over to political risk and sacrifice, heroic action and stoic resignation, that of the women is passive,

65 Jacques Louis David, *The Lictors Returning to Brutus the Bodies of his Sons*. Musée du Louvre, Paris.

domestic and frightened: they are coralled within the house and confined to the atrium, and while the sons of the house are being executed, they sew. The still life with sewing basket sums up the routines, the small duties, also the irrelevance and powerlessness of domestic life in the face of the Roman state. To the left of Brutus, on the pedestal of the statue of *Dea Roma*, a relief showing Romulus and Remus suckled by wolves testifies to the origins of Rome outside the sphere of family life. Rome rejects the household as its political foundation; Brutus condemns his sons to death. The still life of the women is the embodiment of everything that this system of political value refuses: domesticity, routine, repair.

The idea of female seclusion and confinement in the *Brutus* is reinforced by Yvonne Korshak's recent, lynx-eyed observation that on the border of the fabric in the sewing-basket there appears a fleur-de-lis, French symbol of monarchy.[10] As Livy tells the story, Brutus' sons were in fact involved in the conspiracy by their mother, a sister of the Vitelli, one of the most important royalist families remaining in Rome. Leaving for once to one side the question of the fleur-de-lis' reference to contemporary French politics, and placing the motif in the field of sexual difference with which the image is no less concerned, what is striking is the contrast between Brutus' mode of political action and that of his wife. Where Brutus acts openly and in full public view, his wife must proceed obliquely and surreptitiously, acting through the men of Brutus' family: the possibility of direct political action remains entirely closed. That the fleur-de-lis has passed for so long unremarked must in part be a reflection of a situation in which women are not expected to feature in political narratives; but it is also the result of the fact that Brutus' wife has been forced to hide her politics, as she hides the emblem of that politics, and hides it so successfully that generations of viewers seem not to have noticed it at all.

David's painting is crucial for the present discussion as an index of the degree to which the division between the exalted and the mundane is not simply a matter for neutral or philosophical debate, of world-views between which an individual might freely choose. The opposition between megalography and still life, between the values of greatness, heroism, achievement, and the values which rhopography pits against them, certainly operates. Yet the opposition does not exist in a vacuum: *it is overdetermined by another polarity, that of gender*. Let us go back over

the past few images. In the Beuckelaer *Christ in the House of Mary and Martha* (illus. 57), the principal foreground figures are female, and the whole narrative concerns the entry of divinity into a house of women. The domestic space is not conceived as masculine, or named after Lazarus. The only event at the feast which scripture records is Mary's anointing of Christ's feet with perfume and her hair; and whatever other meanings circulate within this complex narrative moment, *visually* it delivers a scene of female submission. In Velázquez' version of the same subject (illus. 59), while Christ confers his benediction, Mary kneels; and in the foreground, low-plane reality is unambiguously gendered through its two representatives, the servant women. In Velázquez, the kitchen is always a female domain. Men may enter it and converse, as they do in the Apsley House painting of *The Meal*. They seem at home there, talking and drinking; but we do not see them work. Whereas the women are never seen doing anything else: their bodies are permanently locked into pestle and mortar, cauldron and spoon (illus. 61). The black servant is completely excluded from the masculine table, and from all the possibilities of escape from creatural limitation which the Emmaüs story might suggest. With David's *Brutus*, the image exactly follows the Roman scale of values: while the male reveals his *virtus* through political action, the virtue of the Roman matron is expressed through her needle.

The universe of rhopography, of creaturely limitation and low-plane reality, is not indifferently gendered: on average its delegates are far likelier to be women than men. Of course there are exceptions. In Cotán, celibacy and monasticism put the question of gender largely to one side. In Beuckelaer's *Christ Shown to the People*, men and women alike occupy the fallen world represented in the foreground, and the sexual flirtations in progress as Christ passes unnoticed outside accuse both sexes evenly of depravity and spiritual sloth. But certainly in the case of Dutch still life of the seventeenth century, the interior of the house is regarded as intrinsically female space. It is women rather than men whose job it is to guard the moral and physical purity of households. Jacob Cats, fountain of popular wisdom, is quite blunt about it:

The husband must be on the street to practise his trade
The wife must stay at home to be in the kitchen
The diligent practice of street wisdom may in the man be
praised

But with the delicate wife, there should be quiet and steady
ways
So you, industrious husband, go to earn your living
While you, O young wife, attend to your household.[11]

Genre scenes showing the interior of Dutch houses are equally
clear on this point: the man's proper sphere is outside the house.
In Vermeer's *Soldier and Young Girl Smiling* (illus. 66) the male
occupies the left of the painting, open to the light outside; he
has just entered the domestic space, and still wears the dashing
hat of the great outdoors; against the hat is placed a map, symbol
of that wider space of commerce which belongs exclusively to
men. While his formally crooked elbow and hidden features indi-
cate some degree of unease at entering the lesser domestic space,
no such awkwardness attends the girl — she, not he, is truly
at home in the interior world. 'Men must earn and see that no
one is in want; women must spend and provide.'[12] The culture

159

prescribes that men and women inhabit separate spatial universes; and painting responds by giving to men the all-male guilds (*doelen* pictures), the constabulary (Rembrandt, *The Night-Watch*), trade (seascape); and to women the management of the home, the supervision of servants, the education of children, the planning of meals.

Someone might complain at this point that the argument has strayed from still life into genre scenes, where different conditions may apply. But to understand still life of the table one needs to take into account the asymmetry of the sexes with regard to the domestic space of which the table is the centre. In Dutch culture of the seventeenth century responsibility for the orderliness and good management of this space is regarded as a female rather than a male prerogative, and when still life of the table sounds the theme of disorder, asymmetry of the sexes is an important factor in the emotional nuancing of the scene. In the iconography of disorderly tables one finds watches, abandoned documents, envelopes spilling tobacco, pipes and pipe-spills, even swords; all masculine attributes, which suggest that the calm of the table and of the household have been disturbed by the male and his unruly habits and pleasures. It is as though the source of the household's well-being and prosperity is also at odds with its peaceable ways. Or rather, in this littering of the table with masculine paraphernalia, there is signalled the male's inability or refusal to harmonise with the domestic space. Something will not yield: against the 'quiet and steady ways' of the household, the male asserts the resistance of his wayward appetites, and the emblems of his masculine identity. Confrontation with the eventless routines of domestic life provokes the re-assertion of an allegedly higher level of reality: dramatic, possibly violent (swords), pre-occupied with more important business (watches, documents), or claiming the right to a few well-earned peccadilloes (pipes, tobacco, drink).

In *pronkstilleven* this other approach to domestic space is particularly evident: the table is totally refashioned in male terms. Instead of being tied to the small-scale routines and local spaces of the house, the objects open out onto the great masculine world of trade and navigation. The Ming porcelain and Turkey rug in Willem Kalf's *Still Life with Nautilus Cup* (illus. 46) speak, certainly, of the colonisation of distant territory, but equally they colonise the household, absorbing it into the larger and abstract space of the commercial empire. More deeply, the image wants

nothing to do with the creatural anonymity and ordinariness of domestic culture. The table, locus of this indifference to achievement and distinction, is rebuilt as a *Wunderkammer*, a place of the extraordinary and exceptional; it is taken over by the drive towards personal uniqueness, as expressed through unique possessions, and is annexed to the merchant dream of riches. At the *de luxe* end of the still life spectrum, the intimacy of the household, its sense of self-sufficiency and completeness, is broken apart by display: now the objects on the table rise up theatrically before a different kind of gaze, coming to the household from the greater world beyond it, where prosperity is not something to be enjoyed in itself so much as something to be converted into prestige and social distance, the distance, in fact, between business competitors. The male gaze of capital demolishes the table as the body's nest of creatural pleasure and hospitality, and replaces it with an imagery of achievement, ambition and grandiloquence; low-plane reality, identified with feminine and domestic space, is refused. The *pronkstilleven* of Kalf portray the table in such a way that between the great spaces of the outer world and the reconstituted interior there is now no detectable break, and an image appears of a unitary world ruled by one sex only, and presided over by the single, masculine gaze.

Nor is this tendency confined to the Netherlands. In the *Peaches and Silver Platters* of François Desportes (1661–1743) one finds the same cancellation of domestic space (illus. 67). The table becomes a sort of buffet, and is given a theatrical velvet drape; no coherent domestic space or action can be inferred from the display. The peaches exist primarily as a means to multiply the reflections of the silverware, not as nourishment, and rhopography's concerns with the creatural culture of the table are overruled by an insistence on aristocratic privilege and power, again expressed as male: the dead game to the right of the table key the wealth to the masculine sphere of hunting. In terms of use the juxtaposition of the objects is absurd: the silver platters, the fantastic ewer, and the sauce boat all seem empty (and the combination of peaches and raw game makes no sense at all at the level of tastebuds). What the image aims for is exactly the triumph of pomp and prestige over the trivial culture of the table, a triumph that is unambiguously coded as male. By contrast the *Still Life with Round Bottle* by Anne Vallayer-Coster (1744–1818) shows none of this rejection (illus. 68): the objects

are stated frankly and on their own terms. There is no desire to inflate the scene beyond itself; domestic life is left as it is, not translated into another, supposedly 'higher' discourse (of achievement, rank or wealth). The painter is able to participate directly in the space without anxiety about her capacity or right to do so (for Chardin such participation is exactly problematic), and there is no attempt to find for the scene any ulterior justification (Chardin always has the alibi of his dazzling technique).

The still life of luxury appropriates the table and recasts it in terms of male wealth and social power. But the appropriation can equally well be aesthetic. The paintings of Peiraïkos showed only the basest kinds of objects, yet they sold for more than other artists were paid for their largest works: a level of material culture that is alleged to possess no inherent value is elevated to greatness by sheer force of technique. What is admired is the bravura display of skill that confers on humble things the mystique of creativity working at a level infinitely higher than that of its nominal subject. Necessarily this idea of the bravura

67 François Desportes, *Peaches and Silver Platters*. Nationalmuseum, Stockholm.

68 Anne Vallayer-Coster, *Still Life with Round Bottle*. Gemäldegalerie, Berlin.

69 Anne Vallayer-Coster, *Still Life with Ham*. Gemäldegalerie, Berlin.

performance downgrades the value of the materials it condescends to work with. In the Caravaggio *Basket of Fruit*, for example, it is important that the objects appear not as prize specimens but as dry, unpromising, and blemished (illus. 70). The imperfection of the fruit makes it clear that it is the painter who confers their beauty and raises them up to the heights of art. The degree to which Caravaggio's striving towards a level of exalted art may be part of a masculine ideology can be sensed if we compare his work with that of his own contemporary, Fede Galizia (1578–1630; illus. 72). Galizia and Caravaggio are the two great pioneers of still life in Italy; both shared the same aspiration to create a new form for Italian art, based on inanimate objects. But where Caravaggio's still life stresses drama, spectacle, and a bravura display of skill, Galizia's still life is much closer to its subject. The fruit are seen from close by; they belong in a continuum with painter and viewer, they do not stand out from their surroundings as do Caravaggio's stencilled forms, but rather merge and blend into the shadows around them. The painting is certainly skilful, but it makes no attempt to astound the viewer with pyrotechnics. Though the work's historical claim to invention is no less than Caravaggio's, the tone of its ambition is far less strident. Caravaggio wants to inject into his scene qualities of the heroic and the extraordinary; mundane space is intensified to the point of theatricality and hyper-reality. But Galizia sees no need to intensify the scene; it is engaging enough in itself. In a sense Caravaggio paints his subject from on high: the basket of fruit is held in a discourse of mastery that disclaims ties with everyday reality; it quotes the everyday as though from above. Galizia paints from within the same plane of existence as her subject; one could reach out to touch these fruits – where in Caravaggio tactility, along with all clues concerning depth, is strikingly suppressed.

Similarly in the Cézanne *Still Life with Apples*, the ordinary logic of the table is overturned by the higher logic of the studio (illus. 71). Although the presence of such things as pitchers, glasses and napkins still refers to the routines of domestic space, the table above all forms an aesthetic composition whose internal order has nothing to do with the usual placement of objects in a house. In a sense Cézanne's collocation of objects is no less irrational in terms of domestic use than the artificial display created by François Desportes (illus. 67). The painter's relation to the objects is presented as utterly different from the relation

70 Detail of *Basket of Fruit*, Caravaggio (illus. 21).

71 Detail of *Still Life with Apples*, Paul Cézanne (illus. 22).

72 Fede Galizia,
*Still Life with
Peaches in a Porcelain
Bowl.* Silvano Lodi
Collection,
Campione.

of those who use them practically. That Cézanne's insistence
on non-participation in the domestic space *as a condition of access*
to high art may again be a function of a masculine construction
of visuality emerges with some force if we turn to a still life
by Paula Modersohn-Becker (1876–1907; illus. 73). Her place-
ment of the objects on the table is handled with scrupulous atten-
tion to the internal rhythms they create on canvas, and that the
forms belong primarily in the flatness of the picture plane is
underlined by the schematism and abstraction of the fleur-de-lis
behind. But this emphasis on design is not *at odds* with the reality
of the table as part of actual and everyday space. The hand which
balances the formal composition is also able to reach out and
make tea; no fundamental discontinuity of levels opposes art
to the ordinary gestures of living.

The risk with Cézanne's strategy of pitting art *against*
domestic space is that the presence of painting in the household
interior can appear as an *invasion*; and this may pose serious
problems for whatever aesthetic harmonies the painting may
seek to create. Cézanne's still life seems actually unaware of the
difficulty. But the work of Chardin is acutely sensitive to the

dangers of disruption that emerge when painting and domestic space collide. In Chardin's genre scenes the work of the household is largely (though not entirely) performed by women: it is they who draw water from the well, return from shopping, supervise the children, and create the atmosphere of placid domestic industry (illus. 74, 75). The division of labour is clear: the women run the house, the man paints. But Chardin works hard to record the domestic scene in such a way that the presence of painting does not disrupt the harmonies it values there. In Zurbarán, for example, the objects are arranged in a straight line, and the line is parallel to the picture plane: placement is dictated to the objects by the commanding force of the frame. But Chardin minimises the intrusive influence of the frame and takes pains to suggest that the work of painting has done nothing to re-organise the contents of the scene. Again, in Zurbarán an intense focus brings brilliance and clarity to all the

73 Paula Modersohn-Becker, *Still Life with Blue and White Porcelain.* Niedersächsisches Landesmuseum, Hanover.

objects represented, but in Chardin focus is relaxed: the image records what a viewer might actually see in a familiar domestic scene, where nothing need be given the strain of high focus. All of these devices imply Chardin's desire to enter the feminine space of domesticity gently and invisibly; Chardin, and his viewer, are ushered in quietly and without fuss. His paintings are the opposite of those Dutch still lifes where machistic emblems strew the table, in male assertion and resistance; Chardin wants to capitulate, to make himself and his canvas *porous* to the female space. The goal of his lazy, peripheral focus is non-invasive participation in the spaces of the household. Informal composition and peripheral haze in Chardin are the means of overcoming the barrier created by the household divi-

74 Jean-Baptiste-Siméon Chardin, *The Return from the Market*. National Gallery of Canada, Ottawa.

sion of labour, and the tensions it creates: the bar of gender is crossed by perceptual immersion.[13]

There is another aspect to this dissolution of the barriers between domestic space and the space of the canvas (or easel). The extraordinary textures of Chardin's paint, the play between wet and dry pigment, and the painstaking development of each square inch of the canvas, all embody a particular attitude of the painter towards his own work. Chardin renounces the rhetoric of artistic inspiration in favour of an even working method, without peaks; he declares that what he does is *métier*, craft. And the craft of painting is made to seem much like the other kinds of craft presented in his scenes. Look at any of his tables: they are painted with an insider's understanding of the skills of cabinet-making, with each joint and groove, every texture of varnish and wood-grain, carefully registered. Where in Kalf the painter and the craftsman are locked in an escalating, high-stakes competition where each tries to outbid the other, in Chardin the sense is rather of their kinship, and the community of craft; he admires the work of the joiner and has no interest in trampling on another's skill. This respect for labour extends to the work performed in the household, by its women. From the pace of the household he takes his own rhythm; art and domesticity are aligned to the point where the work of women is the *comparant* in a metaphor for the work of the artist. Instead of downgrading the genre, he upgrades women's work. The respect he accords his own labour passes into the labours around him, with which it is continuous.

Yet there are limits to such access even here. Chardin's women are far more locked into domestic chores than, for example, the women in the households of Vermeer or Metsu. They are given no dramas or confidantes; and physically they are presented as creatures of labour, always absorbed in the task in hand. Chardin's insistence on his own powers of painterly technique consequently has the effect of polarising this unskilled manual labour of the women in the house, and his own supremely skilled dexterity. At the same time that his technique works to overcome his position as outsider in the household, its virtuoso aspect widens the gulf. Similar complications arise from the feeling his work creates of extreme physical intimacy with the objects of the house. Exactly because the images are so perceptually immersed, they are necessarily viewpointed to a *single* observer. In the more usual still life technique of even high focus,

where all objects appear equally sharp, the issue does not arise so intensely: but when the picture is structured as the journey of an individual set of eyes, moving in unhurried fashion from perch to perch across the scene, the image cannot help but create the idea of *solitary* absorption. No-one else saw the scene this way; the visual field is made private and internal. The paintings convey a certain solipsism: the centre of the house can never be *in* the space of the table, but is always *behind* the eyes of the perceiver. Chardin's fascination with perceptual process consequently locates the scene in the male space behind the easel, rather than the space of the household — the latter accordingly exists to some extent *at a tangent* to the painting's true source, in perception. Chardin is the perceptual centre of the house. And finally there is the problem of the household's wealth. Chardin's extraordinary sense of intimacy with the immediately surrounding space has the effect of making it seem that the location of the still life is always home. All the objects painted have the feeling of personal familiarity and ownership. And it can only be the skilled labour of the painter that produces and pays for this home, not the labour of its inhabitants. The paintings emanate not only from the perceptual centre of the household but its economic centre as well: Chardin remains the man of the house. Though his work aims so carefully for non-seizure, non-intervention in the household space, there remains the sense that despite everything the status of masculine outsider can never be completely relinquished.

The still lifes of Chardin are exceptional in their awareness that when the male artist paints the interior world of the household, he encounters an obstacle which is without equivalent in the other genres, and which must be negotiated. The asymmetry of the sexes with regard to domestic life constantly works to place the male painter of still life in a position of exteriority to his subject. Inevitably, still life's particular mode of vision bears the traces of this exclusion. One such trace must surely be still life's fascination with effects of intense focusing, frequently amounting to glare. While there are exceptions, even in the Netherlands, and although in certain works by Heda and Pieter Claesz. focus varies from sharp to blurred, before Chardin still life seems to have been a camera with only one, unadjustable, lens, with the sole property of rending all objects in the scene in brilliant and *drilling* clarity. Where history painting is allowed and often required to generalise and abbreviate its forms, still

life is committed to meticulous particularity; even into the eighteenth century particularity was considered the essence of still life, the source both of its distinctness from the other genres and of its comparative limitation. For Reynolds, still life's position as craft rather than liberal art was the inevitable result of its inability to abstract itself from sensuous particulars and attain the level of general ideas where alone, Reynolds maintained, great art could be made. And on the basis of the evidence available to him Reynolds' conclusion is understandable: although in the nineteenth century still life was finally able to break with its tradition of 'high fidelity' realism, and for example in Corot, Fantin-Latour, Courbet and Manet at last to put an end to the rhetoric of sharp focus, concerning the still life tradition before and during his own lifetime, Reynolds was right: high focus and minute transcription are *the* dominant characteristics of the genre.

It is as if the world of the table and domestic space must be patrolled by an eye whose vigilance misses nothing. And in trying to understand this emphasis on gripping every last detail of that visual field through high-tension focus, the factors of gender asymmetry and male exclusion cannot be considered accidental. The male artist is peering into a zone that does not concern him directly. In a sense its values are alien to the masculine agenda. And spatially, it cannot be known from the inside. The result is often the production of the uncanny: although everything looks familiar, the scene conveys a certain estrangement and alienation, at their chilliest in *trompe l'oeil*. Freud, in his paper on the uncanny, writes that 'the *unheimlich* is something which is secretly familiar but has undergone repression, and then returned from it'. In the case of the male, what must be repressed and discarded if gender identity is to be secured, are the ties with the world of nourishment and creaturely dependence that centre on the mother. Where uncanniness is found, Freud maintains that it is always the product of the resurfacing of earlier memories, especially those of infancy; from the point of view of his theory, the locus of greatest uncanniness is the mother's body:

> It often happens that neurotic men declare they feel there is something uncanny about the female genital organs. This *unheimlich* place, however, is the entrance to the former *Heim* (home) of all human beings, to the place where each one of

us lived once upon a time and in the beginning. There is
a joke saying that 'Love is home-sickness'; and whenever a
man dreams of a place or a country and says to himself, while
he is still dreaming: 'this place is familiar to me, I've been
here before', we may interpret the place as being his mother's
genitals or her body. In this case . . . the *unheimlich* is what
was once *heimisch*, familiar; the prefix '*un-*' is the token of
repression.[14]

Freud's remarks on the uncanny are highly suggestive here. In
order to develop individual identity the child of either sex must
eventually leave the cocoon of warmth and fusion that is its
mother's body. For within that earliest and deepest relation to

another being, the subject cannot yet exist as subject; the boundaries defining self and other have not yet been drawn, and the infant remains an amorphous, undifferentiated bundle of sensations, bodily movements, and libidinal drives. This reign of fusion and commingling is destined not to last; both sexes lose the mother as site of imaginary plenitude. Yet the manner in which the mother is lost differs in either case. The girl is enjoined to separate from the mother along the path of identification, by modelling her being and her sexuality on the imago which the mother provides. She must pass from fusion to separation to imitation, in a triple movement of extraordinary complexity and difficulty. The boy is enjoined to refuse identification with the mother: the realm of the mother represents what he must give up, and if identification with the mother nonetheless occurs and persists, it is at the cost of running counter to the codes of masculinity that order him to internalise the imago of the father. The ban on remaining within the maternal domain is in his case further reinforced by the proscriptions and sanctions which, issuing from the father, require the male child to disengage from the sexual connectedness with the mother's body which he had previously known. If the male child is to survive the Oedipal crisis, it must be by instituting a rejection of that earlier, archaic fusion. Far more insistently than the girl, the boy must draw a line of separation between himself and the domain of maternal nourishment and warmth. In this later perspective, the persistence of his desire to remain within the maternal orbit represents a menace to the very centre of his being, a possibility of engulfment and immersion that threatens his entire development and viability as a subject; the enclosure woven by the mother's skin, touch, and voice threatens his ability as subject to enter the world of representation and signification. The seductiveness of the mother's body, together with her milieu and its mystique, become dangers he must escape; and he can do so by no other means than by claiming as his another kind of space, away from that cocoon and its fascinations; a space that is definitively and assuredly *outside*, behind a protective barrier, a space where the process of identification with the masculine can begin and can succeed.

Still life bears all the marks of this double-edged exclusion and nostalgia, this irresolvable ambivalence which gives to feminine space a power of attraction intense enough to motor the entire development of still life as a genre, yet at the same

76 Antoine Raspal,
Cuisine Provençale,
Musée Réattu,
Arles.

time apprehends feminine space as alien, as a space which also menaces the masculine subject to the core of his identity as male. The debt which the male painter of still life owes to the maternal enclosure is felt in an aesthetic practice which through and across secondary repression (the founding of signs, including the signs of painting) touches on the primal repression of the mother's body. Still life's preference for focus that strains the visual field to the point of glare is long-lived and widespread: one finds it in Cotán and Zurbarán in Spain, in Caravaggio in Italy, and throughout the golden age of still life in the Netherlands. Given the choice between making the visual field of still life appear welcoming and intimate, in the manner of Chardin or Vallayer-Coster, and making it appear radically estranged, as in *trompe l'oeil*, the tendency to veer towards estrangement is far more pronounced. This sense of the space of still life as alien to the male painter, incapable of being occupied from the inside, and at the same time as a place of fascination and obsessive looking, points to an ambivalence which the discourse of psychoanalysis

173

does much to clarify. Still life of food, in particular, seems to require extremes of rationalisation and displacement. In Cotán, the approach to food is elaborately indirect: it must not be touched; its sensuous appeal is disavowed. At the same time, the repression involved invests the contents of the larder with an uncanny intensity that makes sense in terms of Freud's concept of a return of the repressed. In Caravaggio, the value of food as nourishment is denied, and food becomes the pretext for a bravura display of artistic strength. Similarly in Cézanne, the table is ignored as a place of nourishment and converted instead into the space of the studio, where creatural dependency turns into extraordinary aesthetic ambition. In Dutch *vanitas* still life, the issue of nourishment is deflected into a 'higher' discourse of ethics. Food is associated with an unruliness that is quickly returned to order by the craft values embodied in painting itself. The table is marked by complex signs of hesitation, bordering on refusal and the re-assertion of masculine identity. In the still life of luxury, the space is rebuilt in terms of male wealth and ownership. In all these cases one finds the same pattern of rejection of the space of the table *per se*; to be acceptable it must present itself as some other thing – art, morality, prestige, production – through which male superiority may be re-affirmed. Above all, the space must be controlled: subjected to a relentless and strenuous focus; redesigned first as a composition of objects, and redesigned once more as a composition on canvas. The exteriority of the painter to the scene is dealt with by power working on a number of levels at once, in a tremendous *exertion* of masculine resources operating upon the scene from outside.

Throughout its history still life has been a genre regarded as appropriate for women painters to work in. The paintings by Rachel Ruysch (1664–1750) and Margareta Haverman (*d.* 1772) are virtuoso performances on a par with those of Willem Kalf or de Heem. In all countries, flower pictures in particular are a category in which women painters may excel, though guild membership was always the great obstacle: Fede Galizia, Louise Moillon (1609–1696) and Anne Vallayer-Coster in France, Judith Leyster (1610–1660), Haverman and Ruysch in the Netherlands, Barbara Regina Dietzsch (1706–1783) in Germany.[15] Yet by the eighteenth century flower painting itself devolves towards a genteel female accomplishment: in the second half of the eighteenth century there were between fifty and a hundred women flower painters exhibiting in London

alone, but in the amateur reaches of the art world, well away from the centre stage of the Royal Academy.

From the beginning still life was systematically downgraded by the defenders of the higher genres who in their theoretical work provided the rationale for the professional hierarchy of the genres, with history painting, the exclusively male genre, at its apex. If still life could be regarded as an appropriate channel for female talent, this was because it ranked as the lowest form of artistic life, of course below the painting of biblical, mythological and national subjects, but also below portraiture and landscape, even below animal painting (Félibien: 'He who paints living animals is more to be esteemed than he who only represents *des choses mortes et sans mouvement*'). Supposedly requiring no thought at all to produce, still life represented the mechanical other to the exalted aims of the Academies' *grande manière*. In the words of Reynolds:

> The value and rank of every art is in proportion to the mental labour employed in it, or the mental pleasure produced by it. As this principle is observed or neglected, our profession becomes either a liberal art, or a mechanical trade. In the hands of one man it makes the highest pretensions, as it is addressed to the noblest faculties: in those of another it is reduced to a mere matter of ornament; and the painter has but the humble province of furnishing our apartments with elegance.[16]

Still life, unable to abstract itself from its entanglement in detail, and incapable of producing mental as opposed to merely sensuous pleasure, is crushed by Reynolds' megalographic doctrine, that great art can exist only when particulars are shed and art achieves the level of 'general ideas'. It is true that there is a moment when Reynolds seems to hesitate and go back on his principles, offering a crumb of hope to those condemned to the 'subordinate' branches of art:

> Even the painter of still life, whose highest ambition is to give a minute representation of every part of those low objects which he sets before him, deserves praise in proportion to his attainment; because no part of this excellent art, so much the ornament of polished life, is destitute of value and use.[17]

The phrasing is guarded: the attainment for which Reynolds praises still life is nonetheless attainment within the lowest rank

of painting, and its association, again, is with mere elegance and 'ornament'. And Reynolds quickly goes on:

> These, however, are by no means the views to which the mind of the student ought to be *primarily* directed. Having begun by aiming at better things, if from particular inclination, or from the taste of the time and place he lives in, or from failure in the highest attempts, he is obliged to descend lower, he will bring into the lower sphere of art a grandeur of composition and character, that will raise and ennoble his works far above their natural rank.[18]

Those among his audience not destined by talent or good fortune for the heights of history painting might be forgiven for finding Reynolds' words less than encouraging. If you *fail* as a history painter, all is not lost, because the experience of history painting will enable you to do well in, say, landscape or portraiture. But it will not help with still life, a genre nothing can salvage:

> Some here, I believe, must remember a flower-painter whose boast it was, that he scorned to paint for the *million*; no, he professed to paint in the true Italian taste; and despising the crowd, called strenuously upon the *few* to admire him. His idea of the Italian taste was to paint as black and dirty as he could, and to leave all clearness and brilliancy of colouring to those who were fonder of money than of immortality. The consequence was such as might be expected. For these petty excellencies (of colour) are here essential beauties; and without their merit the artist's work will be more short-lived than the object of his imitation.[19]

Reynolds' official point is that flower paintings are nothing without colour, where colour is the mark of immersion in sensuous detail, and of failure to attain the level of 'general ideas'. But his joke turns on the absurdity that still life should consider even trying to raise its rank by shedding particularity: particularity is its essence – and its permanent disqualification from greatness.

The ability to abstract from particulars and to form 'general ideas' is not, in this context, a matter simply of intelligence, neutrally conceived. The kind of intelligence Reynolds advocates is overdetermined by gender in that the capacity to work in the grand style is assumed to be given only to men; women

may work at flower pictures because the immersion in particularity required is suited to their nature (Valéry: 'the more abstract an art, the fewer women there are who have made a name for themselves in that art').[20] Reynolds' addressees at the Academy, the 'Gentlemen' to whom each of the Discourses is directed, are an exclusively male audience; and the grand style to which he directs their energies is recommended to them in unambiguously gendered terms, as 'the more manly, noble, dignified manner'.[21] In Shaftesbury, for the male viewer to admire the sensuous detail of painting is to fail in the masculine virtues of mental labour and abstraction:

> So that whilst we look on paintings with the same eyes as we view commonly the rich stuffs and coloured silks worn by our Ladys, and admired in Dress, Equipage or Furniture, we must of necessity be *effeminate* in our Taste and utterly set wrong as to all Judgment and Knowledge in the kind.[22]

Shaftesbury's words indicate two distinct modes of vision, divided between the sexes at birth: to the male, vision under abstraction, rising above mere detail and sensuous engagement to attain the general over-view; to the female, vision attuned to the sensuous detail and surfaces of the world, colour and texture, rich stuffs and silks. For the male to be drawn away from abstraction towards the mode of female vision is for him to desert his sex: even to *look* at still life, which entails a descent into the sensuous particularity of things, is to put manhood at risk. The same bias is obvious throughout Burke's discourse on the Sublime: the higher style is couched in terms whose obvious roots lie in gender (rugged, strong, vast, powerful, terrible), as do the terms of the Sublime's opposite, the Beautiful (small, smooth, ornamented, graceful, tender). In discursive formations such as these, it is essential that still life be downgraded; it is the genre which can run counter to the whole project of equating great art with masculinity. Operating with a mode of vision that is proscribed to the male subject, it *must* be systematically denigrated. And the views of Reynolds, Shaftesbury and Burke are not confined to learned aesthetic debates of the eighteenth century. In the nineteenth century they become standard and general wisdom. From a journal of 1860:

> Male genius has nothing to do with female taste. Let men of genius conceive of great architectural projects, monumen-

tal sculptures, and elevated forms of painting. In a word, let men busy themselves with all that has to do with great art. Let women occupy themselves with those kinds of art they have always preferred . . . the painting of flowers, those prodigies of grace and freshness which alone can compete with the grace and freshness of women themselves.[23]

Within the terms of their own discourse the theorists were right in supposing that between the 'higher' and 'lower' forms of painting there existed a fundamental opposition of values. That was exactly the founding axiom of the ideology they worked with. Megalography seeks an image of human life that exalts the exceptional event and individual, magnifies personal distinction and achievement, and raises existence to the level of the gods. Against that, what we have been calling rhopography finds the truth of human life in those things which greatness overlooks, the ordinariness of daily routine and the anonymous, creatural life of the table. It is the same opposition which, in Greek theatre, is projected as the masks of tragedy and comedy. Their perspectives are complementary and intertwined, equally true and untrue, and between them, by exaggeration, they were perhaps able to give some structure and intelligibility to the confusing mass of human experience that lies between their extremes. It was inescapable that, in painting, the opposition between them fed into the division of the sexes. In the societies which produced still life, the opposition seemed naturally to parallel the construction of gender, with men leading so to speak megalographic, and women rhopographic, lives. For as long as painting, and the discussion of painting, concurred in awarding the palm to megalography, the domestic, interior space of still life would be represented as it appeared to men: inviting, alien, *heimlich* yet also estranged. And for as long as painting's mode of vision would be constructed by men, the space in which women were obliged to lead their lives would be taken from them and imagined through the values of the 'greater' existence from which they were excluded. As the category of the nude pictured women's body from the outside and re-fashioned it according to the logic of another point of view, so still life pictured the space of women from the outside and imposed on it the values of another world.

References

FOREWORD

1 Fredric Jameson, *The Political Unconscious: Narrative as a Socially Symbolic Act* (Ithaca, New York: Cornell UP, 1981), pp. 208–9; cit. Marcia Pointon, *Naked Authority: The Body in Western Painting, 1830–1908* (Cambridge: Cambridge UP, forthcoming 1990), Ch. 2.
2 Charles Sterling, *Still Life Painting: From Antiquity to the Twentieth Century* (2nd edition, New York: Harper & Row, 1981).

CHAPTER 1

1 That the rediscovery of the lost antique *xenia* strongly influenced the evolution of later Western still life painting is one of the arguments in Charles Sterling's classic study, *Still Life Painting: From Antiquity to the Twentieth Century*. Sterling's view has come under challenge, not least from Ernst Gombrich in 'Tradition and Expression in Western Still Life', in *Meditations on a Hobby Horse and other Essays on the Theory of Art* (London: Phaidon, 1963), pp. 95–105.
2 On the nineteenth- and early twentieth-century debates concerning the question whether the *Imagines* describe real or imaginary paintings, see Karl Lehmann-Hartleben, 'The *Imagines* of the Elder Philostratus', *Art Bulletin*, XXIII (1941), pp. 16–17.
3 Philostratus, *Imagines*, I, 31. The translation followed here is that of Arthur Fairbanks (Cambridge, Mass: Harvard UP, 1960), p. 123.
4 Philostratus, *Imagines*, II, 26.
5 On the Pompeian painting 'programmes', see the suggestive discussion by Richard Brilliant in his *Visual Narratives: Storytelling in Etruscan and Roman Art* (Ithaca, New York: Cornell UP, 1984), pp. 53–89.
6 Philostratus, *Imagines*, I, 9.
7 Michel Conan, 'The *Imagines* of Philostratus', *Word & Image*, III (1987), p. 163.
8 Mikhail Bakhtin, *Rabelais and His World*; trans. Helen Iswolsky (Cambridge, Mass: MIT Press, 1968), p. 281.
9 On 'pastoral' and 'georgic' in the context of the literary tradition of landscape, see Eleanor Winsor Leach's discussion in *Vergil's Eclogues: Landscapes of Experience* (Ithaca, New York: Cornell UP, 1974).

10 Claude Lévi-Strauss, *Le cru et le cuit* (Paris: Librairie Plon, 1964); trans. John and Doreen Weightmann as *The Raw and the Cooked: Introduction to a Science of Mythology: Volume I* (New York: Harper & Row, 1969). See also Lévi-Strauss, 'A Short Treatise on Culinary Anthropology', in *L'origine des manières de table* (Paris: Librairie Plon, 1968); trans. J. and D. Weightmann as *The Origin of Table Manners: Introduction to a Science of Mythology: Volume III* (New York: Harper & Row, 1978). The pre-cultural status of honey in a number of culinary systems is discussed extensively in *Du miel aux cendres* (Paris: Plon, 1966); trans. J. and D. Weightmann as *From Honey to Ashes* (New York: Harper & Row, 1973).

11 Euripides, *Bacchae*, 692–711.

12 Vitruvius, *De architectura*, Book VI, 7, 4.

13 The rights and obligations of hosts and guests in Greek society are explored in Arthur Adkins, *Moral Values and Political Behaviour in Ancient Greece* (London: Chatto and Windus, 1972), pp. 16, 20, 94. The guest arriving in a strange town was regarded as having too many things to do to attend to his marketing; and so provisions were provided with which he might make his first meal. Dinner with the host might take place some days after the guest's arrival.

14 The phrase is from Bakhtin, *Rabelais and His World*, p. 301.

15 The internal programme of Philostratus' text is analysed (and related to the possible architectural layout of the Neapolitan gallery) in Karl Lehmann-Hartleben, 'The *Imagines* of the Elder Philostratus', pp. 16–44. The question of Roman painting 'cycles' is further explored in Mary Lee Thomson, 'The Monumental and Literary Evidence for Programmatic Painting in Antiquity', *Marsyas*, IX (1960–61), pp. 36–77; and in Richard Brilliant's excellent analysis of painting 'pendants' at Pompeii, in *Visual Narratives*, pp. 53–89.

16 On the absence of signs of the 'paintedness' of the *xenia* in Philostratus, see Stephen Bann, *The True Vine: Visual Representation and Western Tradition* (Cambridge: Cambridge UP, 1989), pp. 36–7. Concerning the interconnections between Philostratus' *xenia* and Pliny's anecdotes about the grapes of Zeuxis and the curtain of Parrhasios, I am indebted to Bann's fascinating discussion in Chapter 1 of *The True Vine*, 'Zeuxis and Parrhasius'.

17 In ancient Greek theatre stage curtains were not used (there was no proscenium arch). But in Roman theatre a curtain placed in a slot next to the stage was used, and in Hellenistic theatre it may have been that the sets or *periaktoi* were hidden behind curtains while the scenery was being manipulated, and these curtains were then drawn back to reveal the new scene. Pliny may be invoking

these (later) theatrical effects in his discussion of Parrhasios'
curtain. Stephen Bann argues that Zeuxis' grapes are 'doubly
fictive', and that Parrhasios' curtain is likely to have been an actual
theatre curtain, in *The True Vine*, pp. 34–5.

18 Plato, *The Republic*, Book X, sections 1–2.

19 Plato, *The Republic*, Book X, section 9.

20 Concerning the ensemble of floor, wall and ceiling in Roman
decoration, I am indebted to Richard Brilliant's excellent account
in *Roman Art from the Republic to Constantine* (London: Phaidon,
1974), pp. 136 ff.

21 On the 'dissolve' effect of Roman ceilings, see Karl Lehmann, 'The
Dome of Heaven', *Art Bulletin*, xxvii (1945), pp. 1–27.

22 Suetonius, *Nero*, 31.

23 Mau's schema has undergone many successive waves of
reformulation and revision. Useful recent redefinitions of the 'Four
Styles' are in Alix Barbet, *La peinture murale romaine: les styles
décoratifs pompéiens* (Paris: Picard, 1985). In particular the neat
chronology of the Four Styles has come under fire: it seems likely
that particular styles were chosen for certain room configurations
and programmes.

24 The marbles of the First Style may have been more *faux* than
marbre: they do not in fact resemble any known marble, nor much
try to look like a possible marble. Professor Lawrence Richardson
has pointed out to me that the first coloured marbles (*Giallo antico*
and *africano*) arrived in Rome only after the First Style had
completely taken over. In the First Style one is already dealing
with the phantasmatic, and extremes of artifice.

25 On the Pompeian gardens, see Wilhelmina F. Jashemski, *The
Gardens of Pompeii, Herculaneum and the Villas destroyed by Vesuvius*
(New Rochelle, New York: Caratza, 1979). In some cases the
author reconstructs the Pompeian garden plans from
palaeobotanical evidence.

26 The opinion that the window in Cubiculum M must be a later
addition (or subtraction) may be supported more by modern
aesthetics than by the aesthetics of the period. It is true that the
window opening cuts right across the wall, and makes no
accommodation to the design; to modern eyes this looks
insensitive, and suggests that later occupants of the Villa Fannius
were unhappy about the room's darkness. However, a case at
Oplontis where a comparable interruption of the mural decoration
is unarguably part of the *original* design suggests that for the
Campanian decorators, modern ideas of 'appropriate' placement
of openings did not apply: the decorators simply excised a
portion from the decorative scheme. Moreover, in Cubiculum M
the column that begins below the opening does not reappear
above, as though the window had been included as part of the

original decorative scheme.

27 The spatial complexity of the frescoes in the Red and Black Rooms is observantly discussed in P. H. von Blanckenhagen and Christine Alexander, *The Painting from Boscotrecase* (Heidelberg: F. H. Kerle Verlag, 1962). See also Alix Barbet, *La peinture murale romaine*, pp. 109–116.

28 Vitruvius, *De architectura*, Book VII, 5, 3.

29 The theatricality of the wall fragment from Herculaneum is discussed in George M. A. Hanfmann, *Roman Art: A Modern Survey of the Art of Imperial Rome* (Greenwich, Conn: New York Graphic Society, n.d.), pp. 232–3.

30 Vitruvius, *De architectura*, Book VII, 5, 2.

31 On the social history of the *villa rustica*, see Maxwell L. Anderson, *Pompeian Frescoes in The Metropolitan Museum of Art* (New York: The Metropolitan Museum, 1987), pp. 13–16.

32 Trimalchio's feast is the subject of a fascinating interpretation in Tony Tanner, *Adultery and the Novel: Contract and Transgression* (Baltimore: Johns Hopkins UP, 1979), pp. 52–7. On the relations between power, violence and representation, my own discussion of the *Satyricon* is indebted to Reinhart Herzog's remarkable essay, 'Fest, Terror und Tod in Petron's *Satyrica*', in *Das Fest*, ed. Walter Haug and Rainer Warning, *Poetik und Hermeneutik*, 14 (Munich: Wilhelm Fink Verlag, 1988), pp. 120–50.

33 I am grateful to Lawrence Richardson for pointing out to me the 'hallucinatory' qualities of scale and focus in the Four Styles.

34 On the damage inflicted on the Pompeian sites by early archaeologists, see Richard Brilliant, *Pompeii AD 79: The Treasure of Rediscovery* (New York: The American Museum of Natural History, 1979), pp. 37–192.

CHAPTER 2

1 See, in particular, 'The mirror stage as formative of the function of the I,' in *Ecrits*, trans. Alan Sheridan (New York: Norton, 1977), pp. 1–7.

2 See Sterling, *Still Life*, p. 27. Sterling's implication, that 'megalography' and 'rhopography' are terms bearing on the painting of antiquity, seems to me unfounded. For one thing, evidence for the currency of the term *megalographia* in the ancient world is unforthcoming. As for 'rhopography', although the word is sometimes used in classical and post-classical texts, its etymology points less towards 'the painting of trivial objects, small wares, trifles' than towards landscape painting, or painting that is badly executed, or the pigments used in painting. Nevertheless, provided that the terms are understood to be modern rather than ancient, the distinction between

megalography and rhopography as Sterling defines them can be a useful one, and the present study employs it extensively. Although the related term 'rhyparography' has the advantage of being used in antiquity to refer to 'the painting of low or sordid subjects', including *xenia*, its inescapably perjorative sense makes it impossible for 'megalography' and 'rhyparography' ever to be on a par in argument: the negative associations of 'rhyparography' enforce a hierarchy in which megalography is necessarily the superior term. Since the present discussion eventually questions that hierarchical placing and judgment, I have avoided the term 'rhyparography' in favour of 'rhopography', even at the cost of assenting to a modern usage which, in the case of Sterling, somewhat muddles the roots of the word. For a comparable modern usage of the term, see Stephen Bann's account of 'high' and 'low' art in antiquity, in *The True Vine*, pp. 37–8.

3 See José Gudiol Ricart in 'Natures mortes de Sánchez Cotán (1561–1627)', *Pantheon*, xxxv (1977), pp. 314–17.

4 Cf. Roland Barthes, 'Imagination', in *Sade, Fourier, Loyola* (Paris: Seuil, 1971); trans. Richard Miller (New York: Hill and Wang, 1978), pp. 48–52.

5 The volumetric complexity of the objects in Cotán's painting is discussed by Martin S. Soria in 'Sánchez Cotán's *Quince, Cabbage, Melon and Cucumber*', *Art Quarterly*, VIII (1945), pp. 311–18.

6 To be more precise about Cotán's calculus: if the estimated centres of gravity for each fruit/vegetable are joined, the result is what is known as an exponential decay curve.

7 The manufacture of the objects in Zurbarán's still life is analysed by Helmut P. G. Seckel in 'Francisco de Zurbarán as a Painter of Still Life', *G.B.-A.*, XXX (1946), pp. 279–300.

8 For Sterling, the Caravaggio *Basket of Fruit* is 'a *trompe l'oeil* in the antique manner . . . undertaken in emulation of the ancients'; *Still Life*, pp. 59–60.

9 My description of the spatiality of Caravaggio's *Basket of Fruit* is indebted to the remarkable essay by Michel Butor, 'La corbeille de l'Ambrosienne', in *Repertoires III* (Paris: Minuit, 1968), pp. 43–58.

10 See the remarks on the *cantarero* by Xavier de Salas in Eric Young, 'New Perspectives on Spanish Still Life Painting of the Golden Age', *Burlington Magazine*, CXVIII (1976), pp. 203–14, note 10.

11 The terms 'presentation' and 'representation' are taken from Stephen Bann's brilliant discussion of Caravaggio and Poussin in *The True Vine*, pp. 68–101. Bann argues that still lifes by Caravaggio and Cézanne share the mode of 'representation as *presentation*', where the viewer does not 'see' but 'is shown' (p. 81). The terms are indebted, both in my discussion and in

Bann's, to Michael Fried's definitions of 'absorption' and 'theatricality' as Fried discusses them in *Absorption and Theatricality: Painting and Beholder in the Age of Diderot* (Berkeley: University of California Press, 1980).

12 The original framing of the Caravaggio *Basket of Fruit* is discussed in Sterling, *Still Life*, p. 60

13 On modes of signification in Cubist collage, see the important essay by Rosalind Krauss, 'In the Name of Picasso', in *The Originality of the Avant-Garde and other Modernist Myths* (Cambridge, Mass, and London: MIT Press, 1985), p. 23–40.

14 Sterling, *Still Life*, p. 95.

15 Quoted in Martin S. Soria, 'Francisco de Zurbarán: A Study of his Style', *G.B.-A.*, XXV (1944), p. 33.

16 On the place of the *Dessert with Wafers* in Baugin's work as a whole, see Sterling, *Still Life*, pp. 69–70.

17 '. . . Parrhasius' work was doubly fictive. Zeuxis thought that he saw a stage curtain, and asked for it to be raised – but even if he had been right, and it had been raised, he would have seen a represented space which openly declared its fictive nature in relation to the 'real' space of the stage. Actually he was wrong, and Parrhasius had managed to create *the illusion of a space in which figuration was destined to appear*': Stephen Bann in *The True Vine*, Ch. 1 ('Zeuxis and Parrhasius'), p. 35.

18 On the whole topic of Chardin's anti-theatricality, see Michael Fried's excellent discussion in *Absorption and Theatricality*, pp. 7–70, especially pp. 11–17.

19 Michael Baxandall, 'Pictures and Ideas: Chardin's *A Lady Taking Tea*', in *Patterns of Intention: On the Historical Explanation of Pictures* (New Haven and London: Yale UP, 1985), pp. 74–104.

20 Thomas Crow offers a less enthusiastic view of Chardin's style in *Painters and Public Life in Eighteenth-Century Paris* (New Haven and London: Yale UP, 1985): 'In the work of (Chardin), paint adheres to the canvas like a growth. It congeals, coagulates, bubbles . . .', p. 149. During the era of modernism more praise than ever has been lavished on Chardin's technique, to the point of hagiography; and in this context Crow's iconoclastic phrasing is particularly welcome (to this writer, at least). Crow goes on to comment on Chardin's 'careful exclusion of all but the most minimal references to the contemporary world beyond his interiors, of sexual and of power relationships among adults', and observes that 'the paintings' appeal is recuperated on the level of transcendent technique' (ibid).

CHAPTER 3

1 On the luxury of the *ancien régime*, see Fernand Braudel, *Civilisation matérielle et capitalisme* (Paris: Librairie Armand Colin,

1967), Ch. 3: *Capitalism and Material Life, 1400–1800*, trans. Miriam Kochan (London: Weidenfeld and Nicolson, 1981), pp. 121–91. And Braudel, *Les structures du quotidien: le possible et l'impossible* (Paris: Librairie Armand Colin, 1979), chapters 3 and 4: *The Structures of Everyday Life: the Limits of the Possible*, trans. Sian Reynolds (London: Collins, 1981), pp. 183–333.

2 See Jean Baudrillard, *La société de consommation: ses mythes, ses structures* (Paris: SGPP, 1970). And Pierre Bourdieu, *Distinction: critique sociale du jugement* (Paris: Minuit, 1979); trans. Richard Nice (London: Routledge & Kegan Paul, 1986). The comparison between Victorian and modernist interiors in relation to habits of consumption is developed further in Jeremy Gilbert-Rolfe and Stefanie Hermsdorf, 'A Thigh-Length History of the Fashion Photograph, An Abbreviated Theory of the Body', in *Bomb*, 25 (Fall 1988), 74–81.

3 On the Dutch ascendancy, see Braudel, *La Méditerranée et le monde méditerranéen à l' époque de Philippe II* (Paris: Librairie Armand Colin, 1966), II, section III: *The Mediterranean and the Mediterranean World in the Age of Philip II*, trans. Sian Reynolds (New York: Harper & Row, 1972), pp. 629–42.

4 On the luxury of Edo, see Braudel, *The Wheels of Commerce* (London: Collins, 1982), pp. 590–94.

5 Simon Schama, *The Embarrassment of Riches: An Interpretation of Dutch Culture in the Golden Age* (Berkeley, California: University of California Press, 1988); referred to below as *Riches*. I am indebted to Simon Schama not only for many points in the present discussion but for the sheer pleasure of his remarkable text.

6 See Schama, *Riches*, pp. 152–5.

7 See Mikhail Bakhtin, *Rabelais and His World*, pp. 301–2.

8 The question of the attitudes towards the peasant figures embodied in Brueghel's 'comic' scenes was the subject of lively controversy in the 1970s and beyond in the journal *Simiolus*. See Svetlana Alpers, 'Bruegel's Festive Peasants', *Simiolus*, VI (1972–3), pp. 163–76; 'Realism as a Comic Mode: Low-Life Painting Seen Through Bredero's Eyes', *Simiolus*, VIII (1975–6), pp. 115–44; and 'Taking Pictures Seriously: a Reply to Hessel Miedema', *Simiolus*, X (1978–9), pp. 52–6. A different view of the 'comic' content of the images is put forward by Keith Moxey and Hessel Miedema: see Miedema, 'Realism and Comic Mode: the Peasant', *Simiolus*, IX (1977), pp. 205–19; and Moxey, 'Sebald Beham's Church Anniversary Holidays: Festive Peasants as Instruments of Repressive Humor', *Simiolus*, XII (1981–2), pp. 107–30.

9 See Margaret D. Carroll, 'Peasant Festivity and Political Identity in the Sixteenth Century', *Art History*, X (1987), pp. 289–314.

10 Josiah Child, *Brief Observations Concerning Trade* (London, 1668),

p. 4; cit. Schama, *Riches*, p. 295.

11 Bernard de Mandeville, *The Fable of the Bees: or, Private Vices, Publick Benefits*, ed D. Garman (London: Wishart, 1934), pp. 148–9; cit. Schama, *Riches*, p. 297.

12 On the two paintings by de Hooch, see Kenneth Clark, *Civilisation: A Personal View* (London: BBC, 1969), pp. 187–201.

13 Dutch flower paintings are discussed by Ingvar Bergström in his invaluable *Dutch Still Life Painting in the Seventeenth Century*, trans. Christina Hedström and Gerald Taylor (New York: Hacker, 1983), pp. 42–97.

14 On the vegetation of the Pompeian gardens, see Wilhelmina Jashemski, *The Gardens of Pompeii*, pp. 1–88.

15 See Agnes Arber, *Herbals: their Origin and Evolution; A Chapter in the History of Botany* (Cambridge: Cambridge UP, 1986).

16 The *locus amoenus* is discussed in Norbert Schneider, 'Vom Klostergarten zur Tulpenmanie', in *Stilleben in Europa* (Munster: Aschendorff, 1979), pp. 294–312, especially pp. 294–301.

17 Bergström, *Dutch Still Life*, pp. 64–5.

18 See Paul Pieper, 'Das Blumenbukett', in *Stilleben in Europa*, pp. 314–49.

19 Michel Foucault, *Les mots et les choses* (Paris: Gallimard, 1966), I, 5; *The Order of Things: An Archaeology of the Human Sciences* (New York: Random House, 1970), pp. 125–66.

20 On the *Kunst- und Wunderkammern* in relation to painting, see Gisela Luther, 'Stilleben als Bilder der Sammelleidenschaft', in *Stilleben in Europa*, pp. 88–128.

21 See Thomas DaCosta Kaufmann, 'Remarks on the Collections of Rudolf II: the *Kunstkammer* as a Form of *Representatio*', *Art Journal*, XXXVIII (1978), pp. 22–8; and Kaufmann, *L'Ecole de Prague: la peinture à la Cour de Rodolphe II* (Paris: Flammarion, 1985), pp. 268–9.

22 The connections between the *Kunstkammer*, the Panopticon and the origins of art history are pursued in a fascinating discussion by Donald Preziosi in *The Coy Science* (New Haven and London: Yale UP, 1989).

23 See Norbert Schneider, 'Vom Klostergarten . . .', pp. 303–12.

24 One of the best accounts of Dutch tulipomania is in N. W. Posthumus, 'The Tulip Mania in Holland in the Years 1636 and 1637', *Journal of Economic and Business History*, I (1929), pp. 434–66.

25 On the links between early flower painting and manuscript illumination, see Bergström, *Dutch Still Life*, pp. 50–1.

26 See J. Michael Montias, 'Cost and Value in Seventeenth-Century Dutch Art', *Art History*, X (1987), pp. 455–66.

27 Bergström, *Dutch Still Life*, pp. 60–1.

28 Schama, *Riches*, p. 354.

29 Svetlana Alpers, *Rembrandt's Enterprise: The Studio and the Market* (London: Thames and Hudson, 1988), p. 20.

30 Melchior Fokkens, *Beschryvinge der Wijt-Vermaerde Koop-Stadt Amstelerdam* (Amsterdam, 1664); cit. Schama, *Riches*, p. 303.

31 On the evolution of the Dutch interior, see Peter Thornton, *Seventeenth Century Interior Decoration in England, France and Holland* (New Haven and London: Yale UP, 1978).

32 See Schama's discussion of the painting in 'The Unruly Realm: Appetite and Restraint in Holland in the Golden Age', *Daedalus*, CVIII (1979), pp. 103–23; and Peter Sutton, 'The Life and Art of Jan Steen', in *Jan Steen: Comedy and Admonition, Bulletin of the Philadelphia Museum of Art*, LXXVIII, No.337–8, pp. 3–7.

33 See Bergström, *Dutch Still Life*, pp. 112–23; and Schama, *Riches*, p. 160.

34 On the development of the 'monochrome' style, see J. Michael Montias, 'Cost and Value . . .', pp. 458–62.

35 Bergström, *Dutch Still Life*, pp. 154–90.

36 John Calvin, *Commentary on Isaiah* 2: 12, 16.

37 *The Spiritual Exercises of St Ignatius* (London: Burns & Oates, 1926), pp. 216–7.

38 John Calvin, *Commentary on a Harmony of the Evangelists* III, in *Works* 33 (Edinburgh: The Calvin Translation Society, 1846), p. 182. For the comparison between Calvin and Ignatius I am indebted to conversation with Glenn Harcourt, and to his excellent forthcoming article 'Eyes of Imagination and Faith: Experience, Metaphor and the Image of Matthew's "Everlasting Fire"'. Glenn Harcourt develops his account of Reformation and Counter-Reformation visuality more comprehensively in 'Rembrandt, Dou, and the Representation of Knowledge in Seventeenth-century Dutch Painting' (Ph.D. dissertation, University of California, currently in preparation).

39 I am indebted to Alpers's by now classic study, *The Art of Describing: Dutch Art in the Seventeenth Century* (Chicago: University of Chicago Press, 1983), for many points in the present discussion, and for the inspiration of her work as a whole. Obviously my own starting-point is to look to the semantic dimension of Dutch painting, and it might seem that here I go against Alpers's denial of the primacy of allegorical modes in Dutch painting; but the difference is, I think, only on the surface. In place of a mechanical and exaggerated allegorising approach to Dutch art, Alpers focuses on the codes which establish its rhetoric of realism, and the place of those codes in Dutch culture of the period; the approach is from the semiotics of culture, as it is here.

40 On *pronkstilleven* see N. R. A. Vroom, *De Schilders van het Monochrome Banketje* (Amsterdam, doctoral dissertation, 1945);

English revised edition, *A modest message as intimated by the painters of the 'monochrome banketje'*, 2 vols. (Schiedam, 1980); and Sam Segal, *A Prosperous Past: The Sumptuous Still Life in the Netherlands 1600–1700* (The Hague: SDU, 1988).

41 Pliny, *Natural History*, XXXV, 85.

42 Svetlana Alpers, *Rembrandt's Enterprise*, pp. 191–222.

43 Quoted by I. Blok, 'Willem Kalf', *Onze Kunst*, XVIII (1919), p. 86.

44 On the objects used by Willem Kalf, see Bergström, *Dutch Still Life*, pp. 270–2; and Segal, *A Prosperous Past*, pp. 195–6.

45 Kalf's 'Paris' period is discussed in Bergström, *Dutch Still Life*, pp. 268–78.

46 'Cet univers de la fabrication exclut évidemment toute terreur et aussi tout style'; Roland Barthes, 'Le monde-objet', in *Essais critiques* (Paris: Seuil, 1964), pp. 19–28.

CHAPTER 4

1 Pliny, *Natural History*, XXV, 112.

2 Ibid.

3 George Kubler, *The Shape of Time* (New Haven and London: Yale UP, 1962).

4 George Kubler, *The Shape of Time*, p. 71.

5 See Jean Baudrillard, 'The *Trompe-l'oeil*', in *Calligram: Essays in New Art History from France*, ed. Norman Bryson (Cambridge: Cambridge UP, 1988).

6 Jacques Lacan, *The Four Fundamental Concepts of Psycho-Analysis*, ed. Jacques-Alain Miller, trans. Alan Sheridan (New York: Norton, 1978), pp. 42–122.

7 Recent interpretations have consistently stressed the didactic function of the spiritual/profane dichotomy (for example Marlier, Grosjean and Craig); the work of Hans-Joachim Raupp has emphasised the class context for such oppositions, particularly as these are revealed in the tradition of peasant satire. Georges Marlier, 'Het stilleven in de vlaamsche schilderkunst der XVIᵉ eeuw', *Jaarboek van het Koninklijk Museum voor Schone Kunsten* (Antwerp, 1939–41), pp. 89–100; Ardis Grosjean, 'Towards an Interpretation of Pieter Aertsen's Profane Iconography', *Konsthistorisk Tidskrift*, XLIII (1974), pp. 121–43; Kenneth Craig, 'Pieter Aertsen and *The Meat Stall*', *Oud Holland*, XCVI (1982), pp. 3–15 and '*Pars Ergo Marthae Transit*: Pieter Aertsen's 'Inverted Paintings of *Christ in the House of Martha and Mary*', *Oud Holland*, xcvii (1983), pp. 25–39; Hans-Joachim Raupp, *Bäuernsatiren: Enstehung und Entwicklung des bäuerlichen Genres in der deutschen und niederländischen Kunst, ca. 1470–1570* (Niederzier, 1986).

8 Aersten's work in the context of the Reformation and

Reformation 'iconoclasm' has been explored by Keith Moxey in
'The "Humanist" Market Scenes of Joachim Beuckelaer:
Moralizing Examples or "Slices of Life"', in *Jaarboek van het
Koninklijk Museum voor Schone Kunsten* (Antwerp, 1976), pp. 109–
87 and in *Pieter Aertsen, Joachim Beuckelaer, and the Rise of Secular
Painting in the Context of the Reformation* (New York: Garland,
1977); and by David Freedberg in 'The Hidden God: Image and
Interdiction in the Netherlands in the Sixteenth Century', *Art
History*, V (1982), pp. 135–53.

9 See Karl M. Birkmeyer, 'Realism and Realities in the Paintings of
 Velázquez', *G.B.-A.*, LII (July–August 1958), pp. 63–77.
10 See Y. Korshak, *Art Bulletin*, LXIX (1987), pp. 102–16, and the
 exchange between Korshak and Francis H. Dowley in *Art Bulletin*,
 LXX (1988), pp. 504–20.
11 Cit. Schama, *Riches*, p. 400.
12 *De Ervarene en Verstandige Hollandsche Huyshoudster* (Amsterdam,
 1743), pp. 3, 8–9; cit. Schama, *Riches*, p. 422
13 On the Chardin figures' absorption in perception, see Michael
 Fried's classic study *Absorption and Theatricality: Painter and
 Beholder in the Age of Diderot* (Berkeley: University of California
 Press, 1981).
14 Sigmund Freud, 'The "Uncanny"', in *Standard Edition* (London:
 Hogarth Press, 1919), vol. xvii, p. 245. On the formation of the
 subject in relation to the maternal body, see also Kaja Silverman,
 The Acoustic Mirror: The Female Voice in Psychoanalysis and Cinema
 (Bloomington: Indiana UP, 1988), pp. 1–41, 101–40.
15 See Germaine Greer, *The Obstacle Race: The Fortunes of Women
 Painters and their Work* (New York: Farrar, Straus, Giroux, 1979),
 especially pp. 227–49.
16 Sir Joshua Reynolds, *Discourses on Art*, ed. Robert R. Wark (New
 Haven and London: Yale UP, 1975), p. 57.
17 Reynolds, *Discourses*, p. 52.
18 Reynolds, *Discourses*, ibid.
19 Reynolds, *Discourses*, p. 71.
20 Cit. Naomi Schor, *Reading in Detail* (New York and London:
 Methuen, 1987) p. 21.
21 Reynolds, *Discourses*, VIII, p. 153.
22 Shaftesbury, *Characteristics*, cit. in the excellent discussion of the
 downgrading of women's art in Rozsika Parker and Griselda
 Pollock, *Old Mistresses: Women, Art, and Ideology* (New York:
 Pantheon Books, 1981), p. 51.
23 *Gazette des Beaux-Arts*, 1860; cit. Parker and Pollock, *Old
 Mistresses*, p. 13.

List of Illustrations

Measurements are given in centimetres.

55 Samuel van Hoogstraten (1627–1678), *Steckbrett*, 62 × 78. Staatliche Kunsthalle, Karlsruhe.

56 Pieter Aertsen, *The Butcher's Stall*, 1551, oil on canvas. University of Uppsala.

57 Joachim Beuckelaer, *The Well-stocked Kitchen (Christ in the House of Mary and Martha)*, 1566, oil on panel, 171 × 250. Rijksmuseum, Amsterdam.

58 Joachim Beuckelaer, *Fishmarket: Christ Shown to the People*, 1570, oil on wood, 151 × 202. Nationalmuseum, Stockholm.

59 Diego Velázquez, *Christ in the House of Mary and Martha*, 1618, oil on canvas, 60 × 103·5. National Gallery, London.

60 Diego Velázquez (1599–1660), *The Black Servant*, oil on canvas, 86·4 × 99. Chicago Art Institute.

61 Diego Velázquez (1599–1660), *Woman Cooking Eggs*, 1618, oil on canvas. National Gallery of Scotland, Edinburgh.

62 Wolfgang Heimbach (*c*. 1610–*c*. 1678), *Woman Looking at a Table*. Staatliche Gemäldegalerie, Kassel.

63 Diego Velázquez, *Las Hilanderas*, *c*. 1657, oil on canvas, 213·7 × 288.9. Museo del Prado, Madrid.

64 Diego Velázquez, *The Kitchen Maid with Christ at Emmaüs (The Black Servant)*, *c*. 1620, oil on canvas, 55 × 118. National Gallery of Ireland, Dublin.

65 Jacques Louis David, *The Lictors Returning to Brutus the Bodies of his Sons*, 1789, oil on canvas, 325 × 425. Musée du Louvre, Paris.

66 Jan Vermeer, *Soldier and Young Girl Smiling*, 1655–60, oil on canvas, 50·5 × 46. The Frick Collection, New York.

67 François Desportes (1661–1743), *Peaches and Silver Platters*, oil on canvas, 91 × 118. Nationalmuseum, Stockholm.

68 Anne Vallayer-Coster (1744–1818), *Still Life with Round Bottle*, oil on canvas. Staatliche Museen Preussischer Kulturbesitz, Gemäldegalerie, Berlin. (Photo: Jörg P. Anders).

69 Anne Vallayer-Coster (1744–1818), *Still Life with Ham*, oil on canvas. Staatliche Museen Preussischer Kulturbesitz, Gemäldegalerie, Berlin. (Photo: Jörg P. Anders).

70 Detail of *Basket of Fruit*, Caravaggio (illus. 21).

71 Detail of *Still Life with Apples*, Paul Cézanne (illus. 22).

72 Fede Galizia, *Still Life with Peaches in a Porcelain Bowl*, oil on panel 30 × 41.5. Silvano Lodi Collection, Campione, Switzerland.

73 Paula Modersohn-Becker, *Still Life with Blue and White Porcelain*, 1900, oil on board, 49·8 × 55·9. Niedersächsisches Landesmuseum, Hanover.

74 Jean-Baptiste-Siméon Chardin, *The Return from the Market*, 1738, oil on canvas, 46·7 × 37·5. National Gallery of Canada, Ottawa.

75 Jean-Baptiste-Siméon Chardin, *Saying Grace*, *c*. 1740, oil on canvas, 49·5 × 38·5. Musée du Louvre, Paris.

76 Antoine Raspal (1738–1811), *Cuisine Provençale*, Musée Réattu, Arles. (Photo: Edimedia).